# PROPERTY OF

Delphine Cormier

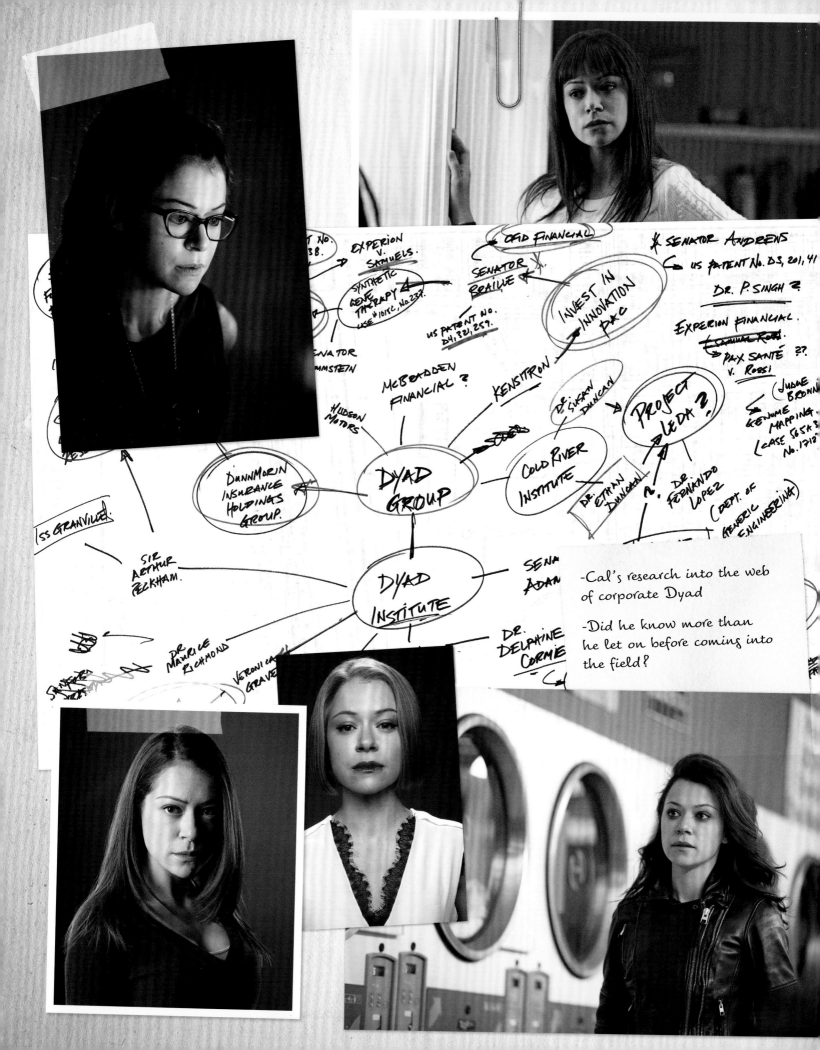

EXPERION v. SAMUELS.

OFID FINANCIAL

SENATOR ANDRENS

US PATENT No. DS, 201, 41

DR. P. SINGH ?

SYNTHETIC GENE THERAPY

SENATOR BRAILLE

INVEST IN INNOVATION PAC

EXPERION FINANCIAL.

SAMUAL ROSS

PAX SANTÉ ??

V. ROSSI

JUDGE BROWN

US PATENT No. D4, 321, 259.

SENATOR HAMMSTEIN

McBRADDEN FINANCIAL ?

KENSTRON

DR. SUSAN DUNCAN

PROJECT LEDA ?

KENOME MAPPING CASE S65A3 No. 1712

HUDSON MOTORS

COLD RIVER INSTITUTE

DR. FERNANDO LOPEZ

DR. ETHAN DUNCAN

(DEPT. OF GENERIC ENGINEERING)

DUNNMORIN INSURANCE HOLDINGS GROUP.

DYAD GROUP

SS GRANVILLE.

SIR ARTHUR PECKHAM.

DYAD INSTITUTE

SENA ADAN

DR. MAURICE RICHMOND

VERONICA GRAVE

DR. DELPHINE CORMIE

-Cal's research into the web of corporate Dyad

-Did he know more than he let on before coming into the field?

# ORPHAN BLACK

CLASSIFIED CLONE REPORTS

CONFIDENTIAL

BY DR. DELPHINE CORMIER
AND KEITH R. A. DECANDIDO

HARPER
DESIGN
An Imprint of HarperCollins Publishers

AN INSIGHT EDITIONS BOOK

If you are reading this, then you are about to learn a great deal about something that has been one of the most closely guarded secrets of this young century. Though in truth the secret goes back to the 19th century . . .

Forgive me, but this is difficult to write. My name is Delphine Cormier, I'm an immunologist, but my job titles of late have ranged from interim CEO of the Dyad Institute to geneticist.

Two years ago, I was hired as a Special Research Assistant to Dr. Aldous Leekie, whose name you might recognize as the author of the pop-science book <u>Neolution: The New Science of Self-Directed Evolution</u>. What you, theoretical reader of this material, likely do not know is that there is nothing "new" about Neolution. It was founded in the 19th century by a visionary named P.T. Westmorland, who first proposed self-directed evolution in his book <u>On the Science of Neolution</u>. That book, however, is known only to a few academics and fringe scientists, unlike Aldous's tome, which brought the concept to the masses.

However, Aldous's movement and the Dyad Institute—which engages in cutting-edge, sometimes illegal genetic research—are only a small part of a much larger organization. The true face of Neolution.

Most of the information I have collected herein relates to the most ambitious project undertaken by Neolution and the Dyad Institute: Cloning.

Long assumed to be the realm of science fiction and Scottish sheep, human clones—or genetic identicals, as they're less vulgarly called—have, in fact, been a reality for three decades, thanks to the work of Neolution in general, and the work of doctors Susan and Ethan Duncan in particular. Through Project Leda, they successfully implanted genetically identical fetuses in women around the world via fertility clinics all over the world. As a result, there are now dozens of women who look the same, have the same DNA, and the same voice, though they have been born and raised in different places throughout the globe.

Those genetic identicals have been monitored by Dyad, originally supervised by Aldous, and his team of monitors. Aldous groomed one clone, Rachel Duncan, to be self-aware. She is one of the Leda clones, the only one who was intentionally self-aware, as she was raised by Susan and Ethan Duncan.

One set of genetic identicals in Europe became self-aware in 2001, and they wound up being killed—on Rachel's order, horrifyingly enough. There were 36 casualties, one survived, however, and Veera Suominen (also known as M.K.) reached out to another of her "sisters" in Canada a few years after that, a police detective named Beth Childs. Beth in turn reached out to Cosima Neihaus in the United States, Katja Obinger in Germany, and Alison Hendrix also in Canada.

My own involvement began when I joined Dyad as Aldous's Special Research Assistant, and he assigned me to be the monitor for Cosima. That put me in contact with other "sisters"—including two who had managed to be raised outside the purview of Project Leda, a grifter named Sarah Manning and an assassin named Helena. Helena, under the influence of the Proletheans, a rabid religious sect, murdered several of the Leda clones, including Katja, before realizing the error of her ways and finding her twin sister, Sarah.

Soon, I became far more attached to Cosima than the monitor/subject relationship would normally permit. I also came to realize that there were many competing agendas that I needed to navigate—Aldous's, Rachel's, Dyad's, the cabal that ran Topside's, and ultimately Neolution's, under the bizarre leadership of a man claiming to be P.T. Westmorland himself. After Aldous's death, I was assigned to take his place, and after Rachel was incapacitated, I was promoted to interim CEO.

But my relationship with the Leda clones has proven problematic. As have those competing agendas I mentioned, as well as difficulties caused by the Proletheans and the other cloning program, Project Castor, which created male genetic identicals, most of whom were raised in a more controlled military environment.

In addition, all the genetic identicals faced a crisis, a disease ravaging them. Our race to find a cure was impeded by those who wished to destroy the work we have done.

If this sounds confusing, you are not alone in believing that. I myself have had difficulty—which is why I began compiling the information contained herein. Attached are transcripts, files, reports, e-mails, articles, websites, excerpts, and so much more. I originally started to compile it in order to help keep track of the labyrinthine twists and turns that my life with Project Leda had become. I later came to view it as an important record of what we have all been through.

To that end, I have gone so far as to include my own diary entries. Many of the conflicts that I and the Leda clones have navigated _____ ame aware _____ ve been due to its secrecy.

_____ was forced to leave this in Cosima's _____ s in fear for my life. In fact, I was _____ r dead, though I was rescued and _____ l, the Neolution "headquarters," _____ ght me back to health. After healing _____ , I became Revival's "country _____ entually was reunited with Cosima, _____ to compile this documentation.

_____ s as a record of the extraordinary _____ t Leda, of cloning, of Neolution, and _____ veral sisters fighting for their lives.

_____ are, dear reader, I hope that this material _____ you. I also hope that it convinces you. _____ n. I wish that it were.

—Dr. Delphine Cormier

# DYAD INSTITUTE

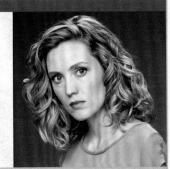

## CORMIER, DELPHINE
## 1924-2763-N

*PIN: 0021121798*

### EMPLOYEE PERSONNEL RECORD

SECURITY LEVEL: _Employment Suspended_

STATUS ☐ REGULAR ☐ PART TIME ☐ TEMPORARY

**Employment Status: Classified**

**Position: Head Immunology - Chief Executive Officer**

**Details:**

*Place of Birth: Lille, France*

*Date of Birth: 21/12/84*

*Nationality: French*

*Education: LMGM, Paris*

DYAD INSTITUTE

DYAD INSTITUTE

NAME: DELPHINE CORMIER
DOB: 12.21.1984
ID: 8380203DI-M

CLASSIFICATION: IMMUNOLOGIST
LEVEL 4 ACCESS

6335-DIID

From the diary of Dr. Dephine Cormier, University of Minnesota

I have seen her. Walking across the courtyard from her first class this morning, her expression thoughtful, her book bag casually thrown over her shoulder. I had seen photographs, of course; I knew she wore clunky glasses and her hair in a youthful, dreadlock style, that her clothes would be dynamic and colorful. I knew she would be 1.63 meters tall, that she would weigh 50 kg. that she was coming away from a neurobiology class; I knew what to expect . . . But I was not prepared for her insouciant manner, the way she squinted and smiled up at the gathering rainclouds, aware of the gray weather in a way that the other students missed, immersed in their phones and conversations. I did not think she would kick at an early pile of leaves. She walks loosely, comfortable in her skin, her face as open and expressive as Ms. Hendrix's is closed. It was a strange, exciting moment, seeing her for the first time—I am a spy, and here is my target!—but I am anxious, too.

Until now, my focus has been so strained and scattered. Working with Aldous, getting close to him . . . I did not expect it to lead me here. Then the move, signing up for classes—the reams of files to read, to memorize. I tell myself I can do this, that I must do this, for Aldous, for myself. The magnitude, the importance of this experiment . . . how could I have said no? But when I saw her today, a real, living young woman laying bare all her eccentricities, hands thrust into the pockets of her red coat . . . The reality of what we are doing, what I am doing, hit me for the first time.

She is no longer Subject 324b21; she is no longer a string of designators on a page.

She is Cosima Niehaus.

She is real. This is all real.

DYAD INSTITUTE

NAME: COSIMA NIEHAUS
DOB: 03.09.1984
PLGI #324b21

CLASSIFICATION: EVO-DEVO
LEVEL 4 ACCESS

7433-DIID

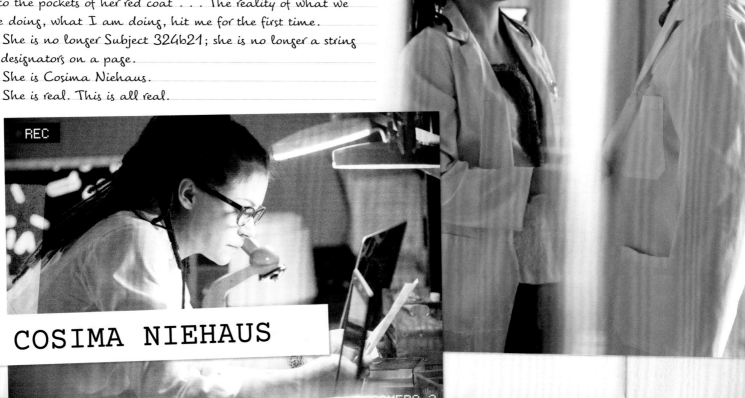

REC

COSIMA NIEHAUS

CAMERA 3

# DYAD INSTITUTE

## NIEHAUS, Cosima
### PLGI #324621

**DOB:** 03-09-1984
**HEIGHT:** 5'4"
**WEIGHT:** 112 lbs. (prior to treatment for PL gynopathic pulmonary autoimmune disorder; weight reached adult low of 99 lbs. at last recorded medical check).
**OCCUPATION:** Graduate student, evolutionary development. Specific family files reference Dyad Surrogate System (DSS).
**SEE ALSO:** NiehausD, NiehausM, GoldmannL (maternal foster aunt).

## PERSONNEL FILE

Besides an early adoption and exhibiting a focused, scientific mind from an early age, Cosima Niehaus's childhood in the suburbs of San Francisco was unremarkable. Told that their child was exhibiting signs of autism spectrum disorder (ASD) by a Dyad plant at Cosima's two-year pediatric checkup, the scholarly adoptive couple willingly filled out form after form regarding their daughter's emotional and educational development; a recommended scoliosis study when subject was four allowed for blood-typing samples and extensive X-ray films. No anomalies were found.

After she was deemed "gifted" at age seven, a school counselor (Dyad plant) recommended Cosima for a new program serving exceptional students; the program's administrator also worked for Dyad. Initial tests put her adjusted IQ at 147, with obvious peaks in memorization, reading comprehension, and logical application. Other than the loss of a beloved family dog in 1994 and a few isolated bullying incidents, subject was not exposed to any severe trauma. In addition to high intelligence, Cosima demonstrated standard Leda traits throughout puberty, including playful and occasionally impulsive behavior; she was caught vandalizing school property (subject decorated three school bathrooms with profane phrases in Latin), and records indicate that she was prone to argue points of fact with some of her teachers. Biological samples continued to be collected. Noted pre- and post-puberty that her romantic/sexual inclinations were toward other females (flexible sexual identity tendencies noted in eleven other documented PLGIs thus far). Besides nearly compulsive reading habits, subject enjoyed visiting the California Academy of Sciences and playing interactive games online, notably massively multiplayer online role-playing games (MMORPGs).

Subject began using marijuana recreationally in 1999, at age 15. GPA at 2002 graduation was 3.9. She traveled for a year through the EU and India before beginning part-time classes at the University of California, Berkeley, in 2005. Advisor/molecular biology professor CryanP and a coworker at a local bookstore, LopezA, served as interim monitors until a full-time observer could be placed.

CheseretE served as subject's monitor from 2010-13. Reports filed indicate that subject was passionate about her work—her focus had narrowed to molecular biochemistry—and she started carrying a full class load in 2011. A CT and MRIs of the brain and spine were performed over a three-week period in March 2011, after subject was administered 2-4 mg. doses of flunitrazepam in wine. No anomalies were found. Became self-aware following direct contact by PLGI Elizabeth Childs in 2013, after which she changed her major to experimental evolutionary biology and transferred to the University of Minnesota.

From the diary of Dr. Delphine Cormier, University or Minnesota

We are in open lab together Thursday afternoons. She is friendly and laughs a lot, and has twice smiled at me, but only in acknowledgment that we share a class—not as a friend or even as a colleague, not yet. I have a plan, though. It is sournois—sneaky? I will try it tomorrow. I have practiced my "cover" story: I am Delphine Beraud, an immunologist studying host-parasite relationships, recently transplanted from Paris.

It has been two weeks since I first saw her, but I've been kept busy. Dyad sends me work files, keeping me up to date on our somatic therapy projects . . . plus lab results for an unnamed patient exhibiting an unusual grouping of symptoms. I am not given any specifics on the pathogen, told only to theorize whether or not our current work might be effective in treating her. Whoever she is, she is getting worse. She is the same age as Cosima . . . Is it one of the Leda clones?

Aldous says I need to "step up my game." This is, faire des progrès. We spoke last night, and he says he will be in town again this weekend. He seems . . . different. Il est stressé, agitated. He is concerned about Leda, but was evasive when I asked for more information. I am still waiting for personal notes from Cosima's previous monitor, Emi Cheseret. Aldous says there have been "difficulties."

It is strange, how I feel about him now. I knew who he was before I started at Dyad; I saw him speak at university, read his papers. When I realized we would be working together directly I was, how is it, star-struck? He was so charismatic and focused and methodical. Arrogant, perhaps, but not entirely undeserved. He is one of those people… when you are with him, when he is focused on you, you are the only one in the room, in the world. I was so flattered when he invited me to work with him on a "private" company project. From then on it was a whirlwind, wine in the lab at three in the morning, impassioned conversations about the possibilities for the human race and the future of science. The intimacy was sudden and intense, passionné. Too fast. I still thought it might have been love, while I was signing non-disclosure agreements and packing to relocate. I was dizzy with excitement, with the secret hope that I would somehow become instrumental in humanity's greatest genetic experiment.

He comes to see me again next week but right now I am here, in my small student's apartment; it is cold, I am alone, and he is not so compelling on a computer screen. His romance has come to seem il est de routine, that is . . . perfunctory. He wants information about Cosima, about what and who she knows, and beneath his sharp eyes and sultry words I see a growing desperation. Was the seduction only to get me involved in Leda? Am I being used?

But then, what if I am? These women, they are miracles of science, the foundation on which Dyad can achieve great strides forward in humanity's understanding of itself. Whatever happens between Aldous and me, he is doing the right thing, trying to find answers. Our deceit is a necessity.

Tomorrow, I will linger at the desk by her station as the students wander away. She is always one of the last to leave. I will call a recorded line and have a tearful break-up with an ex-lover; I will weep and run, leaving something behind. A scarf? No, papers, important papers, something that will impress her. If she does not follow, I shall go back for them, apologize for the scene . . . I think she will come, though. I think she is too inquisitive and kind not to follow me. Our first direct engagement. Aldous will be pleased.

## MONITOR ASSESSMENT REPORT (AR-21)
PTN LV 42

| DATE: 10-20-13 | TIME: 1505-1620 |
|---|---|

**AGENT:** CormierD

**SUBJECT DESIGNATION:** 324b21

**NAME:** Cosima Niehaus

**LOCATION(S):**

Workhorse coffee shop/university grounds

**OBSERVED WITH:**

Alone; subject was studying

**INTERACTIONS/EVENTS OF NOTE:**

Cosima spoke with a departing student for a moment regarding class load. The tone was friendly. Wore headphones and listened to music while she read and wrote on her laptop. Drank two black coffees, ate one plain bagel. Spoke on a small pink phone for a few moments—not her regular phone. Kept her voice low.

### PUPIL GAUGE (mm)

1 2 3 4 5 6 7 8   **B** = BRISK
**S** = SLUGGIS

**HEALTH/APPEARANCE CHANGES:**

Subject appeared tired, slightly pale.
Possible hangover?

**MONITOR-SUBJECT INTERACTION:**

None.

**EMOTIONAL STATE(S) OF NOTE:**

Focused, quiet.

**LIST ANY ATTITUDES, ACTIONS, OR BEHAVIORS**

None observed.

CONTACT SUPERVISOR IMMEDIATELY IF YOU OBSERVE OR SUSPECT ANY O
ACTIVITY, PRIVATE MEETINGS OUTSIDE OF DOCUMENTED FAMILY/ACQUAINTA

DYAD INSTITUTE  |  6750 GARRISON ROAD TORON                E.REG

9

We hold in our hands the capacity to refine the very building blocks of life — thus it is the moral responsibility of visionaries like us to continue healing, feeding, and fueling the future of humanity.

The Age of Biotechnology is upon us.

**THIRTY-DAY EMPLOYEE EVALUATION**
**EMPLOYEE: Scott Smith**
**EMPLOYEE ID: 2045-8819-RND**
**SUPERVISOR: Dr. Aldous Leekie**

## POSITIVES

Smith is a promising employee who was hired on the recommendations of Dr. Delphine Cormier and Cosima Niehaus, Project Leda 324b21. Smith's area of expertise is gene sequencing, a science he understands with an impressive level of natural instinct. His thesis at the University of Minnesota was not yet complete, but I was able to obtain a copy of his current draft, and it was quite brilliant, if a bit too rife with typos—though one would hope that would be fixed by the time of his defense.

Smith is continuing his graduate work with Dyad's assistance, and we hope to have him defend his thesis and obtain his doctorate within a year's time, if not sooner. It is our hope that his talent for sequencing will prove useful in curing the autoimmune disorder that has ravaged Project Leda.

## NEGATIVES

We have another gamer in our midst. Worse, he's an organized gamer, and he has taken to gathering his fellow nerds around a table and playing when they should be working.

I am, perhaps, being unfair. After all, we all have our methods of blowing off steam, and none of the employees who are part of Smith's little gaming group have been dilatory in their work. However, it has been my experience that hardcore gamers such as Smith and his cronies have an unfortunate tendency to let their leisure activities overtake the ones they're actually paid to do, and this requires attention.

The position Smith holds is one traditionally held by a PhD, but Smith is close enough to achieving his, and his work is promising enough, that we can, I think, overlook that detail, especially if he continues to work toward that goal while in our employ.

## OVERALL EVALUATION

Thus far, Smith has proven to be a talented scientist and a promising employee. In addition, his work could be invaluable in Project Leda. I foresee a bright future for him.

-Scott Smith—Loyal to Cosima and Leda clones over Dyad— Keep an eye on him and his actions.

-Tends to stay late to play "board games." Is that a cover?

# NEOLUTION:
## THE NEW SCIENCE OF SELF-DIRECTED EVOLUTION

DYAD INSTITUTE
6750 GARRISON ROAD
TORONTO, M6T JK8
T +416.555.0139
F +416.555.0138
T 1.800.555.0139

INFO@DYADINSTITUTE.RE•
WWW.DYADINSTITUTE.RE

-Cold River Institute—
founded by eugenicists in early
20th century. Now owned by
Dyad. Continuing their work?

-Building torn down. Records
stored nearby.

# DYAD:
## Opening Up A N
## Of Biological Po

DYAD
INSTITUTE

At Dyad Institute, we work together to make breakthrough medicines which have life changing results. Dyad scientists are encouraged to be creative and active members of the scientific community.

For the last three decades, the Dyad Institute has been at the forefront of our field, pioneering solutions to humanity's most pressing problems in the areas of **health care, food, science and energy.**

Our discoveries have also secured more than 10,500 patents worldwide, with many more applications currently pending.

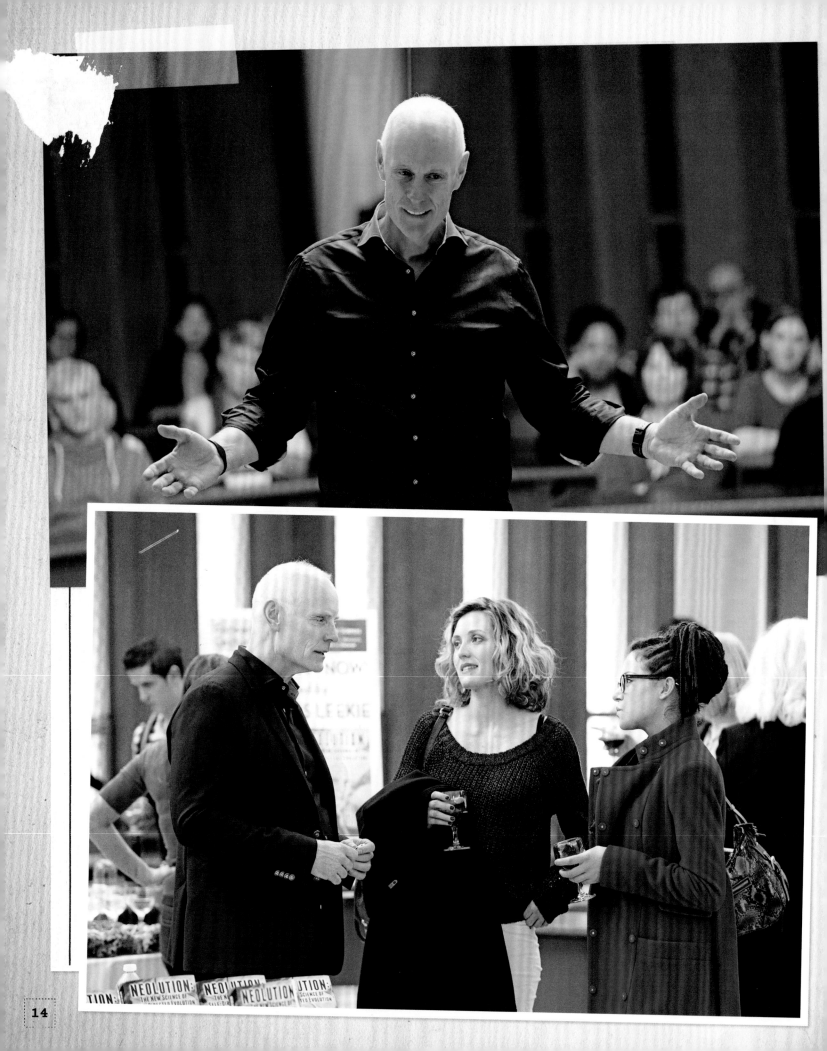

## NEOLUTION

**Excerpt from Lecture,**

**Doctor Aldous Leekie, PhD, MS, ME.**

**Author of** *Neolution: The New Science of Self-Directed Evolution*

Human beings have engaged in genetic engineering, in some form or another, since well before the beginning of recorded history. That's a bold claim, don't you think? But consider our primitive ancestors, nomads, scrounging for resources by day, huddled together at night and listening to the wild animals out in the dark. Wolves lingered near their camps, scavenging from whatever the people threw out. And because some of those wolves got agitated when a scary predator approached the group, growling and yipping and providing a form of warning, a symbiotic relationship began to develop. The people started throwing bones and scraps to the wolves on purpose, to keep them around, and the wolves began to evolve. Those that protected the humans were fed; the puppies they had eventually became domesticated, and were bred with other domesticated pups, their traits deliberately selected—or rejected—to make the animals that served people the best. The very earliest of recorded human history—cave paintings and petroglyphs—shows humans and wolves hunting together.

There are more than three hundred recognized dog breeds today, ranging from shivering lapdogs to lion hunters, and human beings are responsible for every one of them. The very first time a farmer decided to sow the seeds of his best crops to reap a better harvest, or bred two of his prize stock animals together to get a more valuable animal, we embarked on this natural path of genetic engineering. It's part of our evolution, a trait that we've developed and carried for two hundred thousand years; we are hardwired to seek opportunity, to innovate, to make our lives better. We make use of the tools available to us, and if what we've got isn't getting the job done, we make better tools.

Think of how far technology has brought us in our own lifetimes. Think about what's available to children being born today that we didn't have when we were growing up. Advances in medicine, transportation, global awareness, communication, *information*. We all carry around machines that can instantly tell us anything we want to know, that can connect us to one another at the touch of a finger. It has only been fifteen years since the Human Genome Project was completed. Consider that just this year, a team of scientists saved a baby girl's life from aggressive leukemia, after she failed to respond to drug treatment—by modifying her genome. Donor cells were edited to track down and attack her cancer cells. That little girl is alive and well because we did what we're supposed to do: We used the tools we have to make things better.

Consider the development of an organic neural implant that could chemically enhance your learning speed, or that could give you a photographic memory. Scientists have already isolated the proteins and processes that make it happen. Consider the stem cell and what we've already learned regarding its efficacy in disease management. Now imagine a biological transgenic implant that could continually deliver directed gene therapy to patients with cancer, Alzheimer's, Cerebral Palsy, Autism . . . the list goes on and on. Pick your pathogen, disease, or disorder, and realize that we already have the tools we need to mitigate the effects on the mind and body. The Dyad Institute is doing amazing things with gene manipulation, and we're not the only ones. Right now, the human genome is the place to be. It's where some of the brightest minds are working on new ways to improve our lives. How long will it be before we fully implement these astounding tools we've created? The arbitrary, politically motivated restrictions we've been forced to work under will fall away as new generations continue to evolve, to accept the reality that we live in. But the future *can* be now, if we want it. Isn't it time to leave the creation myths behind and fulfill our potential as creators?

Neolution is a simple, obvious concept: evolution that we choose, that we design. We accept and take responsibility for our future, we let go of outmoded morality traditions, and we embrace our true potential—to become the people we want to be. We can live longer; we can think better; we can *be* better.

From the diary of Dr. Delphine Cormier, University of Minnesota

Successes and failures, failures and successes. I found her in the library on Tuesday morning, and she seemed quite pleased to be invited out. When we met before the seminar, she was excited, happy. I have never known anyone to smile so much, with such sincerity. Her humor is "geeky" and very dry. Before the lecture began, after we'd found our seats, she had me laughing to tears, telling me about the "evo-devo" culture, the leaky faucet in her bathroom, her friends back at Berkeley, silly things. She often touched my arm or shoulder when delivering her little witticisms, a trait I've found oddly lacking in most of the Americans I've spent time with.

Aldous spoke eloquently as always, and I'd hoped to see Cosima take interest. She is so progressive in her outlook, I thought the concept of self-directed evolution would appeal to her, but it was not the tension of excitement that made her shift in her seat or mutter under her breath throughout the lecture. At the "meet and greet" afterward, I took her to meet Aldous, and finally saw the fire behind that sparkle in her eyes. She unapologetically introduced herself as a Darwinist, and made no effort to hide her mild disdain for the "business" angle of gene modification. I was a bit surprised . . . but the look on Aldous's face! Like he'd bitten something sour. Perhaps I should have been appalled for him, defensive, but it struck me as funny, to see little Cosima poke poor Aldous in his ego.

After we stepped away and I made some comment on her daring, she grinned at me. Before I knew it we had stolen two bottles of reception wine and were running from security into the cold, laughing. Nous etions comme des adolescents! It was so much fun, the best time I've had since coming here. After we "ditched the fuzz" (her words), we talked and drank wine, walking just off the lighted path across campus. I asked what she'd thought of the

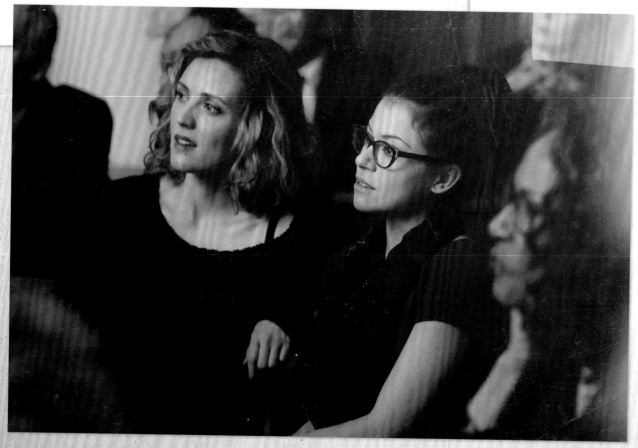

seminar and she called it sound-bite science. She said that Leekie had some interesting ideas but was pushing an agenda that wasn't yet scientifically appropriate—that until we understand how our genes are actually naturally evolving, "fucking" with them is a bad idea. I told her that I thought the idea of helping the sick surely outweighed the risks, at least for those suffering and their families, but she drank more wine and shook her head. "We've got a genome mapped, sure, but the real research is just starting. Right now, we're still loading DNA into viruses in a lab setting to find out what each gene does, what it triggers. That's the scientific method, right? We aren't even close to the next step, and people like Leekie act like we're all done. He's basing his whole . . . theology, for want of a better term, on conclusions we haven't reached. Randomly turning genes off and on in living, breathing people without regard for long-term effects, and thinking we've got it under control, that there aren't going to be ramifications? That's cane toads in Australia, Delphine, it's killer algae. And it's crap science."

She smiled at me then. "And anyway, aren't we kind of amazing already? It took millions of years to get to where we are now, right now. Isn't that enough?"

I started to apologize for dragging her to the seminar, but she half-hugged me and said she was sorry for "going off," that she was having a wonderful time and was really glad I had invited her. When we reached the quad— she lives north of me, off Cleveland—she suggested we continue our crime spree and everything in me said yes, stay, be wild and free! I was supposed to meet Aldous, though—we'd made plans to rendezvous at his hotel—and so I said goodbye. Regretfully. Cosima . . . she's unlike anyone I've ever met. That's funny, considering her origins. She radiates life and will and good humor. Are the other identicals anything like her? My guilt over keeping the truth from her is like a toothache, persistent, unpleasant, getting worse.

My meeting with Aldous felt perfunctory; with Cosima's words running through my mind, I wasn't entirely engaged. I think of myself as a methodical, reasonable person, yet how had I not seriously considered Neolution from this angle? Her analogies to the destruction caused when plants or animals are introduced into a new environment are not lost on me . . . even Aldous admits that the possibilities of genetic pollution have not been fully explored. But then I think of my father and how he looked near the end, his strength gone, his sweet, kind face hollow with disease. My mother never really recovered. She still weeps when she speaks of it.

The benefits outweigh the risks. They must. The unnamed patient that Dyad sends me information about grows weaker every day, one of too many likely doomed to an untimely death, their families forever changed by grief and loss. Neolution proposes answers, and if they're the wrong ones, at least we have tried, yes? Whether or not I am comfortable with the fact, Cosima is 324b21; she is part of an amazing experiment that may unlock a brave new world, for all of us. I mustn't allow the chance of a friendship to cloud my judgment; if she learns that I have lied to her, about everything, she will hate me anyway. Et puis, je serai triste. I will be sad.

—Delphine

# ELIZABETH CHILDS

**OFFICIAL DOCUMENT ~ DOCUMENT OFFICIEL**

The names and date may not agree with information provided on your application, but the certificate is issued exactly as recorded on the birth registration.
Remove card carefully along perforations.

Les noms et la date peuvent ne pas correspondre aux renseignements donnés dans votre demande, mais le certificat est établi conformément à l'enregistrement de naissance.
Détacher soigneusement la carte le long des perforations.

--- CHILDS, ELIZABETH
--- EAST YORK
--- 84-3836209-928    A1014439920M

Please refer to the certificate number if corresponding with respect to this certificate.
Veuillez mentionner le numéro du certificat dans la correspondance relative au certificat.

**DO NOT LAMINATE  —  NE PAS RECOUVRIR DE PLASTIQUE**

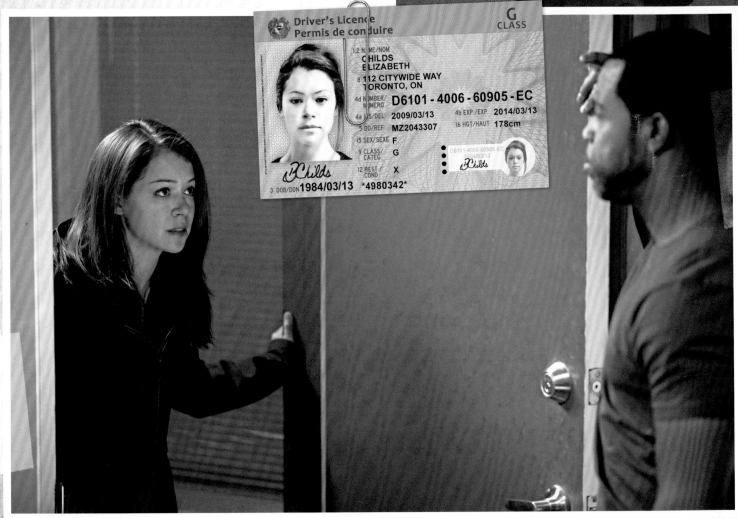

Driver's Licence
Permis de conduire                                    G CLASS

1.2 NAME/NOM    CHILDS
                ELIZABETH
8   112 CITYWIDE WAY
    TORONTO, ON
4d NUMBER/
   NUMÉRO    D6101 - 4006 - 60905 - EC
4a ISS/DEL  2009/03/13    4b EXP./EXP.  2014/03/13
5 DD/REF  MZ2043307    16 HGT/HAUT  178cm
15 SEX/SEXE  F
9 CLASS/
  CATEG.    G
12 REST/
   COND     X
3 DOB/DDN  1984/03/13  *4980342*

# Childs, Elizabeth
## PLGI #317b31

**DOB:** 04-01-1984
**HEIGHT:** 5'4"
**WEIGHT:** 110 lbs.
**SEE ALSO:** ChildsR, Eliot-ChildsA, DierdenP, EUPLGIs ObingerK, SuominenV, ChoE.
**OCCUPATION:** Police detective. Committed suicide by passenger train.

DECEASED

### PERSONNEL FILE

Elizabeth (known as Beth) grew up in East York, Ontario, Canada, adopted from Brightborn outreach by Richard and Anne Childs. Unfortunately, her adoptive father wasn't properly vetted; subject was sexually molested throughout her childhood, the abuse hidden from Dyad monitors until Beth was well into her early teens. School records from the time indicate an oppositional defiant disorder and possible PTSD; subject was monitored by school counselor TenungrenN, neighbor NicosE, and family pediatrician, BurkeD (Dyad employees). Ongoing blood and chem panels tested within ranges. Parents divorced in 1998. Following her graduation from high school, subject broke ties with both parents and began law and society courses at York University in Toronto. She also took up long-distance running, competing in a number of annual marathons. Top grades ensured her admission to the local police college, where she excelled in armament and investigative training. Staff psychiatrist placed by Dyad prescribed antidepressants and antianxiety medications. Her superiors at the college were not informed of her emotional state; indeed, subject presented as unflappable. Subject moved quickly into detective work, achieving detective status by age thirty, the same age she met her last monitor, Paul Dierden, on a 30K charity run in Toronto.

Contacted by EUPLGI Veera Suominen (#3MK29a, also M.K. or Mika) and told of clones being murdered in Europe. Subject received a number of coded contacts, presumably from Suominen, regarding the Helsinki incident (see Helsinki XXX case # REDACTED, ChevalierF) and the individual murders of three other European Leda clones. Beth then began collecting information on her own, finding more matches. She contacted Cosima Niehaus and Alison Hendrix, informing them of their connection to each other.

> Det. Beth Childs was the spark that ignited the self-aware clones. M.K. first told her about them, but it was Beth who brought Katja, Alison, and Cosima together. And it was her suicide that brought Sarah into the so-called "clone club."

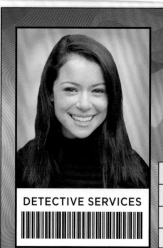

DETECTIVE SERVICES

**METROPOLITAN POLICE DEPARTMENT**

POLICE DEPARTMENT

**NAME: DET. E. CHILDS**

**DIV: HOMICIDE**

**BADGE NO.: 1114**

**EXPIRES: 2014-10-17**

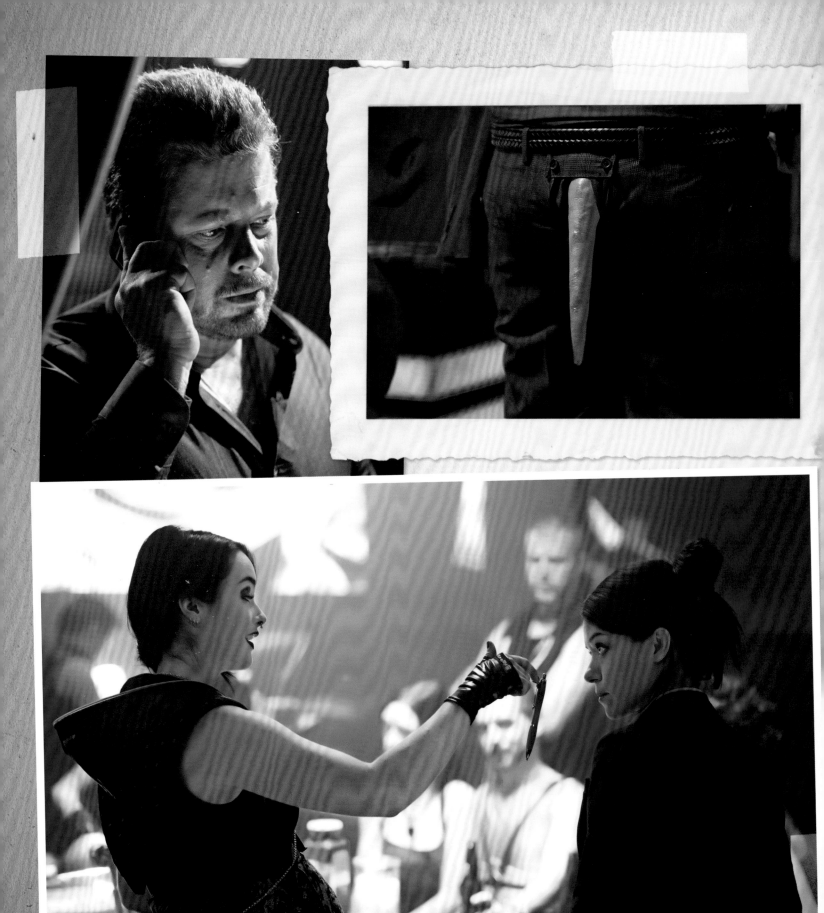

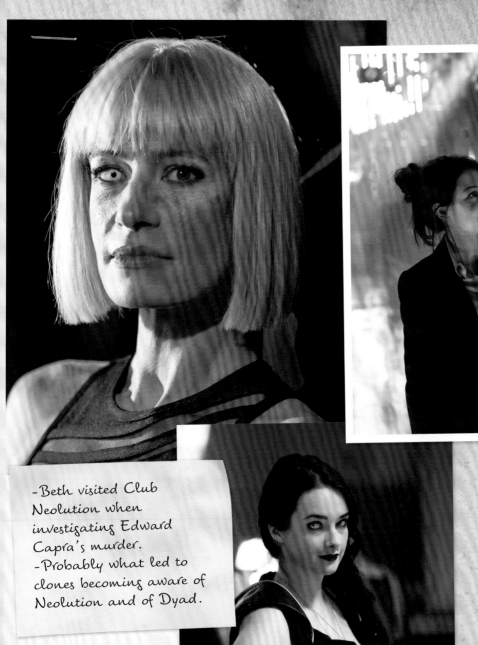

-Beth visited Club Neolution when investigating Edward Capra's murder.
-Probably what led to clones becoming aware of Neolution and of Dyad.

## Notes On Ongoing Investigation
### Primary Investigator: Det. Elizabeth Childs

-Went to Club Neolution, where victim hung out. Looks like average Goth club, but members wear one white contact lens—the secret handshake for "freaky Leekies," a cult that uses Aldous Leekie's Neolution as their bible. Reading the book and it is crazy pop-psych crap, but you can see how it appeals.
-One of the ways it's like a Goth club is that people who look like tattoo artists work there, but they're not—they're performing body-mods. One lady implants things in people. I saw her put magnets in someone's fingertips. This has to be where our victim got his birfurcated penis done.
-Also talked to Leekie, who keeps his distance from the freaky Leekies. Doesn't support them but probably really thinks they're great for giving his ideas prominence, at least in one community.
-Gave card to pregnant Neo girl and her SO. They pulled usual screw-you-pigs attitude we always get from subcultures, right up to the part where I showed them Capra's dead body. I think she'll call eventually.

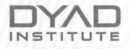

## DYAD INSTITUTE

T204

**MONITOR ASSESSMENT REPORT (AR-21)**
PTN LV 42

| DATE: 10-2-14 | TIME: 1505-1620 | |
|---|---|---|
| **AGENT:** DierdenP | | |
| **SUBJECT DESIGNATION:** 317b31 | | |
| **NAME:** Elizabeth Childs | | |
| **LOCATION(S):** Apartment | | |
| **OBSERVED WITH:** No one | | |

**INTERACTIONS/EVENTS OF NOTE:**

Subject was wearing a dress when I arrived home for dinner, and attempted to seduce me. There are indications that she is using recreational pharmaceuticals. When I suggested a vacation to Barbados, she countered with the suggestion that we take two weeks off and have sex the entire time. She expressed concerns about our relationship, particularly with regard to her infertility. However, she refused to end it, and when I told her I would end it if that was what she wanted, she called me a coward for not ending it, despite her doing the exact same thing—another indication of possible drug use, particularly as that was the most recent of a series of mood swings that characterized the entire conversation. Following that accusation, she stormed out.

**PUPIL GAUGE (mm)**

1  2  3  4  5  6  7  8

**B** = BRISK          **N** = NO REACTION
**S** = SLUGGISH    **C** = EYES CLOSED

**EXTREMITIES:** Record RIGHT ("R") and LEFT ("L") if there is a difference between the two sides.

| |
|---|
| **HEALTH/APPEARANCE CHANGES:** Subject appeared tired, slightly pale. Possible hangover? |
| **MONITOR-SUBJECT INTERACTION:**<br>I believe that she suspects that our relationship is predicated on false pretenses. I have used all the skills at my disposal to appear to be an ordinary boyfriend, but she is a trained detective, and is skilled at reading people. At one point during this evening's heated discussion, she unholstered her weapon and trained it on me. She did not remove the safety, which is possibly an indication that she did not truly mean me harm. It could also indicate that the drug use has compromised her firearms discipline. Regardless, it is becoming increasingly apparent that it's growing more and more difficult for me to function as her monitor, given her perspicacity and her state of mind. |
| **EMOTIONAL STATE(S) OF NOTE:**<br>As indicated, her emotional state is erratic. This evening alone she modulated from seductive to depressed to angry in the space of less than five minutes. |
| **LIST ANY ATTITUDES, ACTIONS, OR BEHAVIORS THAT ARE ATYPICAL FOR THE SUBJECT:**<br>See above. |

CONTACT SUPERVISOR IMMEDIATELY IF YOU OBSERVE OR SUSPECT ANY OF THE FOLLOWING: SIGNS OF ILLNESS, SUICIDAL OR SELF-INJURIOUS IDEATION, CRIMINAL ACTIVITY, PRIVATE MEETINGS OUTSIDE OF DOCUMENTED FAMILY/ACQUAINTANCES, AND ANY POSSIBILITY THAT THE SUBJECT HAS BECOME AWARE OF BEING MONITORED.

DYAD INSTITUTE  |  6750 GARRISON ROAD TORONTO, M6T JK8  |  416.555.0139  |  WWW.DYADINSTITUTE.REG

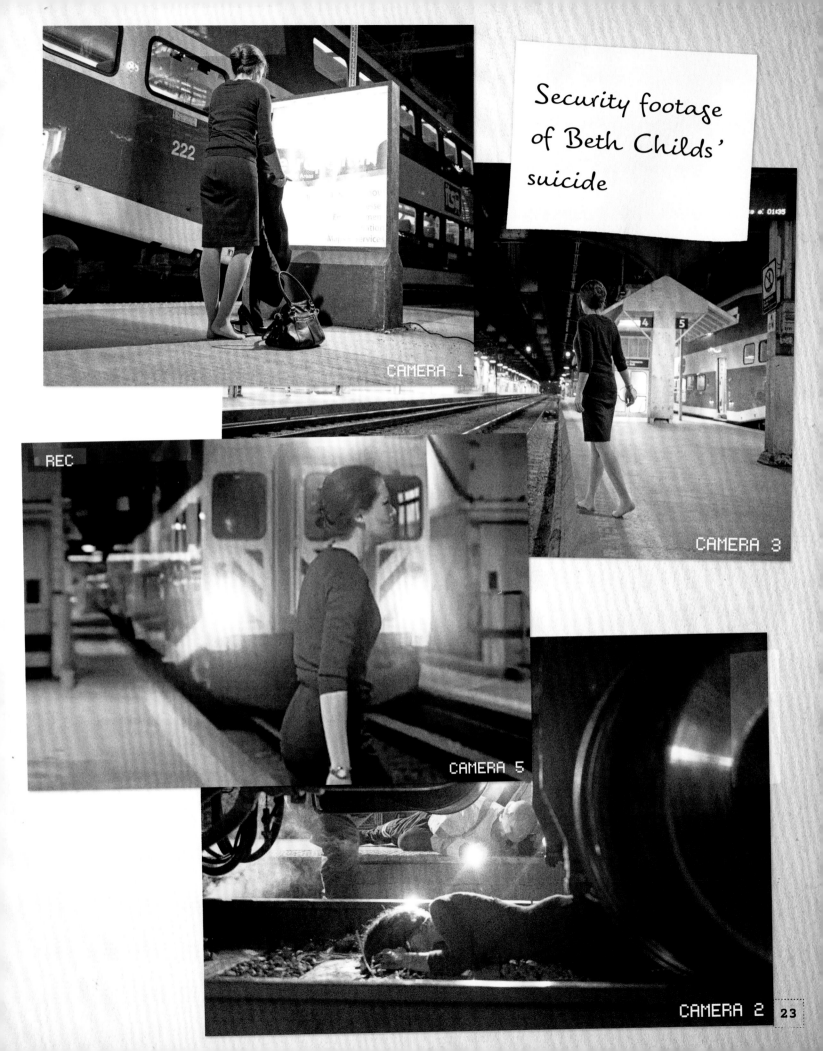

Security footage of Beth Childs' suicide

CAMERA 1

CAMERA 3

REC

CAMERA 5

CAMERA 2

23

# OFFICER-INVOLVED SHOOTING
## POLICE DIVISION
## INCIDENT REPORT

Art—
I wrote it up just like we talked about. Look it over before I turn it in to Hardcastle? We are in this together.

—Beth

| | |
|---|---|
| DATE OF REPORT: October 1, 2013 | DATE AND TIME OF INCIDENT: September 30, 2013, 11:43 p.m. |

| | |
|---|---|
| NAME OF OFFICER: Detective Elizabeth Childs | NAME OF OFFICER'S SUPERIOR: Lieutenant Gavin Hardcas|

INJURED OR DECEASED'S GENDER:
- [ ] MALE
- [X] FEMALE

INJURED OR DECEASED'S ETHNICITY:
- [ ] NATIVE
- [ ] WHITE
- [X] ASIAN
- [ ] AFRICAN AMERICAN
- [ ] LATINO
- [ ] OTHER

LOCATION OF INCIDENT: Alley on the 400 block of Graeme Avenue          INCIDENT RESULT

INJURED OR DECEASED PERSON:
- [X] Carried, exhibited, or used a deadly weapon.
- [ ] Did not carry, exhibit, or use a deadly weapon.

POLICE OFFICER'S GENDER:
- [ ] MALE
- [X] FEMALE

POLICE OFFICER'S AGE: 30

POLICE OFFICER'S ETHNICITY:
- [ ] NATIVE
- [X] WHITE
- [ ] ASIAN
- [ ] AFRICAN AMERICAN
- [ ] LATINO
- [ ] OTHER
- [ ] NOT AVAILABLE

DURING INCIDENT, OFFICER WAS:
- [ ] ON DUTY
- [X] OFF DUTY

OFFICER WAS RESPONDING TO CALL OR REQUEST WITH ONE OR MORE OFFICERS:
- [ ] YES
- [X] NO

INCIDENT OCCURRED DURING OR AS A RESULT OF:
- [ ] Emergency call or Request for assistance
- [ ] Traffic stop
- [ ] Execution of a warrant
- [ ] Hostage or other emergency situation
- [X] Other

IF "OTHER," SPECIFY TYPE OF CALL:

I was responding to a tip from a confidential informant regarding the Sun Jewelry heist (see file R7 4921), received late at night when I was off-duty. CI informed me that Xan Yip—wanted in the US for racketeering—was involved, and could be found on or near the 400 block of Graeme. I immediately followed up on that tip, canvassing on that block. I did not bring backup, but I did inform my partner, Detective Arthur Bell, of my intention to try to locate Yip.

At or about 11:35 p.m., I saw someone I believed to be Yip. I identified myself. The person who may or may not have been Yip turned and ran. I gave chase, and saw an Asian woman who also looked like Yip. She reached into her coat, and I feared she was Yip drawing a weapon on me. (The hot sheet from the States said that Yip owned a nine-millimeter, and so was to be considered armed and dangerous.) I discharged my weapon in self-defense, only to discover that it was not Yip, but rather a citizen named Margaret Chen.

I immediately called it in and surrendered my weapon to the Internal Affairs officer. I also called Detective Bell for moral support.

## METROPOLITAN POLICE
### Detective Arthur Bell

Investigations Division
South Central District
304 Queen St.

Badge #1025
Tel: (416) 555-0188
Mobile: (416) 555-0136

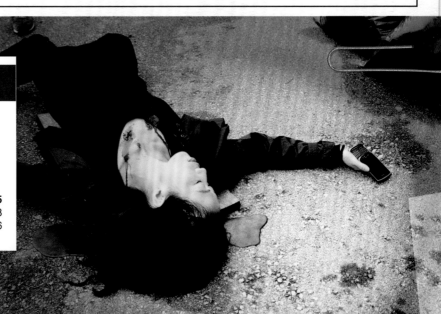

## METROPOLITAN POLICE DEPARTMENT

DETECTIVE SERVICES

NAME: **DET. A. BELL**

DIV: **HOMICIDE**

BADGE NO.: **1025**

EXPIRES: **2014-05-21**

Det. Art Bell was Beth's partner. He investigated both Katja and "Sarah's" deaths, eventually discovering that it was Beth who died, with Sarah posing as his partner. Out of love for Beth, he has become a staunch ally, even as forces within the police have been arrayed against the sisters.

| To... | Beth |
|---|---|
| From... | Art |
| Subject: | You OK? |

Sending this on the personal e-mail, since they monitor the work ones. I'm seriously getting worried here, Beth.

I'm covering for you. You know I'm covering for YOU. And I'm your partner, so I'll keep covering, but this shit has to stop soon.

I don't know if you're using again. I don't want to know. But Hardcastle keeps asking me if you're doing the program and going to meetings, and I keep looking at him like he's crazy and saying, of course she is, why wouldn't she, when the truth is, I have no damn clue, and I'm worried.

Hardcastle's a cop. He used to be a really good detective before they promoted him. And he knows that partners cover for each other. In fact, I remember when I first got my gold shield, Hardcastle used to regularly cover for Martinez.

Now I can say that you're doing what you're supposed to be doing, but if you're not doing what you're supposed to be doing, then BOTH of our asses are on the line.

So get your shit together, dipshit.

—Art

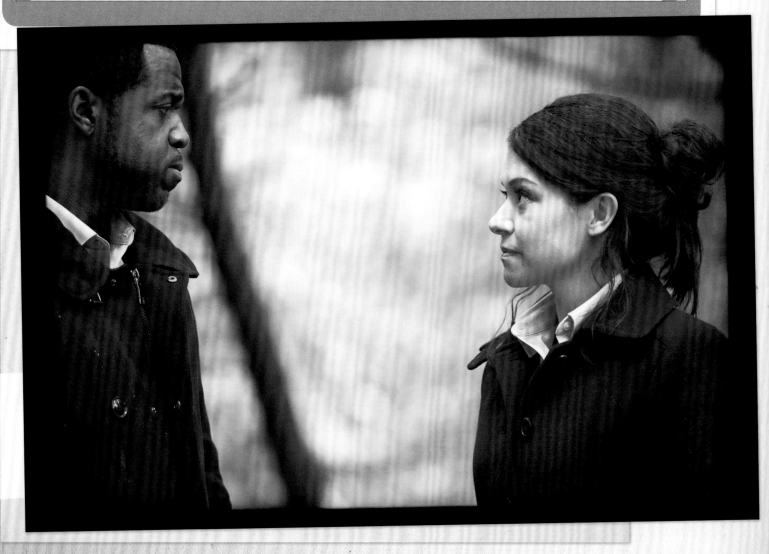

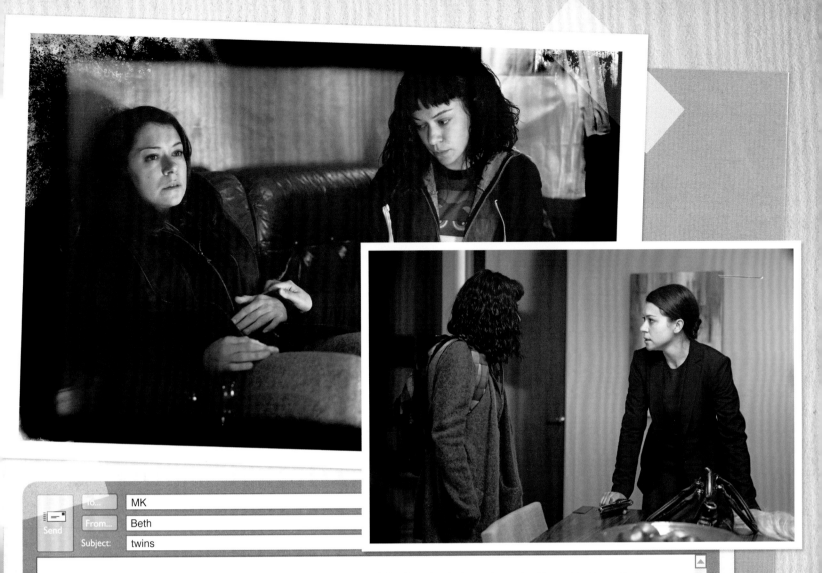

I have no idea if replying to your encrypted e-mail will even work, especially since that isn't a real e-mail address. I just hope that you have some way to see this.

Yesterday, I met up with Alison Hendrix. It was one thing to see the pictures you sent me, but to actually *meet* her was bizarre. She looks just like me, yet doesn't look anything like me. It was *very* surreal.

Obviously, we're all part of some kind of experiment. I've spoken over the phone to Cosima and Katja like you asked, but I don't think we should continue to do so. Or if we do, we should make like drug crews and use burner phones. Alison said she had a friend who could get them for her. I could do it myself even more easily, but a cop buying a burner has bad optics. I've got enough bad optics going on in my life right now. Alison said she could talk it up as a school project for her kids, and that's probably a better cover story than I could come up with.

Well, no, actually, I could do better, but a good investigator will take one look at me and think it's something more devious. I don't think Alison knows *how* to be devious. I also don't know how she survives with that giant pole up her ass.

Don't worry, I haven't told anyone about you, and I won't. I know how confidential informants work. Besides, Katja seems to enjoy taking point on the whole thing, so as far as Cosima and Alison are concerned, she brought this to us.

But I still need more information. When can I see you? In person? I get why you're scared, and I'm scared too. Somebody is fucking with our lives, and we need to find out how and why.

Beth

From the diary of Dr. Delphine Cormier, University of Minnesota

*Elle m'a embrassé! Not as a friend but as a lover, on the mouth! Je ne sais pas quoi penser, quoi faire!*

Okay. Okay, so we had dinner, and I told her my story of leaving Claude behind, hoping she might open up about her own lovers. She is always partnered with Scott Smith in the lab, and I had wondered . . . But no, he looks at her with puppy eyes and she treats him as a colleague, nothing more. She told me at dinner that she had just gotten out of a relationship, but little else. Aldous met us as he and I had arranged, and it went no better than their first meeting. She wasn't openly hostile, but nearly so. Even after he invited us to consider working for Dyad when we're finished at school, an opportunity that most geneticists only dream of. Although, her mood improved noticeably after he left us.

We went back to her apartment, laughing and chatting like old friends. But she seemed . . . anxious, perhaps. I thought it was because of Aldous, I thought she was becoming suspicious of me. I was certain of it when she said that it was time we admitted what our relationship was really all about. I expected her to confront me, accuse me of lying to her—and then she kissed me!

My heart beats faster, my stomach in a sweet, tight knot when I think of it. I was shocked, not because I believed her to be straight—I saw in her file that she was quite open, sexually . . . but *moi?* Why did she kiss me? A diversion, to confuse me? Does she know who I really am? We've had such a fun, dynamic chemistry together, I thought we were becoming friends, close friends, and then she kissed me and now I don't know, I don't know anything. I reacted terribly, I pulled away and she was upset, she said she'd made a mistake. I told her it wasn't, I said I was sorry, I babbled like an idiot and ran, the touch of her lips still warm against mine.

I will not lie to myself. Beneath this confusion I am deeply flattered by her interest. And at the moment she kissed me I felt weak inside, melted with pleasure, with the rush of excitement that accompanies *luxure* (lust?). I have never been attracted to a woman before, but the thought of her in this way . . . I think of it now, and am astonished at what I so easily imagine. Cosima, brilliant and shining and funny, kissing me. Making love to me.

Aldous is to meet with me tomorrow morning, to find out what she said about his offer. What will he say when I tell him? Is my position compromised, will someone else take over for me, to watch Cosima? I don't want that, I don't want to leave her . . . but everything is different now, everything has changed. I have already grown to admire her, to yearn for her company in my lonely new life. I want her to go with me back to Dyad. I don't know what to do.

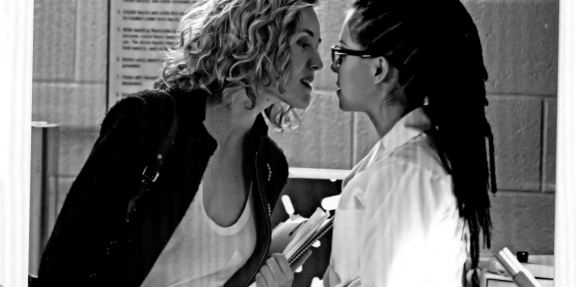

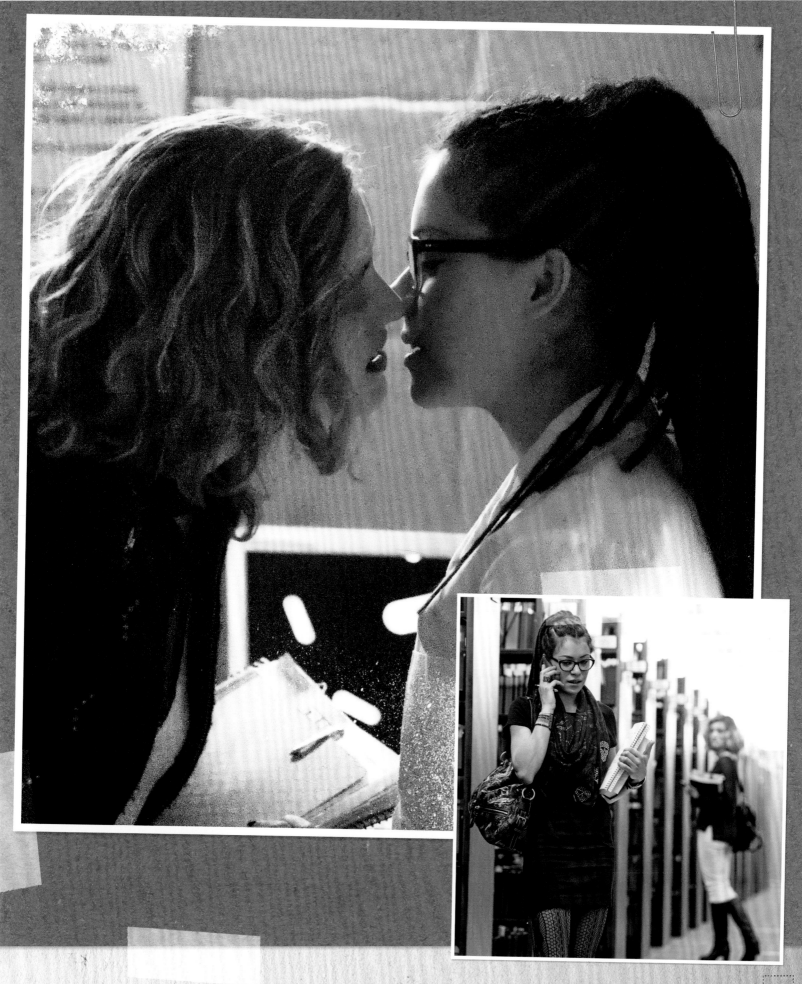

# DYAD

## SARAH MANNING

CAMERA

...ARIO] of [CANADA], with its head office located at:

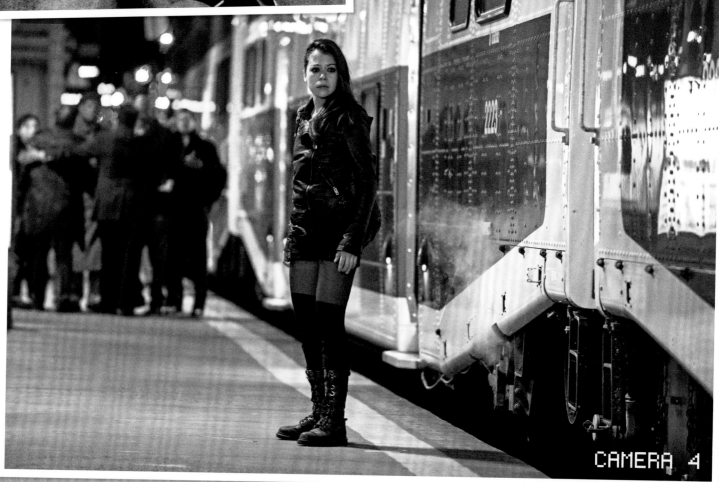

CAMERA 4

30

# DYAD INSTITUTE

## Manning, Sarah

**DOB:** 03-15-1984
**HEIGHT:** 5'4"
**WEIGHT:** 110 lbs.
**OCCUPATION:** Small-time grifter. Specific family files reference Dyad Surrogate System (DSS); cross-reference with subject ID.
**SEE ALSO:** SadlerS, DawkinsF, ManningK (#1K1a01), XHelena (#322d02/T).

An orphan smuggled from the UK to North America by adoptive mother Siobhan Sadler in 1996. Because she was raised without observation, we can only assume that the subject was influenced negatively by her early life in and out of care (birth-8); juvenile delinquency led to an extensive file of nonviolent petty offenses including shoplifting, forgery, and identity theft. Subject demonstrates standard Leda traits including intelligence, stubbornness, and impulsive behavior. In 2007, at the age of twenty-three, Sarah gave birth to a daughter, Kira Manning, not listing a father's name (father believed to be MorrisonC). Ms. Sadler took over caring for the child as Sarah's criminal behavior continued, culminating in Sarah's ten-month absence from Kira's life in 2014–2015.

Upon her return from running short cons with an abusive drug dealer (SotoV; aliases Victor Schmidt, Victor Smith, Vic Garza), Sarah witnessed the suicide by train of her "look-alike," Elizabeth Childs (#317b31). Sarah took Elizabeth's purse, discovering that the dead woman had recently deposited $75,000 into her bank account. As Ms. Sadler had refused to return custody of Kira to her adopted daughter after the ten-month abandonment, subject decided to steal the money in order to start a new life elsewhere, under a new identity, with her daughter and younger foster brother, Felix Dawkins. She enlisted Felix's help to falsely identify Beth's body as her own and moved into Beth's apartment, studying Beth's accent and manner from recordings and practicing Beth's signature to deceive the bank, not realizing that her late genetic identical had secrets of her own. Besides being intimately involved with her chosen Dyad monitor (DierdenP; cross-reference Project Castor, military tribunal file *88m9125/dierden/intg.is*; subsequent internal review of monitor selection process at *dii/293.gw4.is*), Elizabeth Childs was a police detective facing a review for her involvement in a "civilian" shooting (ChenM; also see *00s0407/chen/*

### PERSONNEL FILE

*origplsc/017.is*) and was already aware that she had several genetic identicals—a number of whom had been murdered recently. See insets regarding Proletheans, BellA, ObingerK (#311a55), EUPLGIs.

1    DETECTIVE LANCE JACOBY: Mr. Schmidt, Ms. Manning, I'm Detective Jacoby.

2    VICTOR SCHMIDT: You mind telling us what this is about, Detective? My girlfriend and I were just minding our own business.

3    DET. JACOBY: I realize that, but we need to discuss something with the pair of you.

4    SARAH MANNING: The officers who took us in said something about how our names came up in an investigation. Which is a bit thin, honestly.

5    DET. JACOBY: Are you two familiar with Mr. John Smith and his wife, Ms. Ariella Smith?

6    SCHMIDT: Sure, we met them a few times. They have that house over on McMaster Avenue, right?

7    MANNING: I think so, yeah.

8    SCHMIDT: They seemed nice. What about them? They aren't criminals, are they?

9    DET. JACOBY: That's funny. No, they're not criminals. They say you are. You remember right, they live in 22 McMaster Avenue. They say you squatted in 24 McMaster, which just got sold. They say that you made it look like you two were the new buyers.

10    SCHMIDT: That doesn't sound right at all.

11    MANNING: We happened to be standing in front of that house when we met them, I think. I don't know where they got the notion that we owned it.

12    DET. JACOBY: And then there's the part where you convinced them to give you ten thousand dollars.

13    SCHMIDT: Did *they* say we did that?

14    MANNING: That's a bit odd, isn't it?

15    SCHMIDT: I can assure you, Detective, we would never steal from anyone.

16    DET. JACOBY: All right, let's cut the shit, shall we? You don't have a lawyer in here, there's no Crown prosecutor in here, it's just the three of us. Tell me the truth—it doesn't go beyond this room. You fleeced the Smiths, didn't you?

17    MANNING: I don't know what you're talking about, Detective. We met the pair of them the once. We had a nice conversation. It happened to be in front of the address you said.

18    DET. JACOBY: You expect me to believe that you didn't try to convince them that you'd bought the place, but you had a check that didn't clear fast enough and you needed a quick transfer of funds so the mortgage would go through and could they just lend you the money?

19    SCHMIDT: I gotta say, that sounds like a pretty silly scam. I mean, you'd have to be a special kinda stupid to fall for that. Wouldn't you say so, sweetheart?

20    MANNING: What I expect you to believe, Detective, doesn't really matter, now, does it? What matters is what you—or your friend the Crown prosecutor—can prove.

21    SCHMIDT: And from where we're sitting, you can't prove a damn thing.

22    DET. JACOBY: Maybe. But both of you have sheets in Toronto, Guelph, Kitchener, and Mississauga. And now you're on our radar as well. Trust me, you won't be able to pull this shit off for long.

23    SCHMIDT: Funny, but I could've sworn I've heard all that before. Where was it?

24    MANNING: C'mon, Vic, let's go.

25    SCHMIDT: Wait, I remember now! It was in Guelph. And in Toronto, and in Kitchener, and in Mississauga.

26    MANNING: Let's *go*, Vic.

27    DET. JACOBY: Have a nice day, you two. And do yourselves a favor, and work your scams in another town.

28    SCHMIDT: Yeah, 'cause this town is *so* hard to work in.

29    MANNING: Vic, *shut up*, and let's *go*.

# Metropolitan Police
## Central Processing

## ARREST RECORD MATCH

**BOOKING #: 5120473**

**NAME:**
**MANNING, SARAH**

### PRIOR OFFENCES

04-12-10 - THEFT UNDER $1000
02-06-03 - ASSAULT NO WEAPON
01-10-08 - VAGRANCY

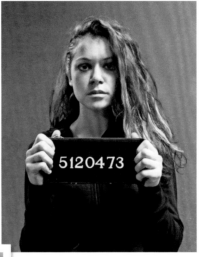

**RIGHT HAND**
3.Middle Finger      4.Ring

**LEFT HAND**
3.Middle Finger      4.Ring Fi

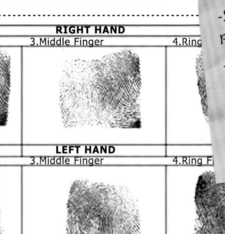

-Sarah has a history of petty crimes

-She stole Beth's identity after her suicide and quickly fell in league with the other self-aware Ledas

**File Sample**
Right Middle Finger

**Recovered Sample**
Right Middle Finger

## Sample notes:
Print similarities consistent enough to make a positive match.

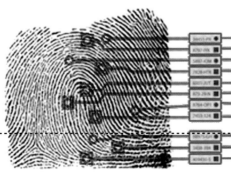

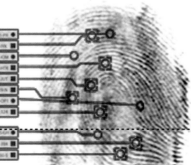

| To... | David Benchman |
|---|---|
| From... | Major Paul Dierden |
| Subject: | Progress Report #105 |

Benchman,

Something significant has changed. It might be the breakthrough we need to get me in deeper with Dyad.

Beth is either dead, incapacitated, or has gone into hiding. A different Leda clone has taken her identity. In order to maintain my cover, I am continuing to act as if I think this is Beth. But this new Leda clone is not her. Beth's recent behavior has been erratic (to say the least). This clone's strangeness is of a completely different variety.

The new clone dresses in T-shirts with band names on them—Beth doesn't even own a T-shirt that has any words or pictures. Plus, she deflected my attempts to talk to her with sex, a tactic Beth has not employed in a very long time.

With apologies for oversharing, I have to also say that the intercourse itself was uncharacteristic as well. There's no need for details, but Beth was never as adventurous as this new clone was.

I think this clone is also in touch with the same other Leda clones Beth was in contact with.

More important, I think this will provide an opportunity to go further into Dyad beyond Olivier Duval. "Learning" about other Leda clones via this new one may permit me to go deeper into Dyad's confidence, especially since our Afghanistan cover story remains intact, and they believe they have power over me.

My next report will come in 24 hours.

—Major P. Dierden

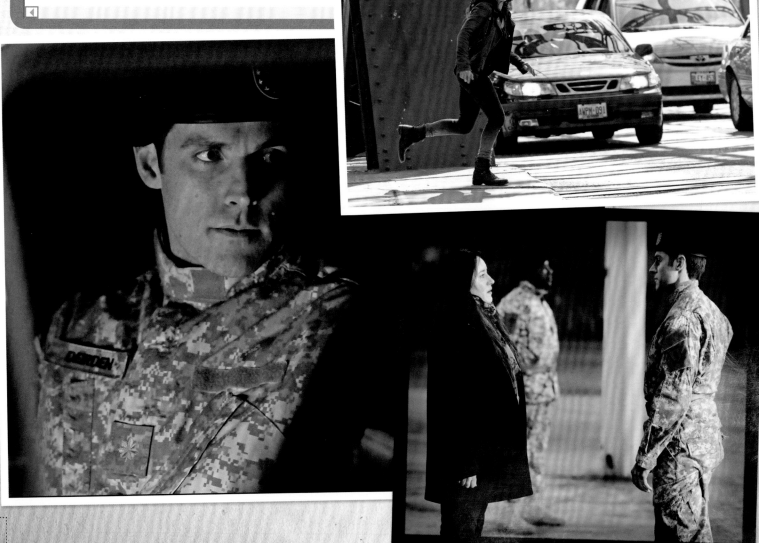

To... David Benchman

From... Major Paul Dierden

Subject: Progress Report #102

Benchman,

If any mission is to be successful, you have to be patient. That was drilled into me back in Basic: Patience is the key to any mission. Rushing a mission only results in sloppy work and failure.This quality is even more necessary in undercover work.

We have been extremely patient, and it has at last begun to bear fruit, thanks to the revelation that Beth is dead and that Sarah has replaced her. Not to mention the fact that Sarah is a previously unknown clone. Because of this, I am officially inside. I have met Dr. Aldous Leekie, the head of Neolution and supervisor of the Leda project.

Now, however, the game becomes more dangerous. Who knows what the inside of Dyad will be like.

My next report will come in 24 hours.

—Major P. Dierden

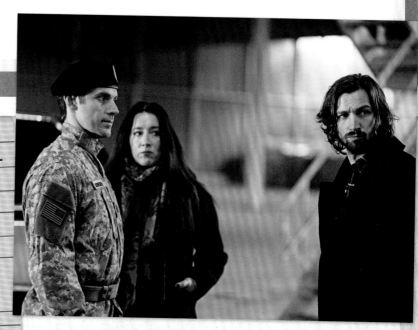

## ARMED FORCES

### DIERDAN, PAUL

Sex: M

Hair Color: Brown

EyeColor: Blue

Ht: 5'10"

0836718

## IDENTIFICATION CARD

To... David Benchman

From... Major Paul Dierden

Subject: Progress Report #105

Benchman,

We knew Leekie had a supervisor. We also knew that the Duncans had raised one of the Leda clones as a daughter.

What is most curious is that Rachel Duncan is not exempt from the requirements of the program. She's just the only one who's—purposefully, anyhow—aware of them. She willingly goes in for the medical tests, and she chooses her own monitors. Regarding the latter, her preferred monitors are ones she can use as sexual partners.

It may or may not be feasible, but my plan is to inveigle myself into the inner circle of Dyad. Leekie seems impressed with how I've handled Sarah, and Rachel seems to have a type, which I can emulate with relative ease.

My next report will come in 24 hours.

—Major P. Dierden

# AN INTERVIEW WITH FELIX DAWKINS

**Up-and-Coming Artist Hitting Big with New Exhibit**

**By Howard Frank**

Felix Dawkins is the hottest new voice on the art scene downtown, and his new exhibit, *Visions of Judgment*, opened to great acclaim at the Mehu Gallery last Friday. I had the opportunity to sit down with "Fee," as his friends call him, during the opening and chat about life, the universe, and everything.

**ARTS TORONTO: So Why Visions of Judgment?**

FELIX DAWKINS: One of the constants of life as an artist, life as a gay man, and life as an orphan is that people are always sitting in judgment. "Oh, you're an artist, are you? Does that mean you're starving?" "Oh, you're gay, are you? That must be complicated—have you ever considered being straight?" "Oh, you're an orphan, are you? That must have been hard for you."

**AT: So your art deals with the issue of judgment?**

FD: Not just judgment, but people being judgmental. People are *terribly* judgmental, and it gets rather tiresome. So the set of collages here [at the Mehu] represent people being judgmental. And what might happen to them.

**AT: I noticed that the centerpiece is an image of four people standing over a first-aid kit. Is that meant to be a statement on AIDS?**

FD: Yes, because I'm Keith Haring and it's 1989. No, to be fair, that's a valid interpretation, I suppose, because art is supposed to be open to interpretation and all that s--t, but the truth of the matter is that it's about the difficulty in accessing medical care. More of an issue in the States than it is here or back home.

**AT: Yes, I did notice the accent. You're from London?**

FD: I'm from everywhere, darling. No, seriously, I am from London, though I came to Canada as a child.

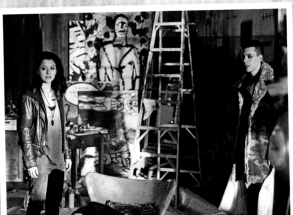

**AT: Anything in particular that drew you to our fair city?**

FD: The weather, obviously.

**AT: Yeah, Toronto is one of the few places that's a step up from London weather. How do you think your art speaks to the patrons of the gallery?**

FD: Well, honestly, Howard, the words I want my art to speak are "Buy me, I would look amazing in your living room over the couch." But I'll settle for making people think.

**AT: So much for the myth of the starving artist.**

FD: Oh, darling, a starving artist is merely an artist who is unsuccessful. And the sooner artists learn that, the better off they'll be. You think Michelangelo wasn't recompensed for the Sistine Chapel ceiling? Trust me, the church shelled out good money for that. Those people who posed for Rembrandt didn't simply sit for him for the hell of it, they paid for the privilege. Now, don't get me wrong, I would still paint even if I made no money off of it. The Muse is very real, and she's quite the fickle bitch.

**AT: I suppose it must be difficult, since we don't have the same kind of wealthy patronage they had in the Middle Ages.**

FD: No, but we also have indoor plumbing and good dental care, so I'll take the trade. And I do have some alternate streams of income, and I have a simply superb deal on my flat.

**AT: Any final words for our readers?**

FD: Oh, must I? I much prefer to go out gloating about my flat.

**AT: Fair enough.**

*Visions of Judgment* will run at the Mehu Gallery in Toronto until the end of the month.

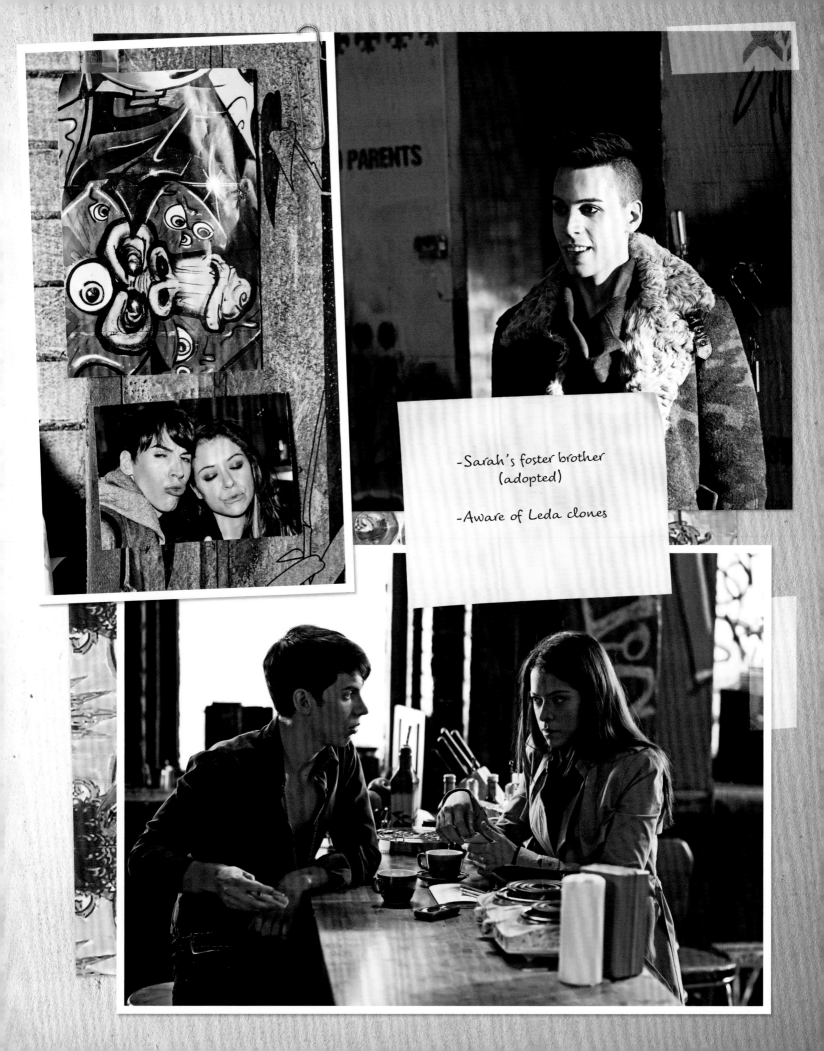

PARENTS

-Sarah's foster brother (adopted)

-Aware of Leda clones

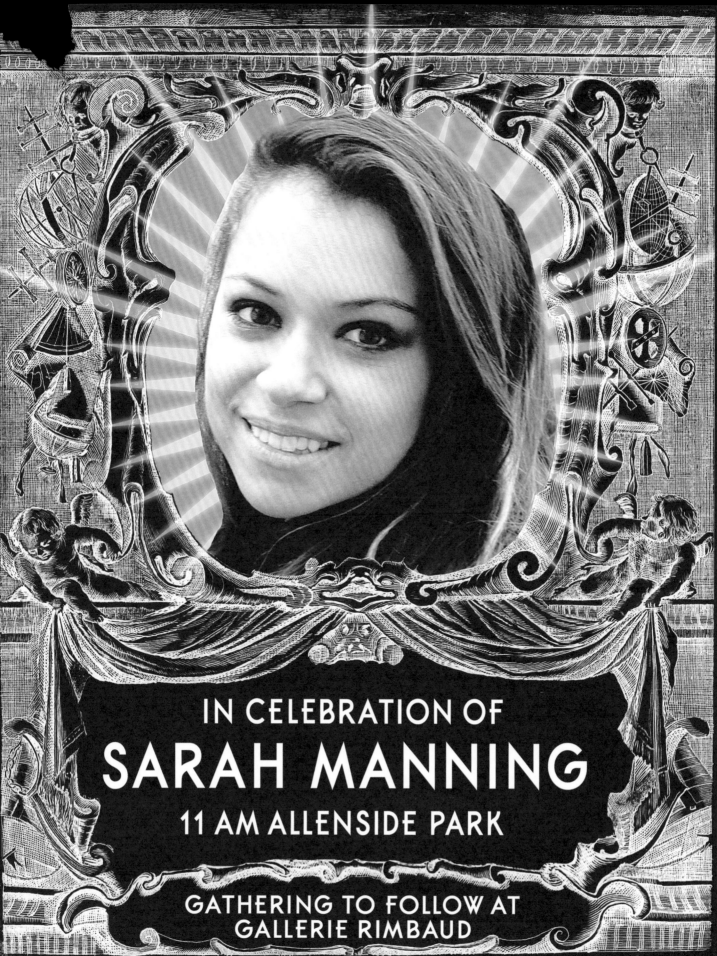

IN CELEBRATION OF
# SARAH MANNING
## 11 AM ALLENSIDE PARK

GATHERING TO FOLLOW AT
GALLERIE RIMBAUD

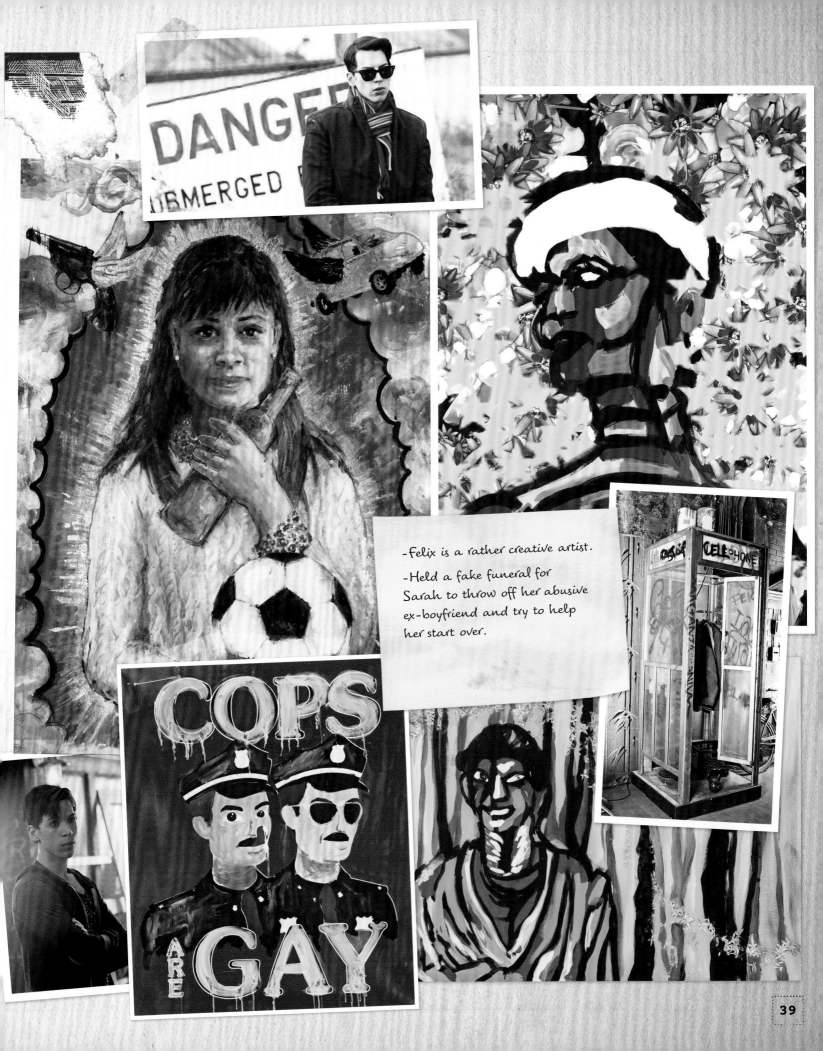

-Felix is a rather creative artist.

-Held a fake funeral for Sarah to throw off her abusive ex-boyfriend and try to help her start over.

DANGER

UBMERGED

COPS ARE GAY

39

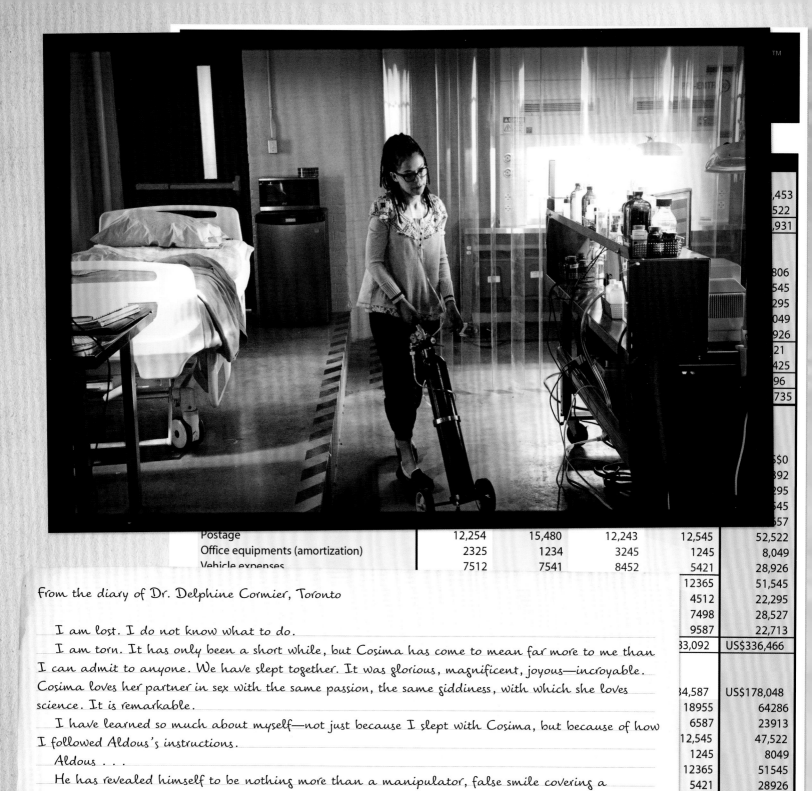

| | | | | | |
|---|---|---|---|---|---|
| | | | | | ,453 |
| | | | | | 522 |
| | | | | | ,931 |
| | | | | | |
| | | | | | 806 |
| | | | | | 545 |
| | | | | | 295 |
| | | | | | 049 |
| | | | | | 926 |
| | | | | | 21 |
| | | | | | 425 |
| | | | | | 96 |
| | | | | | 735 |
| | | | | | |
| | | | | | S$0 |
| | | | | | 892 |
| | | | | | 295 |
| | | | | | 545 |
| | | | | | 657 |
| Postage | | 12,254 | 15,480 | 12,243 | 12,545 | 52,522 |
| Office equipments (amortization) | | 2325 | 1234 | 3245 | 1245 | 8,049 |
| Vehicle expenses | | 7512 | 7541 | 8452 | 5421 | 28,926 |
| | | | | | 12365 | 51,545 |
| | | | | | 4512 | 22,295 |
| | | | | | 7498 | 28,527 |
| | | | | | 9587 | 22,713 |
| | | | | | 33,092 | US$336,466 |
| | | | | | | |
| | | | | | 34,587 | US$178,048 |
| | | | | | 18955 | 64286 |
| | | | | | 6587 | 23913 |
| | | | | | 12,545 | 47,522 |
| | | | | | 1245 | 8049 |
| | | | | | 12365 | 51545 |
| | | | | | 5421 | 28926 |
| | | | | | 4512 | 22295 |
| | | | | | 15% | 60% |
| | | | | | 12,545 | 52,522 |
| | | | | | 3455 | 7809 |
| | | | | | 0 | 0 |
| | | | | | 2,217 | US$484,916 |
| | | | | | | |
| | | | | | 5,414 | US$20,537 |
| | | | | | 1245 | 8049 |

From the diary of Dr. Delphine Cormier, Toronto

I am lost. I do not know what to do.

I am torn. It has only been a short while, but Cosima has come to mean far more to me than I can admit to anyone. We have slept together. It was glorious, magnificent, joyous—incroyable. Cosima loves her partner in sex with the same passion, the same giddiness, with which she loves science. It is remarkable.

I have learned so much about myself—not just because I slept with Cosima, but because of how I followed Aldous's instructions.

Aldous . . .

He has revealed himself to be nothing more than a manipulator, false smile covering a serpent's tongue.

Ah, me, I cannot bear this.

We have learned that Dyad has trademarked the genome for all of the genetic identicals. They, in essence, own Cosima and all of the others. I have also learned that Cosima is indeed in touch with others—and that one of the clones has reproduced! I kept the truth of Sarah Manning's daughter from Aldous, but I fear my silence will only delay the inevitable.

I fear how Cosima will react when she learns that I have betrayed her. And it is "when" she so learns, because I fear I will be unable to keep the truth from her for long.

1

## DYAD INSTITUTE    OFFICIAL MEMO

SENT TO: Doctor Aldous Leekie
SENT FROM: Rachel Duncan
SUBJECT: Sarah Manning

   Your performance with regard to the self-aware Leda clone, or, rather, non-Leda clone, since she somehow managed to escape the project—has been severely lacking. In addition, the monitor *you* placed with 324b21 failed to disclose the fact that Manning is fertile!
   At this stage it would be best to bring Manning in. She is a grifter and a criminal, and we can offer her protection from the police.
   Execute this plan immediately, please, Aldous. Fix your mess.

## DYAD INSTITUTE    OFFICIAL MEMO

SENT TO: Rachel Duncan
SENT FROM: Dr. Aldous Leekie
SUBJECT: Sarah Manning

  It should be pointed out, Rachel, that I was the one who discovered that there even WAS a new PLGI who had taken the place of 317b31 when I examined the results of her latest tests.
  It is becoming increasingly apparent that the monitor that YOU placed with 317b31 figured out that Miss Manning had replaced his charge. Also, while I admit that Delphine's nondisclosure of little Kira's existence is troubling, she has also provided us with considerable intel regarding 324b21 and the other self-aware PLGIs and how much they know about each other, a security breach that appears to trace back to the European branch, which is hardly my fault.
  I will, of course, do as you instruct and start the process of bringing Miss Manning in.

From the diary of Dr. Delphine Cormier, Dyad Institute

Aldous is dead.

I have so much to say, yet I have nothing to say. Everything has become topsy-turvy, and I no longer know who to trust and who to believe.

Ce n'est pas vrai. I can trust Cosima. But no one else.

Not even myself.

There is good news. Cosima is now working with me at Dyad, and we are fighting to find a way to reverse the autoimmune disorder that is ravaging her and has already killed more than one of the genetic identicals.

She does not trust me—she even changed the lock on her lab so I would be denied entrance—but at least we are working toward saving her.

I have learned that Rachel Duncan, another officer in Dyad, is, in fact, one of the so-called "clone club," as Cosima has sometimes referred to her sisters.

And Aldous is dead.

Rachel told me that he perished of a heart attack, a story I do not—cannot—believe. Dyad's power structure is a nest of vipers, and I fear I will be bitten by them before long.

I cannot sort my feelings on Aldous. We shared a great deal, he and I, but I can no longer sort the public persona with the private man with the head of Neolution. They are all the same, yet they are all different. The public persona is engaging, charismatic, brilliant, yet utterly focused on the person to whom he was talking, making you feel as if you are the only one in the room. The private man is passionate, romantic, caring, receptive. And the head of Neolution, the officer of Dyad, is cold, calculating, ruthless.

Ah, look at me speaking of him in the present tense. I still do not entirely believe that he is dead, though reports of his alleged heart attack have made the news services. There is an entire online channel devoted to testimonials on his life from Neolution supplicants.

No, il est morte. I must accept that. What I will not accept is Rachel's version of reality. I need Cosima. I must go to her now and beg her to let me back in. Divided, we will both be destroyed by Dyad's machinations. Together, we stand a chance.

Le
clone
are n
coope
with
Manu
show
symp
of ch
illne
parti
Cosin
is wo
with
now
resea
poter
cures
does
the i
or m
long

# TOPSIDE

TO: Board of Directors
FROM: Ferdinand Chevalier
RE: Siobhan Sadler

It has come to my attention that the self-aware Ledas have a secret weapon, and her name is Siobhan Sadler.

The file on Sadler is very small, and only recently begun but primarily relates to her being Sarah Manning's foster mother. That alone bespeaks how powerful an enemy she is to Topside and Dyad.

Sadler is part of the resistance that smuggled Amelia away from Topside and raised one of the twins as her foster daughter. It is because of her actions that Manning and her sister, Helena, were able to grow up away from us, the former under her care, the latter under the Proletheans and their filthy propaganda. Sadler also took care of Manning's daughter, Kira, the only known offspring of a Leda, on and off for the last 8 years.

Because of Sadler, the entire project has been thrown into disarray. Much of the disruption that we have credited to Manning could quite easily be attributed to Sadler. In addition, she is the one who hid Ethan Duncan from us.

It is my recommendation that we consider Sadler for termination. She has been a thorn in our side for three decades, and until recently, we didn't even know she existed. She is a threat that must be contained, if not eliminated.

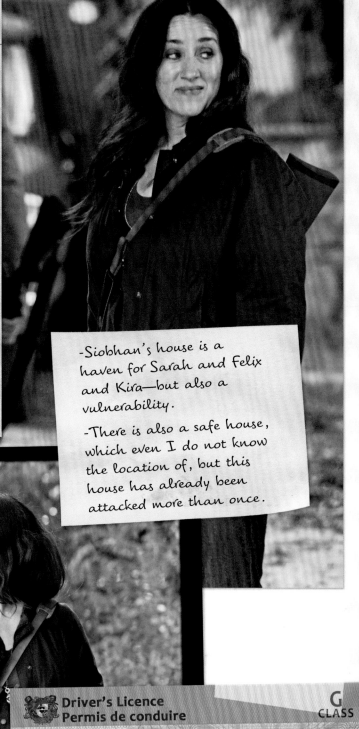

-Siobhan's house is a haven for Sarah and Felix and Kira—but also a vulnerability.

-There is also a safe house, which even I do not know the location of, but this house has already been attacked more than once.

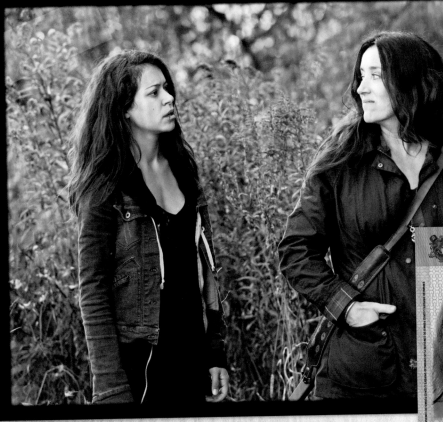

Driver's Licence
Permis de conduire

G CLASS

1.2 NAME/NOM
**SADLER, SIOBHAN**

8 **158 SCOTSBURN AVENUE TORONTO M2N 3Y1**

4d NUMBER/NUMERO **C4806-3925-2830-SSA**

4a ISS/DEL 2012/05/12    4b EXP./EXP. 2017/05/12

5 DD/REF SS5256087F    16 HGT/HAUT 168cm

15 SEX/SEXE G

9 CLASS/CATEG. X

12 REST./COND

S. Sadler

3 DOB/DDN 1965/09/22  *6840019*

C4806-3925-2830-SSA
1965/09/22

From the diary of Dr. Delphine Cormier, Dyad Institute

Until I said the words, I did not believe I would have the courage to say them.

But I told Cosima.

Je t'aime.

And said she loved me as well.

Of course, we were both high. On the day we met, Cosima promised to get me high as the proverbial kite, and last evening, she succeeded very admirably in keeping that promise. We inhaled helium balloons, we smoked a great deal, we might also have drunk some alcohol, I honestly can no longer recall. All I am sure of is that I love her and she loves me. The rest is of no consequence. We do not know what will happen next. She does not trust me, and she knows what I have done. But she loves me, and together, we shall fight for her life.

Yesterday, Rachel made me the interim director, taking Aldous's old position. I accepted reluctantly—I do not have Aldous's skills with being the public face of Dyad or of Neolution—but it puts me in a good position to help Cosima. Rachel says that my dedication to helping Cosima will help all the clones, including Rachel herself. I want to believe that her desire is to aid all of her sisters, but I cannot believe that any more than I can believe that Aldous died of a heart attack.

Today Ethan Duncan arrives. I have a sore throat from inhaling helium, a terrible headache from what I may only assume is the alcohol, and a crick in my neck, no doubt because I slept on it wrong. I also do not care. Dr. Duncan is one of the two people responsible for creating Cosima and the others, and he may hold the key to curing her at last. Cosima and I have declared our love for each other despite everything we have been through. For the first time since Aldous died—non, for the first time since I met Cosima and realized that I would have to either betray her or betray Dyad—I have allowed myself to feel optimism.

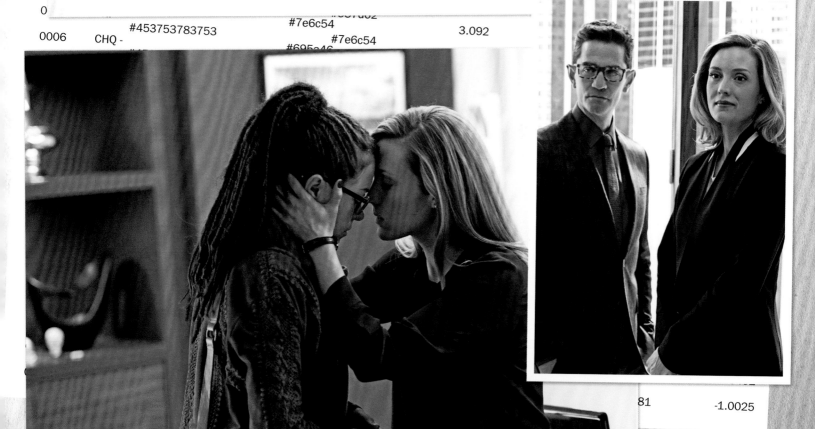

TO: Board of Directors
FROM: Marion Bowles
RE: Sarah Manning

## KIRA MANNING

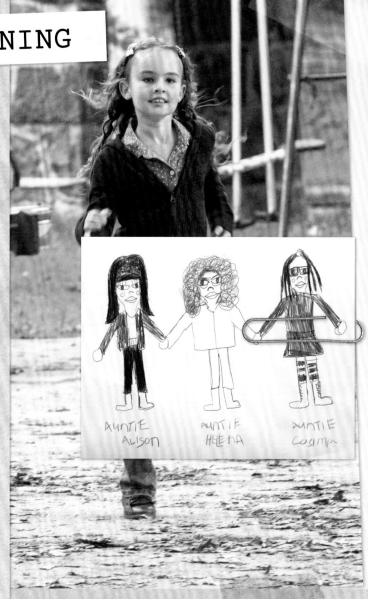

AUNTIE ALISON    AUNTIE HELENA    AUNTIE COSIMA

I have observed the progress of Project Leda with growing alarm. After the security breach that led to the Helsinki purge, we had all hoped that Dyad could keep a lid on the project and prevent so extreme a situation as that.

I fear, however, that we are on the brink of another Helsinki-style disaster. But we can learn from the mistakes of Helsinki and proceed with more caution. I certainly believe that the option of eliminating the newly self-aware Leda clones Cosima Niehaus and Alison Hendrix would be irresponsible.

Rachel Duncan's endeavor to instead bring the self-aware clones into the fold, as it were, is to be commended. In particular, Niehaus may now stand the best chance of finally eliminating the autoimmune disorder that has already claimed far too many Leda clones.

The X factor in all this, however, is Sarah Manning and, to a lesser extent, her twin, Helena, though she is currently with the Proletheans and therefore not a threat. Manning, however, has proven to be quite able. She is a talented con artist, one who managed to easily insert herself into the life of Elizabeth Childs. Were it not for the distinctive markers in each Leda clone's DNA, we would never have known that Childs had even been replaced.

In addition, Manning's daughter is a gold mine. First of all, there's the fact that Manning has a daughter. The Leda clones were supposed to be infertile, but it seems that Manning has the ability to reproduce. The child herself is a treasure trove of useful genetics, the first offspring of a Leda clone, and it behooves us to learn more about her.

However, little Kira is also expertly protected by Manning. She has done a superlative job of controlling every situation her daughter has been in. I realize that the Leda clones were bred to cultivate a level of excellence, but still, it boggles the mind that a grifter with no visible means of support, who probably wouldn't have anywhere to sleep if it weren't for her foster family, has somehow managed to control every interaction she's had with Neolution, Dyad, and Topside. Whenever she appears to have her back against the wall, whenever we seem to have the upper hand, she slips away.

Some among you may view her as more trouble than she is worth, but I disagree. Manning is far too valuable to lose. Besides the obvious—her ability to procreate—her skills are ones we should be exploiting for our own benefit rather than struggling against them.

I intend to observe the situation with Manning more closely, as well as Rachel's reactions to her. Leekie's bungling of the affair should be an object lesson to us all, and Rachel is giving lip service to the goal of doing better by the project than the late, unlamented Aldous. However, she has a particular animus toward Manning, no doubt at least in part out of envy of her ability to reproduce. Either way, the resentment Rachel feels is something she, as a professional, should be able to work past. If she cannot, then actions will have to be taken.

I also approve of Rachel's hiring of Dr. Delphine Cormier to replace Aldous. Her relationship with the self-aware Leda clones in general and Niehaus in particular will prove an invaluable asset.

The upshot of all this is that it is my strong recommendation that we continue on course with integrating the self-aware Leda clones into the program. It has worked for Rachel, and I believe it can work for Niehaus and Hendrix and even Manning, if we're careful.

# DYAD INSTITUTE

## Morrison, Calvin

**DOB:** 07-11-1981
**HEIGHT:** 6'
**WEIGHT:** 175 lbs.
**OCCUPATION:** Former tech engineer, currently living off grid, location unknown.

Surveillance has managed to obtain photos of Kira Manning with this person. Facial recognition identifies him as Calvin Morrison, though that search only bore fruit after a lengthy online deep dive. The hit was paperwork on a weapons contract with the United States Navy.

As near as we can determine, Morrison was a weapons designer of some sort who did contract work for the Navy, as well as the Air Force. It's unclear if he was independent or working for a company, as Morrison has no online footprint worth mentioning. That's only really possible in this day and age for someone who lives completely off the grid—but that's impossible for anyone doing government work, which means he also has skills in hiding his tracks. Or has sufficient funds to hire someone to do it for him.

Based on the behavior observed during surveillance, it's safe to say that he is Kira's biological father, or at least believes he is. His clothes, grooming, and general demeanor bespeak someone with wealth—or at least who has enough money to dictate his own comfort—so it's possible that he is one of Sarah Manning's former marks. Needless to say, his presence further complicates any attempts we might make to obtain Kira Manning for study; such attempts would already be incredibly difficult thanks to her mother's stubbornness and talent at hiding.

### PERSONNEL FILE

## WILMUT-CAMPBELL MEMORIAL HOSPITAL
### FROM THE DESK OF DR. RAFI GREGORIAN

Memo to Dr. Emily Pak, Hospital Administrator:

I have just had the most extraordinary patient in the ER. It seemed like a routine car crash. The victim is named Kira Manning, she's eight years old, and she came in with enough blunt-force trauma to kill a person, particularly one of her size.

I swear, Em, I could feel the broken ribs when we moved her from the gurney to the bed, but the X-rays and then me actually feeling her ribs a few minutes later showed no broken bones. She had a deep enough head wound that I was sure there'd be a hematoma, but the ultrasound showed no evidence of swelling, no internal bleeding at all.

I know what you're going to say, that kids are made of rubber. The victim's uncle said something similar to the girl's mother at least twice in the waiting room that I heard. And maybe that's it, but I'm telling you she had broken ribs and sufficient head trauma for there to be internal bleeding. The fact that there were no signs of that just a few minutes later is astounding, if not a miracle.

Maybe she's just a lucky little girl, like I told her mother or maybe she's something else. I'd like your permission to look into this further.

Thanks much,
Rafi

**Berliner Morgenpost** [translated]

# MAGAZINE EDITOR MISSING

### STAFF WRITER

Katja Obinger, the features editor for the fashion magazine *Die Mode*, has been declared missing. The report was made by her assistant, Karla Fischer.

Obinger was last seen riding a taxicab bound for Flughafen Berlin Brandenburg to board a plane to London. According to Fischer, the trip to London was business related, but Obinger did not inform Fischer what the business was.

While Obinger was booked on Vista Atlantic Flight 231 to London, there is no record of her boarding that flight.

Interpol has been alerted and Polizei Berlin is continuing to investigate. If anyone has any information about Obinger, they should contact Polizei at +49 30 4664-4664.

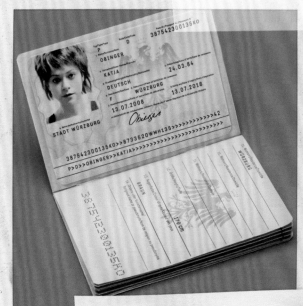

-Katja—made contact with Beth and Alison—killed by Helena

-Other known Ledas: Aryanna Giordano, Italy (deceased), Janika Zingler, Austria (deceased), Danielle Fournier, France (deceased)

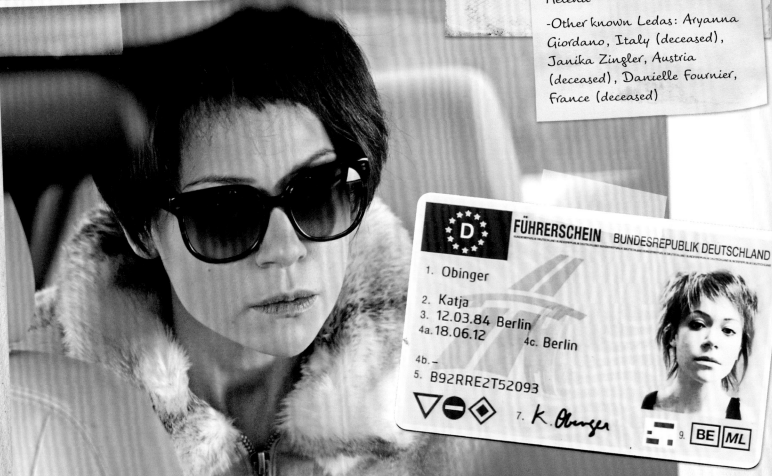

# DYAD
### INSTITUTE

September 14, 2013

Jennifer Fitzsimmons
1082-20 Main Street, Apt 2B
Chicago, IL 60018

DECEASED

Dear Ms. Fitzsimmons:

I am writing in response to your request to be included in The Dyad Institute's Polycystoid Autoimmune Clinical Trial.

The PAC Trial began treating its first cycle of patients in 2010, with an initial control group of 35 subjects. All patients displayed a variety of symptoms of autoimmune disorders of unknown origin. Like you, they were facing a mysterious and degenerative condition, plagued by misdiagnoses and ill served by a medical community bound by conventional thinking. Our experimental protocol resulted in positive outcomes for 68% of the initial test group, with eight subsequent trials bringing our success rate up to 88%.

Here at The Dyad Institute, we strive to push the boundaries of biological possibility each and every day. The PAC Trial is one of many experimental protocols we are conducting to expand our understanding of disease and treatment — with the aim of helping patients like yourself who have been failed by standard treatment options.

Ms. Fitzsimmons, I am pleased to welcome you as a participant in the latest cycle of the PAC Trial, and look forward to your joining our patient group at The Dyad Institute. Your travel, board, and treatment expenses will be provided for under the Trial agreement, as well as travel and board for one additional family member or significant other.

My office will be contacting you shortly to make arrangements, and I look forward to meeting you in person.

Sincerely,

Dr. Aldous Leekie
Chairman, The Dyad Institute

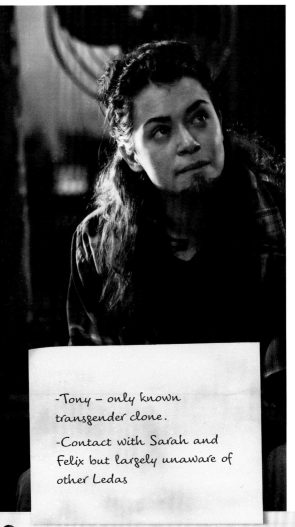

-Tony — only known transgender clone.

-Contact with Sarah and Felix but largely unaware of other Ledas

## SELECTED TRANSCRIPTS OF VIDEO DIARY, JENNIFER FITZSIMMONS (325b31)

### Entry 1

Hi, I'm Jennifer Fitzsimmons, I'm a teacher and swim coach at Sheldon High. So, uh, they asked me to keep this video journal because they found polyps on my lungs. I was, uh, having trouble breathing, and went in for tests, and—Yeah, unidentified polyps. So that kinda sucks.

What else? The team's doing great this year. Usually I run laps with them, but it was when I did that that I first started having the problem. My boyfriend forced me to go to the ER, and here we are. Great, right?

I guess that's what I should be recording here, huh? How it happened? I guess? So, I ran laps with the kids, and Kelsey was keeping up with me like usual and Omar was lagging behind, also like usual, I made the turn and I came up, and—nothing. I just couldn't catch any air. And it wasn't like when I swallowed water or anything. God knows, I've had that happen plenty of times. No, this was, uh, this was bad. I couldn't catch my breath at all.

You know what it was like? Okay, back when I was a kid, I used to take karate. I gave it up to join the swim team, but I remember the sensei told this great story. We had to learn words for parts of the body—Japanese words. Sensei told us that the word for solar plexus was suigetsu.

It's funny, I googled it years later, and that's not the Japanese word for it, I don't think.

But it doesn't matter. The story's what's good.

Suigetsu means "the monkey in the water." Or at least that was what he told us. See, there's this monkey and he sees the reflection of the moon in the water. He thinks it's cool and he grabs for it. But his paw disturbs the water and the reflection of the moon goes away. The monkey's all sad now, because, let's face it, monkeys aren't the brightest creatures in the world. Although, I've taught some kids who probably were just as dumb.

Anyhow, the water calms down and the moon's reflection comes back. The monkey's happy, so he grabs for it. And it starts all over again.

Getting hit in the solar plexus is like the monkey grabbing for the moon.

Never been hit in the solar plexus. But that day, in the pool? I was totally grabbing for the moon's reflection and not getting it.

It took a lot of tests, but they finally found polyps. So now it's time for treatment. Hooray.

From the diary of Dr. Delphine Cormier, Germany

We have all been betrayed. I cannot believe that I was such a fool as to believe what Rachel told me!

I write this from an airplane that is taking me to my new position in Dyad's office in Frankfurt. I have been forbidden from seeing Cosima, removed from my position as interim CEO, and removed from North America entirely. I should have known that I could not serve three masters. D'accord, I could not even truly serve two. I tried to be Cosima's doctor and her lover, when every letter of medical ethics tells me that such a course is incredibly unwise. The moment I declared my love for her—no, the moment she joined Dyad—I should have recused myself from my responsibility for her medical care.

That has been done for me, but because I tried to serve a third master— as a Dyad employee and interim director—I have been denied the chance to be her lover as well. Rachel manipulated me, indeed all of us, to get what she desires. She disguised herself as Sarah, used me to sow discontent among Sarah's allies, and kidnapped Kira. While this is good news in the abstract for Cosima, as Kira's stem cells are her best hope for surviving until Dr. Duncan can provide a gene therapy for us—that is, for Cosima's doctors to use—it is terrible news for Kira. There is no worse place to be than in Rachel's clutches, as I have learned to my detriment.

Je suis desolé, ma chère. I tried to be your doctor and your lover, and now I am neither. I am trapped on another continent while you fight for your life.

Je t'aime, Cosima. Je t'aime toujours.

# BOARDING PASS

Please keep this document until the end of your trip.

**R E G A L ▲ A I R W A Y S**

**SEC. NR:** RA0489: 281

| Name | **CORMIER, DELPHINE DR.** |
|---|---|
| Passport | O2O11B89A |
| E-ticket # | 0741691517833 |

| FLIGHT | DATE | FROM | TO | DEPARTURE | GATE | BOARDING | CLASS | SEAT |
|---|---|---|---|---|---|---|---|---|
| **RA0381** | 0804 | SCBRH | **FRANKFURT** | **17:10** | unknown | **15:55** | F | 18D |
| | | | | | | | DES13 | |

Verify terminal and gate at airport

---

**BAGGAGE DROP**
At least **90 min** prior to departure

If you have baggage to check-in please take it to the REGENT AIR baggage drop-off.

**BOARDING**
From: **15:55**

If you have hand-baggage ONLY you may go straight to the gate.

**LAST CALL**
Check the monitors at the airport

Be aware that after boarding closure time you will be refused and your baggage will be off-loaded.

REGENT AIR wishes you a very nice flight.

# Ultimate Comfort

In your living room
– or in ours.

Flight updates and mobile
check-in on your smartphone.
High Speed Internet anywhere.

## Important departure information please read all instructions carefully!

1. Check in your baggage at least 180 minutes prior to departure for intercontinental flights and 150 minutes for European flights.
2. The check-in desk and luggage drop-off opens at 04:30 hrs.
3. If your baggage weighs more than 23kg, you will have to pay an excess baggage fee. The maximum baggage weight is 32 kg.

[no translation: /pndPrint/en/all/FirstClass;}

**SEC. NR:** RA0489: 281 032.RG0381: 18D

**SEC. NR:** RA0489: 281 032.RG0381: 18D

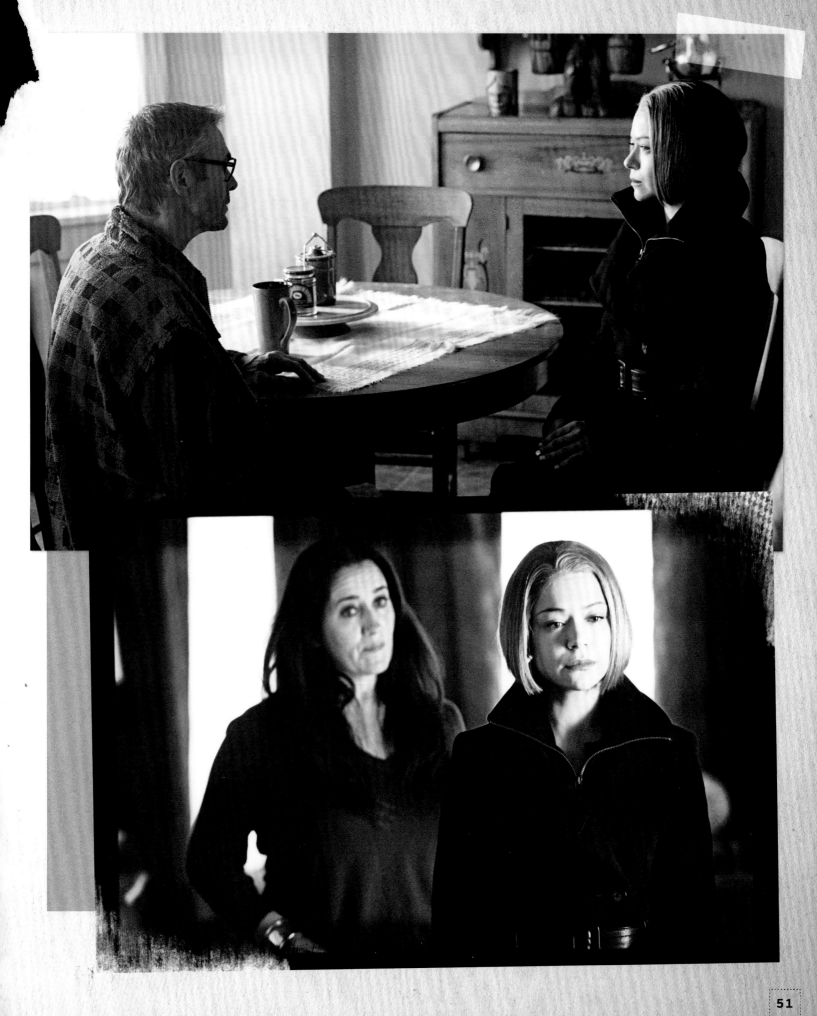

# DYAD INSTITUTE

## Duncan, Rachel
### PLGI #308a01

DuncanR, executive status/employee ID 0415-2112-B. AA clearance needed for medical Hx.
**DOB:** 03-31-1984
**HEIGHT:** 5'4"
**WEIGHT:** 108 lbs.
**OCCUPATION:** Executive at Dyad.
**SEE ALSO:** DuncanE, DuncanS, BowlesC, LeekieA, Nealo-nA, RosenD, DierdenP, SuominenV (PLGI #3MK29a).

Adopted by Project Leda's lead scientists, Drs. Ethan and Susan Duncan, Rachel was informed early that she was a clone, one of many. While her early formative years were stable, the death of her parents at Dyad's Cambridge lab explosion in 1991 deeply traumatized her. A ward of Dyad through Aldous Leekie, the subject was essentially raised by researchers, doctors, and private tutors. In a series of laboratories, her cognitive, physical, and emotional development were continually documented. From thirteen to seventeen, she was sent to boarding schools and summer programs across the EU. The subject worked to embody what she believed herself to be, what her guardians told her she was: an advancement on humanity, self-aware as the next evolution. By the time she was eighteen, Rachel was fluent in seven languages and was an accomplished art historian. Although she was required to take a series of intensive science courses (core genetics, theoretical evolution) she chose to study psychology, marketing, and behavioral economics at university. After which she earned her MBA from the University of Toronto's prestigious Rotman School at the top of her class. Dyad fast-tracked her into an executive position. She became a key negotiator between Dyad and its umbrella companies, and outlined an aggressive plan to begin more comprehensive testing of her genetic identicals.

## PERSONNEL FILE

**INSTITUTE**     OFFICIAL MEMO

```
OFFICIAL MEMO
SENT TO: Board of Directors
SENT FROM: Rachel Duncan
SUBJECT: Promotion

    I would like to thank you all for welcoming me to my new position. While my
mother was an adequate scientist, I do not feel that she had sufficient under-
standing to run the project and serve Neolution's agenda with sufficient skill.
    For my entire life, I have been told — mostly by my mother — that my sta-
tus as a subject in Project Leda compromised my ability to be an administrator
of it. And yet, the project thrived under my leadership. I can assure you that
Neolution will do the same. I will gladly and skillfully do P. T. Westmorland's
great work. Together, we will change the world. Together, we will improve the
world. Together, we will make humanity great.
```

YAD INSTITUTE

**OFFICIAL MEMO**

**OFFICIAL MEMO**
**SENT TO:** Doctors Emmett Christiansen and Caren Plant
**SENT FROM:** Rachel Duncan
**SUBJECT:** Laboratory Space

It has come to my attention that there is conflict between the pair of you with regard to Laboratory 313. Because of space restrictions, you have been assigned to share the facilities in 313. While your respective botany projects are both of great scientific interest, they are not suffiiciently important to our bottom line to justify separate laboratory facilities for each of you, as you have both separately demanded of me. Your childish arguing will cease and the pair of you will work out a method by which the laboratory and its equipment may be shared.
I do not expect to hear any further complaints from either of you on this subject. Consider it closed.

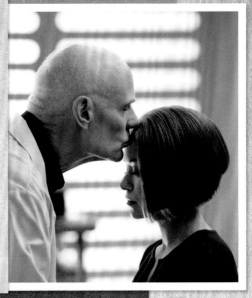

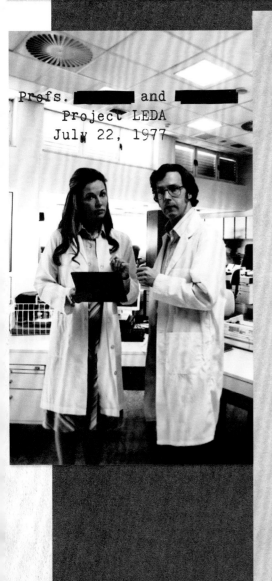

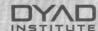
Profs. ▓ and ▓
Project LEDA
July 22, 1977

DYAD INSTITUTE    OFFICIAL MEMO

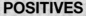

**ANNUAL EMPLOYEE EVALUATION**
**EMPLOYEE:** Rachel Duncan
**EMPLOYEE ID:** 0415-2112-B
**SUPERVISOR:** Marion Bowles

## POSITIVES

Duncan continues to bring an intensity to her work that is reflected in her department's efficiency and timeliness. None of her projects have run behind schedule, none of her projects have gone over budget—or under budget, for that matter. Her projections tend to be brutal, but also unerringly accurate. She also brings the unique perspective of actually being a Leda clone while heading up Project Leda.

## NEGATIVES

That same intensity leads to difficulties in her interpersonal reactions. Turnover in her department is heavy, particularly among the lower-ranked and lesser-tenured personnel. Duncan's demeanor is cold and unfeeling, which can be useful in a supervisor, but can also sometimes be problematic. Her solutions to personnel issues have been either to give orders for people to get along (not a strategy with a history of success) or to fire one or both of the offending parties—which primarily discourages people from mentioning their personnel issues at all, thus allowing them to fester.

To this end, we have transferred many of the personnel responsibilities to Aldous Leekie, who is a far better evaluator of people.

## OVERALL EVALUATION

Duncan is a valuable asset to Dyad and Topside, the last link we have to Ethan and Susan Duncan's work, and a firsthand Leda clone. It is recommended that she be given a title bump and salary increase commensurate with a satisfactory job performance. It is further recommended that she be encouraged to attend therapy sessions in order to improve her interpersonal skills, though such encouragements in the past have been met with steely-eyed refusal.

# Six dead in laboratory blast

## Six scientists incinerated in lab explosion, while working on a medical research project spearheaded by Professors Susan and Ethan Duncan.

LOCAL authorities are investigating the causes behind a laboratory explosion that claimed the lives of six scientists on Tuesday evening at the University Campus Science Park. Witnesses reported hearing a pair of "loud booms" at 7:20 p.m., with flames becoming visible from the upper floors of the Thallenberg Building within minutes of the blast.

University Constabulary was first to arrive on the scene, helping to evacuate staff and students from the building.

In a press conference this morning, Chancellor Strickland praised the quick response of the Constabulary. "This is has been a tragic day for all, and our prayers go out to the victims of this terrible accident, as well as their families. We are thankful cellor Strickland praised the quick response of the Constabulary. "This is has been a tragic day for all, and our prayers go out to the victims of this terrible accident, as well as their families. We are thankful for the actions of the University Constabulary, as well as local authorities, for helping our students and colleagues to safety, and for preventing further loss of life."

At this time, little is known about what triggered the explosion. "We will be conducting an investigation into the events that led to this tragedy, whether it was through human error in mishandling combustible materials in the lab, or whether the issue is one of safety in the building itself" said Chief Fire Officer Carlisle.

"We will be coordinating with the University Constabulary in our investigation, with the hope of coming to a determination about tthe cause of the fire as soon as possible. We will also be reviewing the lab safety protocols at the school, to help prevent similar accidents in the future."

Across the campus, faculty and students are stunned by the loss of mentors, colleagues and friends. Graduate student Marcus Newberry recalls his former professors: "The scientific community lost two of its most brilliant minds yesterday. I had are stunned by the loss of mentors, colleagues and friends. Graduate student Marcus Newberry recalls his former professors: "The scientific community lost two of its most brilliant minds yesterday. I had the privilege of assisting the Duncans as an undergraduate and found them to be dedicated and passionate in their work. I believe I can speak for all those fortunate to have been under their tutelage — they were true role models."

**Turn to back page, col. 3**

# Police struggle to contain mobs

Dearest Rachel,

Your mother and I are so proud of you, darling! First to make the honour roll at school, and then to be chosen to give the reading at the nativity play! I have to say that it is a truly fine Christmas present, to know that our brilliant little girl is being recognized for her brilliance.

Between you and me, your mother is less happy about the nativity play, but her school didn't have one. I remember when I was your age and I was chosen to play one of the Three Wise Men. I only had one line, and I spent days memorizing it.

You, though, get to read an entire passage from Luke! With your superb elocution and your dedication, I am quite convinced that you will read it with eloquence and grace.

We are very grateful for you, Rachel. You are the proof that what we do is worthwhile, and we will always love you for that.

Love and kisses,
Dad (and Mum)

Witnesses reported hearing a pair of "loud booms" at 7:20 p.m., with flames becoming visible from the upper floors.

Six scientists incinerated in laboratory explosion, project spearheaded by Professors Susan and Ethan Duncan.

# Gun battle held near route of hunger striker's funeral

**By a Staff Reporter**

An army snatch squad seized six suspected members of an IRA firing party in Belfast yesterday after a gun-battle in a house near the route of the funeral procession for Joe McDonnell, the hunger striker who died on Wednesday.

"On entering the house the soldiers were confronted by armed men," said the statement. It added that two men were shot.

The three Garand (M1) rifles were found with combat jackets and hoods.

As troops then made four further arrests queues from the

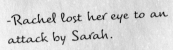

-Rachel lost her eye to an attack by Sarah.

-Now has bionic eye—what kind of control does that give Neolution over her?

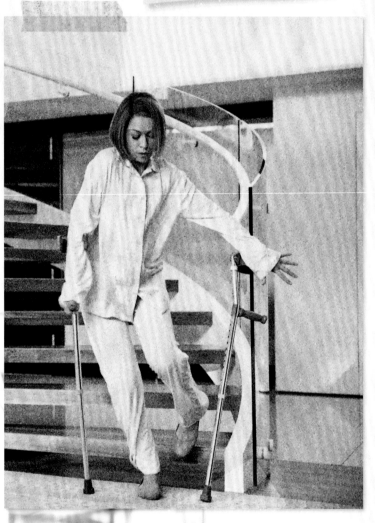

**POSTOPERATIVE REPORT**

**SURGEON:** Alan Nealon
**PATIENT:** Rachel Duncan
**ANESTHESIOLOGIST:** Alfred Morgan
**ASSISTANT:** Giancarlo Wu
**PROCEDURE:** Corneal foreign body removal
**ANESTHESIA:** Lidocaine with l:100,000 epinephrine
**PREOPERATIVE DIAGNOSIS:** Foreign projectile (#2 pencil) embedded in left oculus at high speeds, resulting in significant damage to the lens, cornea, retina, and medial rectus. The point of the pencil also penetrated the frontal lobe of the patient's brain.
**NOTES ON PROCEDURE:** Foreign projectile was removed without further trauma to ocular region, however function in the eye was deemed negligible given the damage, and so preparation for prosthetic was indicated. Patient reacted well to anesthesia and ocular region was irrigated so that no trace of the projectile remained.
**POSTOPERATIVE DIAGNOSIS:** The eye has been cleared for a prosthetic, which will be implanted after the eye has sufficiently healed. However, the extent of the brain damage is impossible to know immediately. There are likely to be cognitive issues, speech issues, and mobility issues. For the moment, patient cannot use her legs or her left arm and is suffering from aphasia. These symptoms may fade with time or may be permanent.

From the diary of Dr. Delphine Cormier, Dyad Institute

Never have I felt sympathy for Shakespeare's Richard III as much as I have these past few weeks. It has truly been my winter of discontent. I celebrated (to use the verb "to celebrate" very loosely) a holiday season that was filled not with cheer but misery. A Christmas that should have been the first of many with Cosima was instead, thanks to Rachel's machinations, spent alone in a dingy Dyad-rented flat in Frankfurt. I was convinced I would never see my love again.

Winter is a time that is focused on endings. It is when the days are shortest, and when they start to lengthen again. It is not a coincidence that many calendars, including the one now used most in the world, end at this time and then start anew. So many festivals are held at the winter solstice because that is when the sun renews itself.

In the past, I have spent New Year's Eve at parties with friends, most often in Paris, drinking a great deal of wine and champagne. This year, I had hopes of being with Cosima, and perhaps some of her sisters.

Instead, I was alone and miserable. I sat with red wine, the color of blood, and wondered if perhaps opening my veins might be the best solution, to simply end the pain in the only way I could think of.

That thought was fleeting, lasting only a brief moment, but its power nearly felled me. I was so lost, and I promised myself never to be that lost again.

I also had an epiphany. I realized that I could not balance all the needs of my life at once, for they were in conflict. I had set myself up to fail, for I could not do the job Aldous gave me without betraying Cosima, and I could not be Cosima's helpmeet and remain a loyal Dyad employee.

Having come to this realization, I am now faced with a further dilemma. Marion Bowles has offered me the position of the head of Project Leda. I would, in essence, be doing both Rachel's and Aldous's jobs, supervising the project, taking reports from monitors—and making sure that a cure is found for the autoimmune disorder that is ravaging Cosima.

This is further complicated by Ethan Duncan's suicide before he could provide the key to all his ciphers. He provided only information for Cosima, for which I am of course grateful, but his selfish actions may sign the death warrant for the other Leda clones.

And then there is Project Castor.

I do not know what to make of that. Knowing there is an American military project that is adjacent to Leda, developing male clones and training them as soldiers. The one that Marion has captured for Topside is a sociopath, and I do not hold out much hope for the others being much of an improvement, given what we know.

On the one hand, this will give me an opportunity to finish the work I started when Aldous recruited me. It will also allow me to again have a direct hand in curing Cosima.

On the other, I cannot—will not—allow myself to be hurt again. Never will I look at a glass of wine and see it as the blood pouring from my wrists as I did on New Year's Eve. No, I must be detached.

Nothing is more important than Cosima. I must be her doctor and that means I cannot be her lover. I must remain detached, for if I am not, I will live and die with every cough, every seizure, every test, every treatment. It will eat away at my heart and soul and I will be unable to care for her.

In addition, I made a promise to Cosima that wonderful, amazing night when we declared our love for each other: If I love her, I must love all her sisters. And so I must love them all the more by not loving her. It is the only way either one of us will survive.

2.1    [**DYAD INSTITUTE**] represents and warrants that:

Transcript of call from Marion Bowles to
Delphine Cormier, 1-2-2015/1207

DELPHINE CORMIER: *Allo?*

MARION BOWLES: Is this Dr. Cormier?

CORMIER: This is she.

BOWLES: Dr. Cormier, I'm Marion Bowles. Happy New Year.

CORMIER: Ah, thank you. To you, as well. Er, what may I do
for you, Ms. Bowles?

BOWLES: Please, call me Marion.

CORMIER: And I am Delphine.

BOWLES: Delphine, I know you're only just getting settled
in Frankfurt, but I'm going to need you to fly back to
North America and take charge of Dyad.

CORMIER: Excuse me?

BOWLES: Things have—well, changed in Dyad. Significantly.

CORMIER: Is Cosima—

BOWLES: Cosima is fine. She's responding to treatment,
at least so far, but she's the least of our problems.
I'm afraid that Rachel can no longer be trusted in a
position of authority at Dyad. She has been reckless and
dangerous, and we no longer believe she has the company's
best interests at heart. But the one thing I believe
Rachel did right was offering you Aldous's position after
his passing. In fact, I think you are absolutely the right
person to take over the project entirely. You know the
science *and* you know the people. Your relationship, not
only with Cosima, but with her self-aware sisters, makes
you the ideal candidate to supervise Project Leda going
forward.

CORMIER: I am honored, but before I can even consider
accepting—

BOWLES: Before you can even consider accepting, Delphine,
let me tell you what else is going on. (takes deep breath)
Do you know anything about Project Castor?

CORMIER: Not a thing. If I was forced to guess, I would say
it would be related to Project Leda in some way, given the
mythological background of both names. However—

BOWLES: No, you're exactly right. Project Castor is also
creating genetic identicals. One of them has targeted a
naïve Leda clone. This needs to be dealt with and quickly.

CORMIER: Marion, I—

BOWLES: Don't give me an answer right now. This is too
big a decision to enter into after one phone call. My
assistant is e-mailing you all the relevant information
we have on Castor, as well as a formal job offer. Look it
all over, sleep on it. Call me in the morning. Okay?

CORMIER: *D'accord. Merci,* Marion, I—I have much to think
about.

BOWLES: We all do. We'll talk tomorrow.

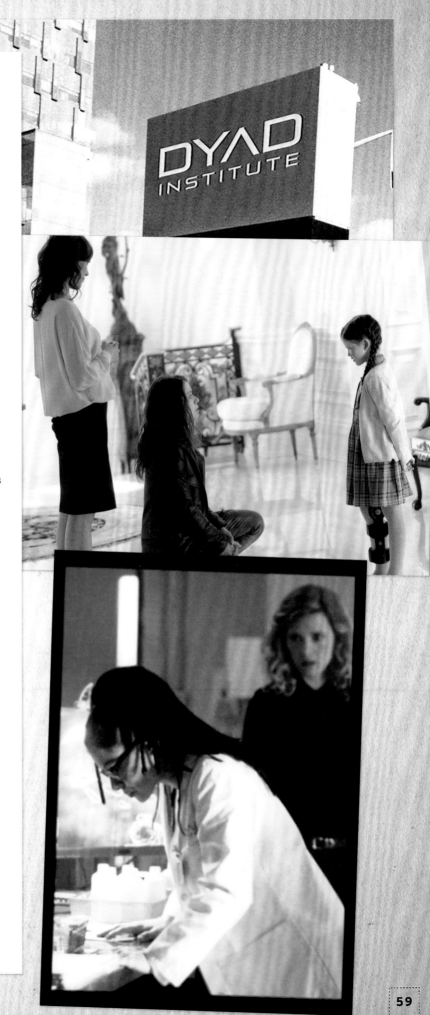

# DYAD INSTITUTE

**Bubbles**
HANDMADE BATH & BODY

**DOB:** 04-04-1984
**HEIGHT:** 5'4"
**WEIGHT:** 108 lbs.
**OCCUPATION:** Housewife.
**SEE ALSO:** ReferenceHendrixD, HendrixO, HendrixG, HendrixC, HendrixF.

## Hendrix, Alison
### PLGI #327624

PERSONNEL FILE

Alison Hendrix grew up in Toronto, Ontario, raised by an outspoken, passive-aggressive mother and a browbeaten father; the couple divorced when Alison was in middle school.

Having been raised with strict expectations regarding behavior, appearance, and ambition, the subject found her early attempts at independence met with punishment—primarily withdrawal of her mother's affection. After the subject developed a tic beneath her right eye at the age of eleven, her pediatrician (Dyad employee EudalyC) diagnosed a general anxiety disorder. Subject was treated with sertraline until 1996. Cognitive behavioral therapy was recommended but refused by the mother.

A cheerleader and class valedictorian, the subject became highly organized at a young age (PLGI trait) and has since showed the same kind of ruthlessness exhibited by a number of this series. Alison met her future husband and monitor, Donnie Chubbs*, in her senior year.

*HendrixD ("Donnie"), Alison's husband, took Alison's maiden name as his own when Connie Hendrix (her mother, unknowing participant in Canadian donor program) insisted. Believing that Alison was a subject in a harmless, long-term psychology experiment (social metrics), Donnie unwittingly worked as Alison's monitor from when they first began dating in college (2003) to 2015. His reports were poorly organized, but gave Dyad access to standard medical data and temperament changes.

Eager to have children, subject underwent testing in 2008 (hysterosalpingography, hysterosonography, luteinizing hormone level checks) and was found to be infertile for nonspecific genetic reasons. A five-month period of depression and alcohol abuse was documented after the tests. Subject then began researching adoption and had siblings Oscar and Gemma placed with her in 2010.

Subject lives in the suburbs with her family. A soccer mom and book-club participant, she also acts in her local community theater and enjoys target practice in her spare time (Alison was given a handgun and trained in its use by Elizabeth Childs in late 2013, after which she became an avid collector). Hobbies include baking, aerobics, scrapbooking, sewing, reading, tatting lace, and soap making.

Became self-aware following contact with Elizabeth Childs in late 2013. Before Rachel Duncan's decision to "open" Dyad to the PLGIs, Alison briefly suspected that her husband was working as a Dyad monitor, her suspicion then moving to Aynsley Norris, a neighbor and friend. Norris died in a freak household incident shortly thereafter. Subject was already using prescription pills and alcohol to deal with the stresses of motherhood; after learning that she was a clone, one of several who were being stalked, with some already murdered, her drug use increased substantially. Subject spent a brief period in rehab in 2013, at which time she confessed witnessing Norris's death to fellow rehab patient (and former boyfriend to Sarah Manning) Victor Schmidt. After her husband's job loss, subject briefly took over an illegal prescription business from her drug and weapons dealer, OzerovR, to help fund her run against her children's school district trustee incumbent, Marci Coates.

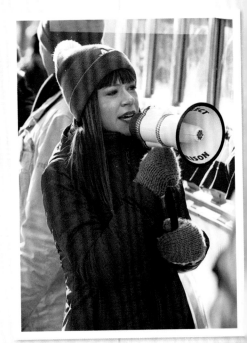

## DYAD INSTITUTE

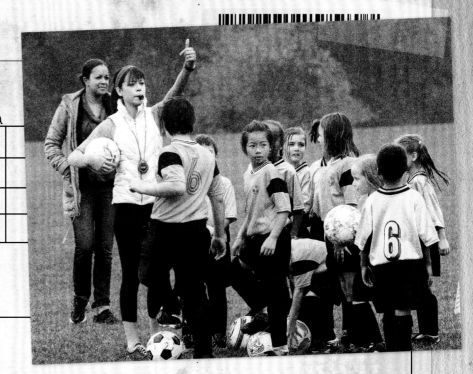

**MONITOR ASSESSMENT REPORT (AR-21)**
PTN LV 42

| | | |
|---|---|---|
| DATE: | TIME: | Monday afternoon and at around 9 and then at around 10 p.m. |
| AGENT: HendrixD | | |
| SUBJECT DESIGNATION: 327b24 | | |
| NAME: Alison Hendrix | | |
| LOCATION(S): Home | | |
| | | |
| OBSERVED WITH: Oscar, Gemma, me | | |

**INTERACTIONS/EVENTS OF NOTE:**
Oscar asked if we could have breakfast for dinner—he loves bacon—and Ali went off about how she had already thawed a chicken and that we had bacon for breakfast already. Then she said that too much bacon will make you fat and she shot me a look, even though I haven't gained any weight lately, I've even lost a couple of pounds, I'm pretty sure. Gemma caught on and said, "Like Daddy, right?"

**PUPIL GAUGE (mm)**

1 2 3 4 5 6 7 8    **B** = BRISK    **N** = NC
                    **S** = SLUGGISH  **C** = EY

**HEALTH/APPEARANCE CHANGES:**

I think she has PMS.

And Alison didn't say no, she just said that we're all doing our best to eat healthy and that "Daddy is starting a new exercise program because he wants to be healthier," even though we haven't talked about anything like that.

**MONITOR-SUBJECT INTERACTION:**
After we tucked the kids in, she printed out an article on obesity and heart disease and put it on the fridge. I took it down, and she didn't say anything then, but she was pissed off, I could tell.

**EMOTIONAL STATE(S) OF NOTE:**
Before bed I said I was thinking about taking up swimming and she calmed down and told me about all the health benefits of low-impact cardio and said it would be better for my joints than jogging. So she's not mad at me anymore.

**LIST ANY ATTITUDES, ACTIONS, OR BEHAVIORS THAT ARE ATYPICAL FOR THE SUBJECT:**

Nothing except maybe PMS, which is normal.

CONTACT SUPERVISOR IMMEDIATELY IF YOU OBSERVE OR SUSPECT ANY OF THE FOLLOWING: SIGNS OF ILLNESS, SUICIDAL OR SELF-INJURIOUS IDEATION, CRIMINAL ACTIVITY, PRIVATE MEETINGS OUTSIDE OF DOCUMENTED FAMILY/ACQUAINTANCES, AND ANY POSSIBILITY THAT THE SUBJECT HAS BECOME AWARE OF BEING MONITORED.

DYAD INSTITUTE  |  6750 GARRISON ROAD TORONTO, M6T JK8  |  416.555.0139  |  WWW.DYADINSTITUTE.REG

Underlying document (partially obscured):

**BRE**
**INC**

## LICEN

This Lice
[SEPT 25

**BETWE**

**AND:**

**1. DE**

In this A
terms s

"Intelle
circuits
know-h

"Modifi
Source

"Softw

"Sourc
readal
Softwa

**DYAD INSTITUTE**

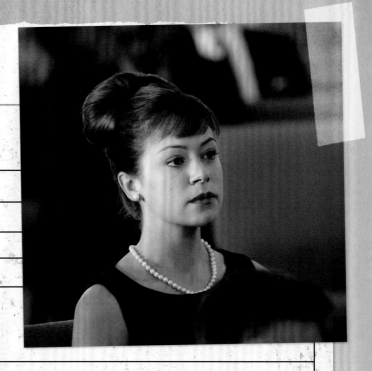

**MONITOR ASSESSMENT REPORT (AR-21)**
PTN LV 42

| DATE: | TIME: Wednesday morning at 4am | |
|---|---|---|
| **AGENT:** HendrixD | | |
| **SUBJECT DESIGNATION:** 327b24 | | |
| **NAME:** Alison Hendrix | | |

**LOCATION(S):**

home

**OBSERVED WITH:**

Just me — why would anyone else be up at that hour?

**INTERACTIONS/EVENTS OF NOTE:**
So I woke up at 4am and Ali was up, and she was talking to herself. Now she said she was running lines from that "Blood Ties" play she's in. I can't believe they're even still doing the play, since Aynsley was the lead and you can't do a play without a lead, right? Anyhow, I don't think she was really running lines, I think she was talking to someone she was hiding behind the door. One of the voices I heard her talking

**PUPIL GAUGE (mm)**

1  2  3  4  5  6  7  8

**B** = BRISK  **N** = NO REACTION
**S** = SLUGGISH  **C** = EYES CLOSED

**HEALTH/APPEARANCE CHANGES:**

Ever since Aynsley died, she's just been weird. I don't think she's drinking again, but I can't rule it out either.

**MONITOR-SUBJECT INTERACTION:**
I asked her what she was doing up so late, and she gave me some nonsense a[bout]
doesn't care what time it is or something like that. I don't remember exactly [...]
muse? Honestly? She's just a supporting character in a dumb play about a mu[...]
kind of muse does that need? I don't get her.

to was not her. Besides, I thought I heard one of them interrupt the other. Of course, it was 4am, maybe I was just really tired. Either way, it's weird that she'd be up that late. Or that early. Whatever.

**EMOTIONAL STATE(S) OF NOTE:**

Snappish. Annoying. Insomniac. Talking to herself or to someone else. She might be drinking again.

**LIST ANY ATTITUDES, ACTIONS, OR BEHAVIORS THAT ARE ATYPICAL FOR THE SUBJECT:**

Just—off. Maybe it's Aynsley. Maybe it's drinking. Maybe it's an actor's temperament, I don't know.

DYAD INSTITUTE | 6750 GARRISON ROAD TORONTO, M6T JK8 | 416.555.0139 | WWW.DYADINSTITUTE.REG

STARRING
ALISON HENDRIX • SARAH STUBBS

A MUSICAL

BLOOD TIES

Doors at 9:00 PM
Show at 9:30 PM

GLENDALE COMMUNITY THEATRE

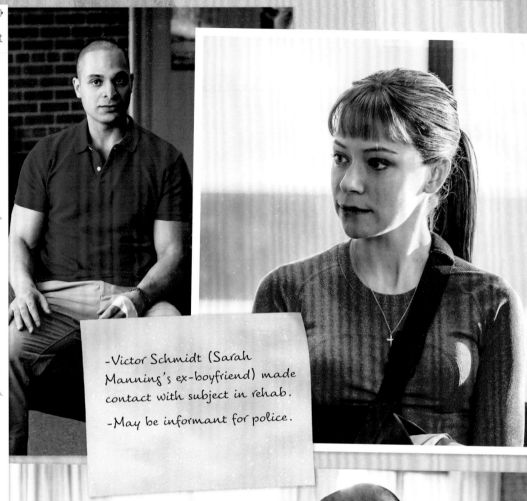

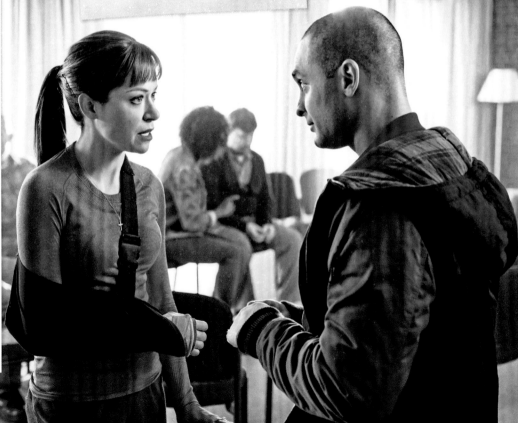

●●●○○ �📶    3:32    22 % 🔋

‹    **Detective Bitch**   Contact

Today 8:32 AM

Yo, Deangelis, it's Vic. I'm in.

Of course you're "in," asshole, you're a drug addict. It's not hard for you to be "in" in a rehab facility.

Why you gotta bust my ass? You told me to keep you informed.

I told you to keep me informed about what Hendrix is doing. She's the target. I don't need to hear about your rehab. Just her.

Don't know why you have a hard-on for Miss Uptight Suburbia. I keep telling you, I can get to Sarah more easily.

Yeah, right. She played you like a five-dollar fiddle.

See, there you go, busting my ass again.

Vic, stop texting me. You're wearing down my phone battery. When you've got Alison admitting to a crime, text me. Otherwise, go to your group hugs or whatever and stop making my phone buzz until you do.

Yes, MA'AM!

📷  Text Message        Send

-Victor Schmidt (Sarah Manning's ex-boyfriend) made contact with subject in rehab.

-May be informant for police.

# A Guide for Impersonating Sisters - By Alison Hendrix

## Sarah
- Loosen shoulders.
- Stand with one foot in front of the other exposing your side so you can move away at a moment's notice.
- Shove out chin in defiance of authority.
- Put hands in pockets.
- Talk with a British accent.
- Don't sound educated, but don't sound stupid, either.
- Attitude. Lots of attitude.

## Cosima
- Tilt your head when you talk.
- Gesture a lot when you talk.
- Try to sound like you're twenty instead of thirty, but legitimately, not because you're trying to sound cool. It's just the way you talk.
- Talk about science a lot. Make sure you're enthusiastic when you do.
- Don't keep scratching your nose where the ring is or fiddling with your hair.

## Helena
- Talk with an Eastern European accent.
- Move like a dancer, but with a heavier tread.
- Keep head bowed a lot.
- Say funny things that aren't meant to be funny.

## Rachel
- Wear an eye patch on your left eye.
- Try not to use your left arm at all.
- Try to stay seated as much as possible. If you must walk, do it haltingly.
- Talk haltingly and struggle with words.
- Despite all this, speak in as controlled a manner as possible.
- Talk with a British accent.

## Alison
- Well, act like me, obviously!

# Bailey Downs Soccer Mom Blog, A Blog
## for the Concerned Mothers Of The Bailey Downs Community

Greetings, fellow moms!

The community is just a-twitter—and a-facebook, hehe—with anticipation over the school trustee election, and I just want to put in my two cents. If you don't vote for Marci Coates, you have to be on drugs.

I almost mean that literally. I mean, Alison Hendrix used to be a pillar of this community, but lately? She gets into fights on the street, she falls off the stage while "performing" in a play, and best of all, she goes into rehab! And we're supposed to reward this appalling behavior by giving her the ability to make decisions about our children? How about we make a decision about her children and maybe take them out of that awful house and give them parents who aren't drugged-out psychopaths or ineffectual buffoons who get fired from their jobs?

So vote smart. Vote for Marci Coates.

I want to add that, while Marci is one of my oldest friends and was maid of honor at my wedding, that has NOTHING TO DO with this blog post. I truly think that she's the best woman for the job.

Post by Eleanor Fitzgerald, January 20, 2015, 16:34:21

---

**COMMENTS**

**Marci Coates, January 20, 2015, 16:55:01**
Thank you for your support, Ellie! Mwah!

**Charity Simms, January 20, 2015, 17:05:55**
I think Ellie's being a little harsh, but I will agree that we should just stay the course and stick with Marci.

**Sarah Stubbs, January 20, 2015, 17:11:59**
Alison is the bravest, most wonderfulest person I know! Yes, she's been through rehab, but that just means she's STRONG and POWER[...] us REALLY hard, but I think it hit Ali more harder than it did ANYONE. I think it's AWFUL of people to be so mean to someone who's such a[...] from a horrible tragedy, and I say go girl!

**Meera Kumar, January 20, 2015, 17:15:22**
Alison has completely lost it, and I thought that before she fell off the stage. I'd sooner vote for our dog for school trustee.

**Vera Keating, January 20, 2015, 17:42:42**
I think Sarah's right, Aynsley's accident really messed Ali up, but she's come back swinging and I admire that. And I think Ellie's "on drugs" crack is totally off-base. Shame on you, Ellie, for saying such horrible things about people who simply disagree with you. Not likely to trust your judgment now, are we?

**Aynsley Norris, January 20, 2015, 18:01:33**
The most popular way to make prank phone calls online!
ASFDASDGASDSDAFHSAD ZVXZZSDGASDSDGASD
ZVXZSDGSADSDFH QWERADFHGDAFXZCBZX
ADFHGSDGSADASDFHGAD DSGASDGSADSDFH
FGBNFSDGSADXZCBZX GJTRSDGSADDSFGHADS

**Eleanor Fitzgerald, January 20, 2015, 18:05:45**
Oh God, someone hacked Aynsley's account again! Can't someone get that to stop?

**Charity Simms, January 20, 2015, 18:06:11**
I've e-mailed the host site AGAIN. Let's hope.

**Kelsey Johnston, January 20, 2015, 18:35:29**
I will say in Alison's defence, she was a mess during the rehearsals for BLOOD TIES, so I'm not surprised at her falling apart. But I think it's awesome that she's doing this. Mind you, I'm totally voting for Marci, but I also totally admire what Alison is doing. Brava!

**Alison Hendrix, January 22, 2015, 21:15:14**
I only signed back on here for the first time in months because I was told my name was being taken in vain. Eleanor, I appreciate you voicing your opinion, though I agree with Vera that it's mean-spirited to characterize those who don't share your views as drug addicts. I was hoping to run a clean campaign, but obviously Marci does not agree, since she endorsed your vitriol in the very first comment.
Then again, this is a blog that can't even keep dead people off it. I'm reminded why I haven't been posting or reading here. And won't be again, because I'll be far too busy as your next school trustee.
<3, Alison H.

**MOUNT ON 3/16" GATOR**

ELECT
**Alison** HENDRIX ✓

**A STRONG VOICE FOR GLENDALE.**
**IT IS TIME FOR CHANGE.**
GLENDALE DISTRICT SCHOOL BOARD

VOTE FOR ALISON
VOTE FOR CHANGE

●●●●○ 🛜                  80 % ▰

< Messages        **Ali**        Contact

Today 8:32 AM

> The meat is out of the package.

What? Donnie, I don't have time to sext right now.

> No, I mean the MEAT is out of the PACKAGE. Package, I mean. C'mon Ali.

Oh fudge, have you been watching THE WIRE again?

> No, I haven't been watching the wire. OK, I did watch the one with the "fuck" scene again. But we need to have codes and stuff. What if the cops are listening?

The cops aren't listening, Donnie.

> How do you know?????

They couldn't even do a proper sting operation when I was in rehab. You really think they're bugging our cell phones now?

> Yeah, I guess. But still like having code words. Makes me feel like a REAL drug dealer.

What makes me feel like a REAL drug dealer is the fact that we're dealing drugs. And, I might add, making a killing. Besides, we're just a tiny operation, just a small part of Jason's territory, and he's just one of Pouchy's operators. We've got nothing to worry about.

> I really don't like that.

Like what?

> Wer're not part of Jason's operation, he's just our go-between with Pouchy.

Fine, dear, yes, whatever you say.

> Don't patronize me, Ali. I've seen the way he looks at you. He still wants you.

Look, Donnie, you can keep the code, okay?

> Thank you!

But no more meat in packages, all right, dear?

> Fine. The hot dog is out of the bun.

Donnie, that really isn't any better. And what does it even MEAN?

> Isn't it obvious?

No.

> Well, good it wouldn't be a very good code if it was obvious.

It also isn't a very good code if I don't know what it means.

> Right. Okay. I'll work on a proper code tonight after we put the kids to bed, okay?

If you want.

> Okay.

Donnie?

> Yes?

WHAT DOES THE HOT DOG OUT OF THE BUN MEAN?

 Text Message          Send

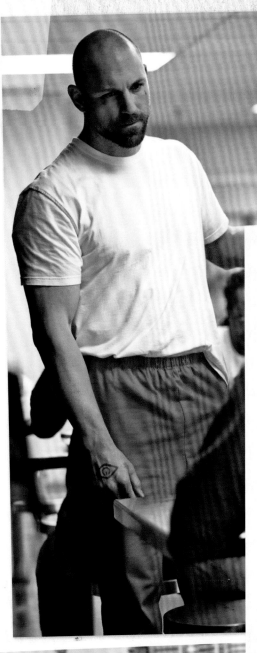

ADELE HAMNER
Atorney-at-Law

Lieutenant Gavin Hardcastle
Toronto Police Department

Dear Lt. Hardcastle,

I would like to protest in the loudest possible terms the treatment of my client Donald Stubbs Hendrix. Mr. Hendrix is a pillar of the community, the husband of the school trustee, and a devoted father of two. The detectives under your command chose to arrest him on flimsy charges on a Friday night while his children were holding a sleepover. And by the way, the civil suite that the parents of Bailey Downs are going to ram up your butts for traumatizing their children is on the way, and it'll be a doozy.

Mr. Hendrix is, as I said, a pillar of the community. To leave him stuck in jail over an entire weekend before being arranged constitutes cruel and unusual punishment, something I plan to bring up with the judge at the arrangement.

This is an abuse of power, and I can assure you that my client and I won't stand for it lying down.

I can also assure you that this is not over. These baseless accusations of dealing drugs will be proven false, and you will be sorry you decided to accuse my client of a crime he didn't commit.

Yours sincerely,

Adele Hamner
Attorney-at-Law

Not bad, darling, but a few notes:
- Donnie's "maiden" name is Chubbs, not Stubbs.
- It's a civil suit, not a civil suite, and it's arraigned, not arranged.
- I don't think you can stand for something lying down, really.
- You should probably get new letter head that spells the word "attorney" properly
                                    —Felix

# RESEARCH DISCLOSURE AGREEMENT

This Research Disclosure Agreement is made as of the Effective Date, December 16, 2012

BETWEEN:

>**Alison Hendrix**, currently residing at
>
>**35 Black Oak Drive, Scarborough**
>
>("Subject")

AND:

>**Dr. Aldous Leekie**
>
>**Principal Investigator and Chief Medical Officer.**
>
>(the "Researcher")

*Entire definition of "intellectual property" in Clause 1 is called into question by Dyad and Topside patenting the clones.*

**BACKGROUND:**

A. The research program described in Schedule "A" attached to this Research Development Agreement was developed **jointly by Subject and Researcher** (the "**Research Program**");

B. The Researcher wishes to provide financial and/or in-kind support for the Research Program as set out herein; and

C. Institution agrees to perform the Research Program in accordance with the terms and conditions set out in this Research Disclosure Agreement.

**NOW THEREFORE**, in consideration of the foregoing premises, the mutual covenants and obligations contained in this Research Disclosure Agreement, and other good and valuable consideration, Subject and Researcher agree as follows.

## 1. DEFINITIONS

1.1 In this Research Disclosure Agreement:

*Clause 2.2 says that any materials must be provided—this could include blood sample and urine, which is contrary to Aldous's promise that any medical tests would be non-invasive. Language vague and dangerous.*

>(a) "**Background Intellectual Property**" mean[...] proprietary to that party and that was c[...], or independent of, the Research Program [...] the Research Program;
>
>(b) "**Budget**" means the budgeted amount se[...] his Research Disclosure Agreement to be paid by Subject for the research conducted by the Institution in the Research Program;
>
>(c) "**Researcher Intellectual Property**" means Intellectual Property conceived or reduced to practice during the Contract Period solely by one or more employees

**Text message conversation:**

---

**iPhone Messages screen — conversation with "Sarah, Alis..."**

Today 8:32 AM

> **Cosima:** Dudes, we cannot sign this.

**Alison:** I already have! Look, I have my family to consider.

**Sarah:** So do I, Alison. If I sign this, what happens to Kira?

**Alison:** I don't know Sarah, but I do know what will happen to Gemma and Oscar if I DON'T sign it.

**Sarah:** Look, Alison, I get it, you're scared. And you have to do what's best for your family. But NFW I'm signing ANYTHING that comes from these bastards.

> **Cosima:** So say we all.

**Alison:** Excuse me? So say you two, maybe.

> **Cosima:** Sorry, it's what they say instead of Amen on BATTLESTAR GALACTICA. The point is, they already think they own us because of that patent we found in our DNA. Now they're putting it in writing!

**Sarah:** This is bullshit.

> **Cosima:** I don't even want to think about what the next step would be.

**Alison:** Well, I guess we'll find out, won't we?

Text Message    Send

---

**Right column (contract text):**

unenforceable, which will most nearly approximate the intent of the parties in entering this Research Disclosure Agreement.

12.6 Waiver. No condoning, excusing or overlooking by any party of any default, breach or non-observance by any other party at any time(s) regarding any terms of this Research Disclosure Agreement operates as a waiver of that party's rights under this Research Disclosure Agreement. A waiver of any term, or right under, this Research Disclosure Agreement will be in writing signed by the party entitled to the benefit of that term or right, and is effective only to the extent set out in the written waiver.

12.7 Survival. Sections 2.4, 3.2, 10.6 and 12.7 and Articles 4, 5, 6, 7, 8, 9 and 11 will survive the expiry or earlier termination of the Contract Period, unless expressly set out in Schedule "B" attached to this Research Disclosure Agreement.

12.8 Time of the Essence. Time is of the essence of this Research Disclosure Agreement.

12.9 Further Assurances. The parties will promptly do such acts and execute and deliver to each other such further instruments as may be required to give effect to the intent expressed in this Research Disclosure Agreement.

12.10 Enurement. This Research Disclosure Agreement will enure to the benefit of and be binding upon the parties hereto, and their respective administrators, successors, and permitted assigns.

**IN WITNESS WHEREOF**, the duly authorized officers of the parties have executed this Research Disclosure Agreement to be effective as of the Effective Date noted below.

Signed: _Aldous Leekie_
Name: Dr. Aldous Leekie
Title: Principal Investigator and Chief Medical Officer

Signed: _Alison Hendrix_
Name: Alison Hendrix
Title: Subject

*Handwritten note:* Clause 12.8 is maddeningly vague, as "time is of the essence" could literally mean anything, and that clause could be used to justify shortcuts that would be dangerous.

*- 13 - Research Disclosure Agreement*

*- 3 - Research Disclosure Agreement*

71

From the diary of Dr. Delphine Cormier, Dyad Institute

I put it off as long as I could.

While Marion is aware of Sarah's rather crippling attack on Rachel, Topside in general is not aware, and it would not bode well for any of the Leda clones if that news got out. Unfortunately, one of Topside's cleaners, a Ferdinand Chevalier, is coming to inspect the premises soon. I must convince Sarah to disguise herself as Rachel. She already has convincingly acted as Detective Childs, and her past as a con artist will prove invaluable in fooling Chevalier. From what Marion has told me, and what I have read in his file, Chevalier is sufficiently narcissistic that he will not even notice as long as Sarah is at least mildly convincing. I am avoiding the issue. I went to Felix's

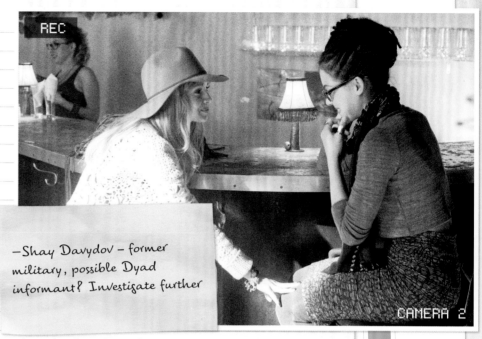

—Shay Davydov — former military, possible Dyad informant? Investigate further

flat in the hopes that Sarah would be there—and in the fear that Cosima would be. My resolve, it was easy to maintain as long as I was not in her presence, as long as I could not see her eyes peering at me through those thick-framed glasses, as long as I could not smell the soap she uses, as long as I could not feel her hand touching mine.

Ah, me, I came so close. For a brief moment, I almost broke, I almost took her in my arms and promised my ever-lasting devotion. But I did not. I stood fast. I told Cosima that in order to save her and the rest of her sisters, in order to keep my promise to love them all, I needed to not be her lover. It destroyed her. However, it will also save her. I must now keep it from destroying me.

My life, it seems, is awash in unintended consequences. Simple enough, I thought: monitor one of Dyad's projects. I did not anticipate falling in love. So then, again now: I thought it would be simple enough to keep my relationship with Cosima professional, to be her doctor, and to make sure that the Leda clones are safe. I did not anticipate her seeking out another to be with.

It began when a standard online sweep revealed a profile on Sapphire for Cosima. My initial reaction was shock that she would put herself out there so blatantly. There was no last name, but that name and that face are both fairly distinctive. The computer program, it found her easily, which means Castor or the Proletheans or any number of other people who have an animus toward Leda might also find her that way.

We already know that two Castor clones attempted to kidnap one of the Ledas, a young woman named Krystal Goderitch, and that Project Castor also has Helena in their custody.

Now Cosima is putting herself on a dating app! I should not be jealous. It was I who stopped any possible resumption of our relationship before it could re-commence. She has every reason to move on, to see other people.

But an online dating app? I should not be jealous, no, but I do believe I have a right to be angry. The security of Dyad in general and Leda in particular is a responsibility of mine and I cannot dismiss this behavior as something charming or adorable. When Leda clones are being stalked it is the height of irresponsibility for Cosima to meet strangers in a bar whom she only knows via an Internet profile.

And yet—is that why I am so angry? Is that why my heart pounds in my chest when I see her sitting at a bar with a blonde wearing a sun hat? Is it my desire for security and the safety of those under my supervision? Ou suis-je jaloux? Am I upset that Cosima is enjoying the company of a beautiful woman, or that the beautiful woman whose company she is enjoying is not me?

DYAD INSTITUTE | 6750 GARRISON ROAD TORONTO, M6T JK8 | 416 555 0139 | WWW.DYADINSTITUTE.REG

# DYAD INSTITUTE

**DOB:** 12-02-2005
**HEIGHT:** 4'8"
**WEIGHT:** 75 lbs.
**SEE ALSO:** DuncanE, DuncanS, BowlesM, DuncanR.

## Bowles, Charlotte
### PLGI #400a01

After the Helsinki incident (see Helsinki XXX case # REDACTED, ChevalierF), Topside felt the pressure to attempt to re-create the Leda genetic identicals, in the hope that a second generation would be viable.

At that, the project was something less than a success. Without access to the genetic original, whose identity was lost in the fire that reportedly claimed the life of Ethan Duncan, the process proved difficult to replicate.

More than four hundred genetic identicals were bred between 2005 and 2006, with only a dozen surviving past infancy, and only one surviving past the age of two.

That one survivor was formally adopted by Marion Bowles of Topside and given the name Charlotte. While Charlotte did survive, her life has been difficult, as she suffers from multiple genetic defects that leave her with stunted legs, a limited diet, and poor stamina.

To her credit, she has overcome most of these difficulties, and she remains a bright

## PERSONNEL FILE

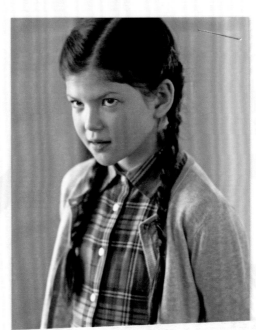

---

**To...** Topside Board of Directors [e-mail list suppressed]
**From...** Alberto Castiglione
**Subject:** Marion

I'm sure you all saw the e-mail I sent to our employees. That is the official story of Marion's death, one that will not be gainsaid, as the body has already been cremated. Charlotte has been sent to join Susan, as requested.

Marion's covert activities in support of the Leda clones reveal a streak of misguided altruism in her that was no doubt born of her caring for Charlotte and viewing the Project Leda Genetic Identicals as something other than an experiment, a dangerous way for us to think of these assets. I'd like to take this opportunity to remind you all that the PLGIs are our property, first and foremost. To think of them as anything else will only lead to more difficulties of the type that we have been beset with these last several months.

The next meeting of the Board will take place tomorrow at 3 p.m., following Marion's memorial service and the spreading of her ashes.

Alberto Castiglione
Chairman of the Board

---

...ing at 10 a.m. Attendance is not man-....... Marion's wishes were that there be no funeral as such, and that her remains be cremated and spread over the quad behind Topside HQ, which will take place following the service tomorrow.

Alberto Castiglione
Chairman of the Board

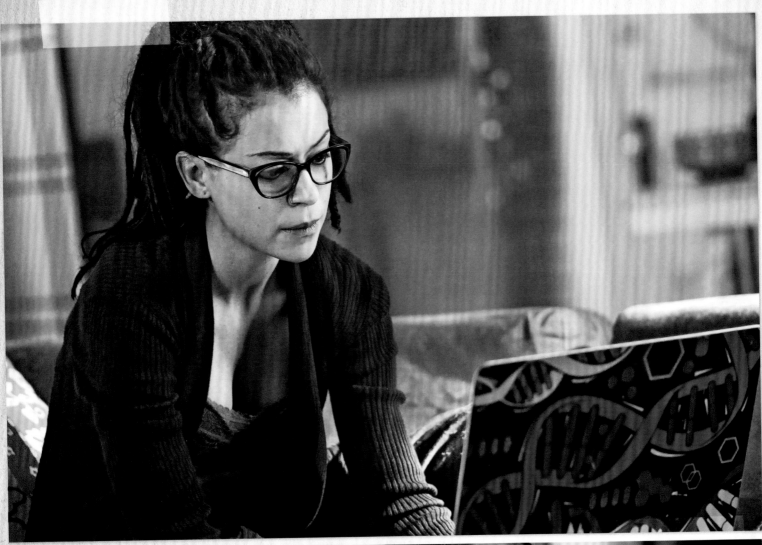

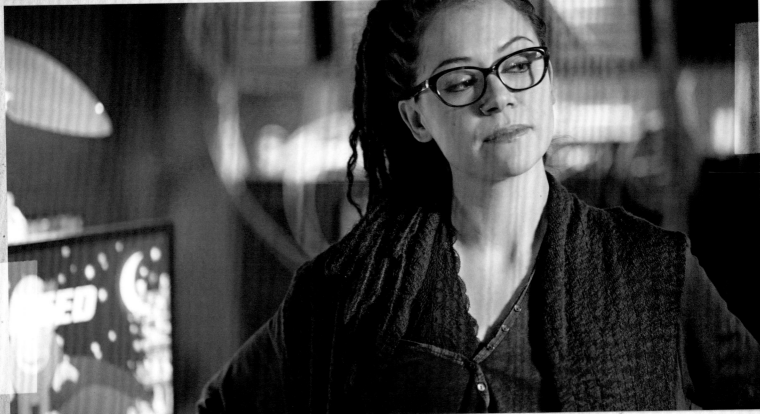

# COSIMANERD

**View Photos (4)**

## I'M LOOKING FOR

Women
Ages 23-50
Near me
Who are single
For new friends, long-term dating, short-term dating, short-term fun

## DETAILED INFO

**Ethnicity:** Caucasian

**Orientation:** Lesbian

**Status:** Single

**Relationship type:** Whatever

**Height:** 5'4"

**Body type:** Lithe

**Diet:** Vegetarian

**Smoking:** Weed

**Drinking:** Sometimes

**Drugs:** I'm game

**Religion:** Science

**Sign:** Seriously? People still ask that? I mean, it's Pisces, but seriously???

**Education:** All for it! I'm working on my PhD.

**Offspring:** None

**Pets:** None

**Speaks:** English, bits and pieces of French

# COSIMANERD
Toronto, ON

### Who am I?
I'm a science geek first and foremost. That's where my heart and soul are, in learning about the world.

### The six things I could never do without:
- Conversation
- Weed
- The Internet (seriously, that's where you can find stuff!)
- Books (that's where you find all the other stuff)
- A good laboratory
- The Ocean

### I spend a lot of time thinking about:
How things work. Genetics are the building blocks of what makes us us. Don't worry, I promise not to bore you with all that TOO much on our date. Probably.

### On a typical Friday night I am . . .
In the lab. That's when it's usually empty and I can get stuff done.

### Do you believe that everything happens for a reason?
I keep going back and forth on this one. Sometimes I believe it with all my heart. Sometimes I don't believe it even a little bit. Life keeps throwing curveballs, you know?

### You should message me if . . .
I don't know—if you like board games and bio ethics?

**MESSAGE ME**

# DYAD INSTITUTE

**DOB:** (anecdotal; surrogate left program prior to completion) 03-15-1984
**HEIGHT:** 5'4"
**WEIGHT:** 110 lbs.
**OCCUPATION:** Unknown
Specific family files reference Dyad Surrogate System (DSS); cross-reference with subject ID.
**SEE ALSO:** SadlerS, ManningS (#322d01/T), Proletheans.

## Helena

We know precious little about Helena except that she was carried by Amelia Lawrence, the same surrogate who mothered PLGI Sarah Manning (#322d01/T). Manning's twin, Helena has the condition situs inversus—she is a so-called "mirror twin," with her visceral organs on the opposite side of her body from their normal positions.

Raised in Europe and western Asia—her native tongue is Ukrainian, so she likely spent many of her formative years in Ukraine. She has significant training as a sniper and as an assassin, and is skilled in the use of firearms, knives, and the bow and arrow.

At some point, Helena was recruited by the Proletheans. She was told that she was the original from which the other PLGIs were cloned and was brainwashed, tortured, and sent to kill the other PLGIs. In many ways, Helena is responsible for the cabal of self-aware clones that formed in Canada, as it was her systematic killing of PLGIs in Europe that led Katja Obinger (#311a55) to reach out to the PLGIs in North America. Obinger observed Helena's murder of Ania Kaminska (#309a12) and fled. *Cf. file on PLGI 311a55.* Helena followed Obinger, killing her and almost killing Manning, who was at the time posing as Elizabeth Childs (#317b31). Helena killed Lawrence and Manning shot Helena, who survived what no doubt seemed to Manning like a heart shot thanks to Helena's situs inversus.

In addition to killing several PLGIs, Helena caused injuries to DuvalO that eventually resulted in his termination; killed several members of an enclave of Proletheans, including the sect's leader, Henrik Johanssen (who impregnated her in the hope of producing several babies who were made up of genetic material from both himself and a PLGI); murdered four area drug dealers (Guilherme "Pouchy" Pouzihno, Luisa Pouzihno, Lionel Tracey, Joao Alves—see city police file H447931); killed the Project Castor Genetic Identical (PCGI) Rudy; and

### PERSONNEL FILE

-Helena is incredibly unstable.

-She is now welcomed by her sisters, and I fear they have forgotten that she killed several of their fellow Ledas, including Katja, not to mention her and Sarah's birth mother.

-Must be careful of her psychosis.

killed Dyad operative MatthewsF. She is known to have posed as Childs, Manning, and Hendrix at various points, despite her paler complexion, blonder hair, and thick accent.

Helena is the most dangerous of the self-aware PLGIs, and should be terminated on sight if found.

HELLO MY BOYFRIEND!
I AM WRITING TO TELL YOU THAT I AM MISSING YOU VERY MUCH. I WANT TO FEEL THE SALTY TASTE OF YOUR LIPS AGAINST MINE WITH YOUR BEARD TICKLING ME. MY BABIES ARE DOING VERY WELL SO FAR.
I AM VERY LUCKY BECAUSE I HAVE MY SESTRAS. EVERY DAY I MUST ATONE FOR WHAT I DID TO THEM AND SO I WILL PROTECT THEM. BECAUSE I KILLED SO MANY I MUST NOW MAKE SURE THAT THE SESTRAS I HAVE LEFT MUST NEVER EVER EVER DIE. I HAVE ALREADY SAVED ALISON AND HER HUSBAND FROM CRIMINALS WHO WOULD HURT THEM AND THEIR CHILDREN.
I LOVE ALISON AND DONNIE'S CHILDREN. I HOPE MY BABIES ARE GOOD CHILDREN LIKE THEM.
IT IS MY HOPE THAT YOUR TRUCK WILL TAKE YOU TO ME SOMETIME SOON SO I CAN TASTE YOUR LIPS AGAIN.

> WRITE TO ME SOON JESSE!
> - HELENA

PS: GEMMA PUT THE HEARTS ON THE PAPER. SHE SAID HER MOTHER SAID THAT THAT IS HOW YOU WRITE A LOVE LETTER. SINCE SHE AND DONNIE ARE VERY HAPPY SHE MUST KNOW HOW TO WRITE LOVE LETTERS, SO I HAVE LISTENED AND THERE ARE HEARTS.

REC

CAMERA 2

INCIDENT REPORT

OFFICER REPORTING: Dominick LaManna

DATE AND TIME: 2/4, 10:35pm

LOCATION: Charlie's Bar & Grill, Hillside Drive

DESCRIBE THE INCIDENT

RCMP received a 911 emergency call to Charlie's. Caller said that a crazy woman was beating everyone up in the bar. I responded to the call, though I assumed it was a prank call, since the fights that break out in Charlie's are usually over women, not committed by women.

Upon arrival, I noted that paramedics had already arrived and were treating several bar patrons for contusions, sprains, cuts, and at least three broken bones. Which is fairly normal for a brawl at Charlie's.

However, multiple witness statements, including that of the bartender and both waitresses, confirm that the injuries were all caused by a single woman. A blond-haired Ukrainian woman with no ID—she called herself Helena—was playing pool with a truck driver named Jesse. According to witnesses, she was being harassed by the other patrons, and she sprained the finger of one of them, which got them to leave her alone for a while. After she and Jesse dominated the pool table for the better part of an hour—and after the sprained-finger victim had had another bourbon or four—the harassment re-commenced.

Helena has no injuries. The other people in the bar have several.

None of her victims pressed charges. Not a real surprise there. I can't imagine any of these boys, most of whom are truckers and bikers, wish to have it on the record that they got beat up by a skinny Ukrainian girl.

# PROLETHIA: A MANIFESTO, BY THE REVEREND DR. ALISTAIR OLDFIELD (1987)

God created us in His own image and made a covenant with us that we would continue to worship Him and do good works in His name.

And for many centuries, we were content with that. Men tilled the fields, women bore the children, and all men did service to our God. And in return, He gave us bounty, crops for the men and children for the women.

Somewhere along the centuries we lost our way.

Somewhere along the centuries we rejected His Word.

Somewhere along the centuries we became arrogant.

We came to believe that we could do God's work, that we could suborn His greatness for ourselves. Our towns and villages that were as one with the lands and the waters instead became urban blights — cities that are entirely composed of things unnatural.

Factories, manufacturing, construction — all vocations strictly in the bailiwick of God became the purview of arrogant men, who thought they could do better than God's work.

Now we face a world of chaos.

This century has seen two wars that we have seen fit to modify with the adjective "world," so grand they were in scope, beyond anything we have ever seen before.

This century has seen development of weapons that could destroy this Earth that God created dozens of times

over and these weapons are in the hands not of religious men, not of spiritual men, but of politicians, that most venal of professions.

And this century has seen abominations propagated in the name of what is laughingly referred to as "science," but is truly alchemy. Alchemists were the worst heretics then and they are the worst now, and like all heretics, they must be stamped out.

We must forget our lives as they have been lo these many centuries as we have choked our world with pollution and industry, and automobiles and airplanes, and other monstrosities that choke us with the very air that we breathe.

The only way to return to the path of righteousness is to travel down the river of oblivion, to purify ourselves of the filth that has superseded God, and return to the simple basics of His Word.

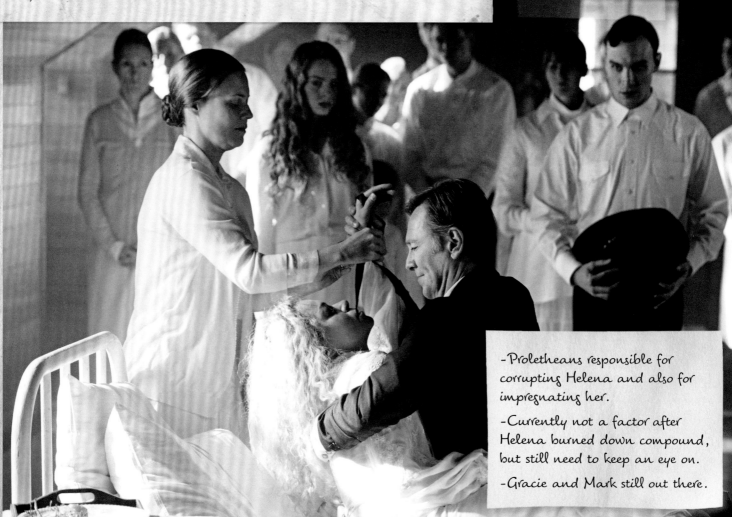

- Proletheans responsible for corrupting Helena and also for impregnating her.

- Currently not a factor after Helena burned down compound, but still need to keep an eye on.

- Gracie and Mark still out there.

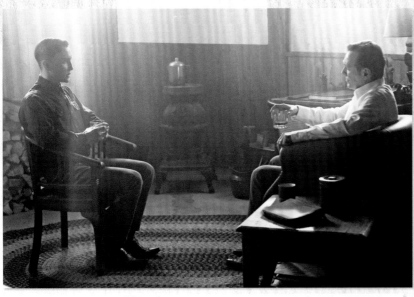

OFFICIAL REPORT

## A REPORT ON THE PROLETHEANS

Reliable information on the Proletheans has been difficult to come by, in part because the members of the cult have very little in the way of an online footprint. They are Luddites, refusing to embrace technology past a certain point and preferring to remain agrarian, very much like the Amish. However, the Prolethean desire to avoid technology is more aggressive; they actively fight against it.

The Proletheans are divided into sects, with each sect seeming to follow the traditions of the group's leader—always a man. One, located in North Dakota, embraces strict vegetarianism, a tenet not followed by any other sect. Another group, in Saskatchewan, refuses to use any tools or wear any clothing that is industrially produced. If it couldn't be made in 1790, they will not touch it.

Most fascinating, however, is the sect in rural Ottawa led by Henrik Johanssen. Johanssen is unusual in that he is one of the few Proletheans who does see the value of at least some of the progress humanity has made. In particular, he has a degree in biology, and might have continued on to achieve a doctorate had he not returned home to work with his fellow Proletheans.

While doing graduate work at King's College London, he also served as a laboratory assistant to Ethan and Susan Duncan during their earliest days of work on what eventually became Project Leda and Project Castor.

Upon his return to Canada, he embarked upon a eugenics program, attempting to breed descendants using his own genetic material. He has injected his own DNA into most of the women under his leadership in the sect, using state-of-the-art in vitro fertilization techniques—much in contrast to the rest of the Prolethean mind-set.

Johanssen's experiments with eugenics are fallacious and based on very poor science. His incomplete study of the field as well as the generally nonscientific bent of the Proletheans leads one to conclude that nothing significant will come of it, save perhaps for some odd genetic quirks in the offspring. Given the Proletheans' isolationism and their place on the fringe of the fringe, as it were—even other religious cults view them as outliers, and Johanssen's sect is an outlier within that group—his work is very unlikely to have any effect on the gene pool.

# FIRE IN RELIGIOUS CULT COMPOUND

By: James Smith

**The compound on Oak Lawn Drive, just off Route 33, owned by the religious cult known as the Proletheans caught fire last night. At present there are seven confirmed dead, all male members of the cult. All the women and children were able to get away from the compound without being harmed, though several of the women have suffered first-degree burns and contusions.**

The Proletheans themselves have refused to speak to RCMP or fire department authorities, saying only that it is an "internal matter." They have also refused to provide a full list of residents of the compound, making a true accounting of the dead and injured difficult.

However, this reporter was told by one Prolethean, who spoke only on the condition of anonymity that one of the women who lived on the compound, described only as "blonde" and "a foreigner," was the one who got the women and children out of the compound before the fire blazed out of control. It is unknown if this mystery woman is considered a suspect for starting the fire, though the witness statement would seem to indicate that as a possibility.

RCMP spokeswoman Heather Julian said that the arson investigation is ongoing, as is the RCMP investigation into the death of Henrik Johanssen, who was apparently the leader of this sect of Proletheans. While the other deaths are being treated as accidental, Johanssen's is considered a murder, though Julian was not forthcoming with details as to why Johanssen's death was different from the others. Julian neither confirmed nor denied the existence of the blonde woman, saying only that the investigation was ongoing and she could not comment directly.

The injured Proletheans refused treatment at Gemini Hospital in Ottawa.

Dear ~~creatures~~ ~~clones~~ ~~abomina~~ ~~friends~~ Sisters:

    I do not know if I will ever send this letter. I do not even know what to call you all. It took me several minutes to figure out how to handle the salutation of this letter. I decided upon "sisters" only because you are sisters. You have that bond, which I envy. I know that no matter how many times I apologize, it will not matter. I did what I did because I wanted to be with Mark. I love Mark with all my heart and all my soul. Loving Mark is the only thing I have done that was truly me. Everything I have done in my life has been because Henrik and Bonnie told me it was what I was supposed to do. But I didn't fall in love with Mark because it was my duty. I fell in love with Mark because I love him.

    I hope that makes sense. I honestly do not know if it does.

    When I came to live with the Hendrix couple, Helena, and the Hendrix children, I must confess to the sin of envy. They had the family that I wanted. I know that Oscar and Gemma were adopted, but they were still a family. A happy one. Alison and Donnie love each other so much that it burns brightly even when they argue. They are utterly devoted to their children.

    I saw that and I was upset. At the time, I believed that I would never ever see Mark again.

    Then Doctor Coady contacted me. She told me that I would be allowed to see Mark again. All I had to do was provide her with information about you all. I jumped at the chance. Mark is dying, I know that. It was all the more reason why I could not bear the notion of never seeing him again.

    We are together again, he and I. I know that I betrayed you all and that is a sin even greater than the envy that I felt. I know that I will be condemned to damnation because of it, but I was already condemned. I sinned many many times. I do not see how God can possibly forgive me for what I have done.

    I hope that you will forgive me. I will understand if you do not. I hope Helena's babies are strong and healthy.

<div align="right">Yours in God, Grace</div>

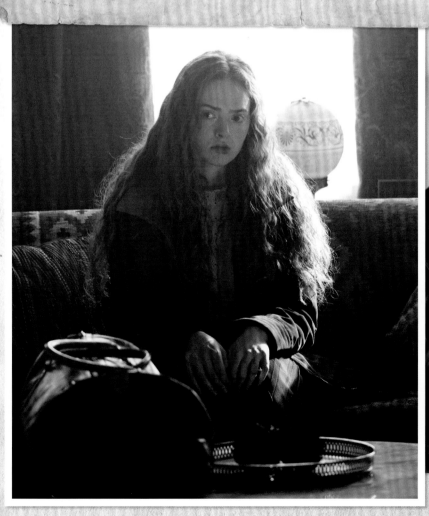

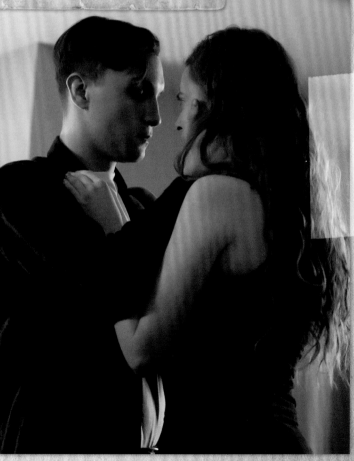

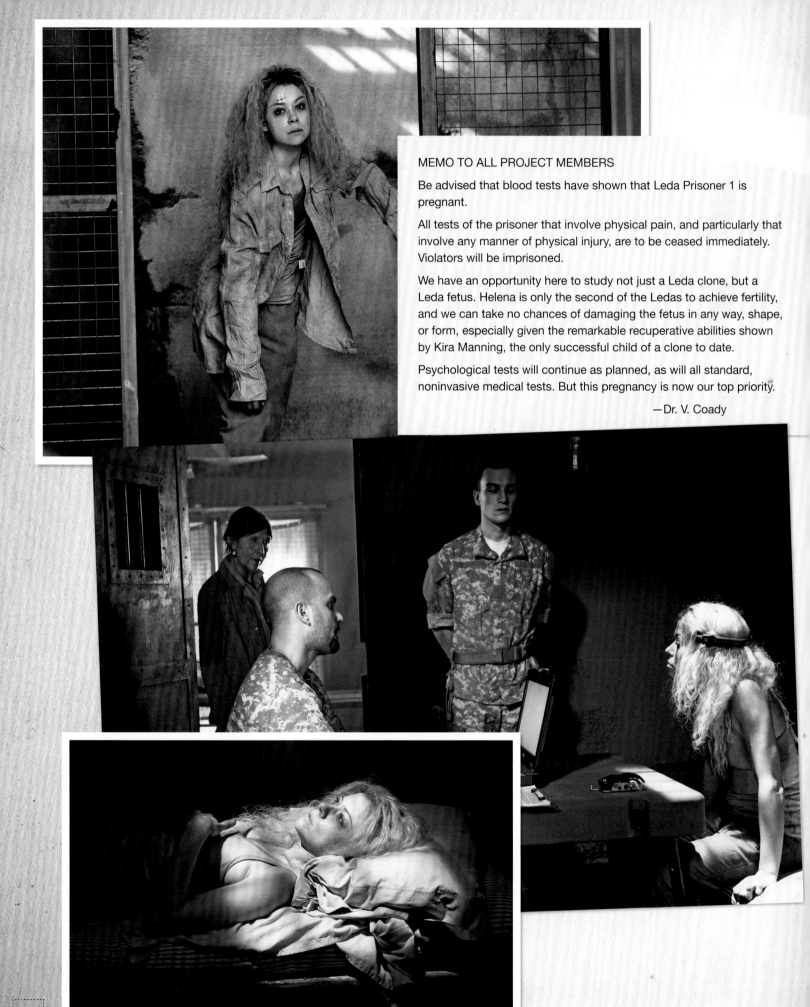

**MEMO TO ALL PROJECT MEMBERS**

Be advised that blood tests have shown that Leda Prisoner 1 is pregnant.

All tests of the prisoner that involve physical pain, and particularly that involve any manner of physical injury, are to be ceased immediately. Violators will be imprisoned.

We have an opportunity here to study not just a Leda clone, but a Leda fetus. Helena is only the second of the Ledas to achieve fertility, and we can take no chances of damaging the fetus in any way, shape, or form, especially given the remarkable recuperative abilities shown by Kira Manning, the only successful child of a clone to date.

Psychological tests will continue as planned, as will all standard, noninvasive medical tests. But this pregnancy is now our top priority.

—Dr. V. Coady

From the notebook of Detective Troy Collier:

POUZIHNO/ALVES TRIPLE MURDER NOTES (continued)
- Tuesday
- Follow-up on campaign stuff found at scene for Alison Hendrix for school trustee
- Linstein & I went to Hendrix house, interviewed owners Alison & Donnie
  A. spoke strangely, English not first language? Check immigration status.
  D. squirrelly, kept answering for A.

- Campaign staff to follow-up with:
  - Sarah Stubbs, campaign mgr
  - Carol Lombart, coordinator
  - Trevor Sawatzky, transport
  - Kathy Melichi, gopher

- A. & D. both off. Made like they didn't know Pouzihnos, but probably did, even if not involved in murder.
- Possible dealers/users/both?
- Pouzihnos had fingers in Bailey Downs.
* FOLLOW UP. Stay on them. Also call E.C. about them.

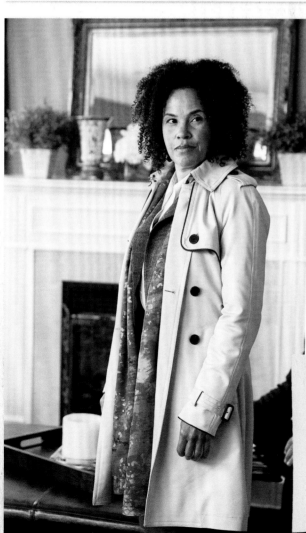

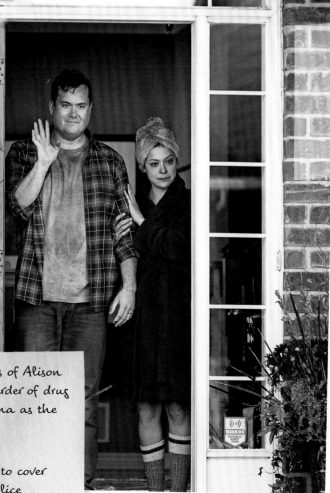

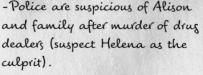

-Police are suspicious of Alison and family after murder of drug dealers (suspect Helena as the culprit).

-Helena successfully impersonated Alison to cover tracks, but further police monitoring is likely.

From the diary of Dr. Delphine Cormier, Dyad Institute

I believe that Sarah would, under these circumstances, say that everything has gone to shit.

For some of this, I must accept the blame. My hands, they are not clean. When I required a urine sample from Cosima, rather than wait for her to arrive at work—late, as has become typical—I instead went to the flat of Shay Davydov, the woman from the Sapphire app. She and Cosima have become very close very quickly. If I did not fear she was a spy from Castor, I might be happy for her, as Davydov seems an open, kind woman, well suited to ma chére.

Still, to go to her directly like that, to confront her in front of her new lover, was childish. Davydov herself very calmly informed me that my being there was "not cool," and damn her, she was correct.

And some of the blame must also go to the adversarial relationship between the self-aware Leda clones and Dyad that was fostered by Rachel's jealousy and by Aldous's megalomania. Or perhaps it was Rachel's megalomania and Aldous's jealousy, it is impossible to know. Regardless, the actions of Rachel and Aldous make it difficult for the Leda clones to trust the person who replaced them, and as a result, they have kept vital information from me. First, they hid the fact that they had the brain of a Castor clone in the lab and were examining it. Then, they did not notice that both that brain and a pregnant Prolethean woman who had taken asylum with Sarah's foster mother had the same misfolded protein—a rather critical piece of data that greatly added to our knowledge of the Castor clones. And one that they would have missed had I not been there to confront them about the Castor brain in the first place.

That should have been enough for Cosima to know that I was on her side, but apparently it is not. Perhaps I should have responded better to her relationship with Davydov, though the results of her background check revealed that her Sapphire profile bears only a passing resemblance to the truth.

However, there is no excuse, none, for her not telling me of the copy of The Island of Dr. Moreau that Ethan Duncan gave to Kira, which has handwritten notes by Ethan that may hold the key to decrypting his data. It is the closest we have come to unlocking the synthetic sequences that could save all the Leda clones' lives and they did not trust me to know of it.

But they did trust Rachel. And that is the greatest betrayal of all, for Rachel is the most untrustworthy individual I have ever known. She had been painting the same symbols from the handwritten notes on the awful paintings she has been scribbing out on as part of her rehabilitation therapy, and because of that, Cosima and her lab assistant, Scott, have taken Rachel into their confidence regarding the book.

Less than a day after they welcome Rachel into their little circle of secrecy, a Castor clone broke into Scott's home and stole the book. Cosima told me there was no copy, but of course there was one. They kidnapped Rachel from Dyad to get her to decode it.

However, the stress of the adventure was too much for Rachel. She has lapsed into a coma, from which Dr. Nealon says she may never wake. There is a Castor mole somewhere in either Dyad or amidst the so-called "clone club," and I cannot shake the feeling that it is Davydov.

Cosima and Scott are no longer working for Dyad. I will continue to supervise the research into a cure, but I am less hopeful now than ever I have been. Dyad has lost two valuable resources in those two, but it has become abundantly clear that they are not truly Dyad's resources, and as their supervisor, I cannot trust them or their work. Science must be open—it was Cosima herself that I learned that from. This constant secrecy and hiding of valuable data will only corrupt the science and everyone will lose.

Right now, though, I feel as though everyone has lost. I have the same pit in my stomach that I had last month when Rachel sent me to Frankfurt, that I will never see ma chere again. Except this time it is my own doing.

# DYAD INSTITUTE

**DOB:** 05-05-1984
**HEIGHT:** 5'4"
**WEIGHT:** 115 lbs.
**OCCUPATION:** Cosmetologist at beauty salon

## Goderitch, Krystal
### PLGI #331c02

Subject was born in Toronto to Yvonne Goderitch, who had gone through a series of bad relationships in an attempt to find someone with whom to have children. After her fifth consecutive broken engagement, in this case due to the man in question abusing her, she gave up, until she inherited money from her uncle, a used-car dealer named Cornelius Goderitch, who left her with enough to pay for IVF, which she did at Jonathan Myers Baby Making, in which Topside was invested at the time.

Yvonne raised the subject in Hamilton, Ont. spending the remainder of her inheritance on a house for the two of them. However, she proved unable to hold down a job because of an undiagnosed and untreated disorder that kept her from focusing.

Subject was an average student, spending her off-school hours working at Siegel's Department Store as a clerk to help pay the bills, which sparked her interest in cosmetology. After graduating high school, she attended the Willow Beauty Academy to obtain her certification.

MartinezH was assigned as her monitor and her boyfriend. Monitor was killed by Project Castor agents who attempted to kidnap subject under the guise of seducing her. New monitor ZukavZ assigned under guise of providing documentation of possible PTSD symptoms following MartinezH's death.

Subject was victim of identity theft by Sarah Manning (#322d01/T) in order to aid Rachel Duncan (#308a01) in leaving the country after her injury. Subject was placed in Dyad's medical facility as Duncan while Duncan was removed to an undisclosed location. Deception was uncovered by Duncan's replacement, CormierD, who released subject.

While she remains nominally naïve, her encounters with Dyad and other PLGIs indicate that she will become self-aware before too long, if she has not already. Monitor reports bear close examination for signs of that self-awareness and for appropriate action to be taken in such an event.

**PERSONNEL FILE**

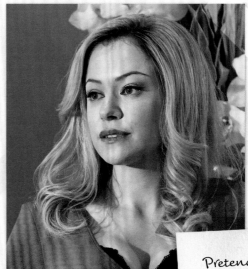

Pretended to be a customer of Krystal. Not as foolish as she seems—I doubt anyone could be as foolish as she seems—and is very observant, if not discreet. Bears watching.

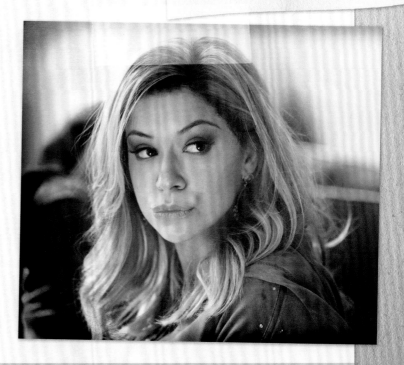

## DYAD INSTITUTE

**MONITOR ASSESSMENT REPORT (AR-21)**
PTN LV 42

| DATE: | TIME: Day before yesterday |
|---|---|

**AGENT:** ZukavZ

**SUBJECT DESIGNATION:** 331c02

**NAME:** Krystal Goderitch

**LOCATION(S):**
Salon

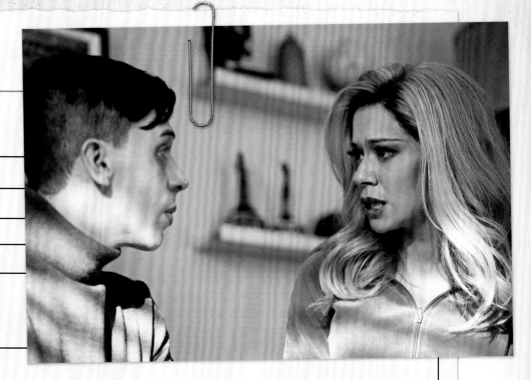

**OBSERVED WITH:**
All the customers, obviously.

**INTERACTIONS/EVENTS OF NOTE:**
So this total creep came in and started asking Krystal all kinds of weird questions about makeup. I mean, a guy can come in and do that, and they do all the time, but this guy just had a vibe, you know? Like, he was asking how to paint a corpse to make it look like it was a real live person. So gross! Krystal handled it like a pro, though. I mean, if it was me, I totally would have told him to go bother a mortician

**PUPIL GAUGE (mm)**

1 2 3 4 5 6 7 8     **B** = BRISK
                    **S** = SLUGGISH

and stay out of my personal space, but she actually answered. Then, of course, she had to tell him all about the stupid kidnapping, because God forbid anyone not be told Krystal's entire life story.

**HEALTH/APPEARANCE CHANGES:**
Fabulous, as always!

**MONITOR-SUBJECT INTERACTION:**
We went to lunch, and then had drinks after work at McSorley's, which is a *dive*, but she likes it for some reason. We only got hit on a few times, and we got free mojitos out of it for about an hour, so that was cool.

**EMOTIONAL STATE(S) OF NOTE:**

Normal stress stuff. She's still Krystal like always. I don't know why you people keep making me fill these stupid forms out, it's just the same thing every day.

**LIST ANY ATTITUDES, ACTIONS, OR BEHAVIORS THAT ARE ATYPICAL FOR THE SUBJECT:**
Totally normal. God.

CONTACT SUPERVISOR IMMEDIATELY IF YOU OBSERVE OR SUSPECT ANY OF THE FOLLOWING: SIGNS OF ILLNESS, SUICIDAL OR SELF-INJURIOUS IDEATION, CRIMINAL ACTIVITY, PRIVATE MEETINGS OUTSIDE OF DOCUMENTED FAMILY/ACQUAINTANCES, AND ANY POSSIBILITY THAT THE SUBJECT HAS BECOME AWARE OF BEING MONITORED.

Neolution

(Swedish company, part of Brightborn?)

(that cute guy from a yard in Scotland who said he was a cop said that they're behind it)

(cute guy I don't trust anymore, even though I maced him; but he's probably right)

(VAN LIER! OMG, he's the guy who recognized me in the garage when that doctor got shot and besides, Van Lier is TOTALLY a Swedish name!)

Involves clones, says the guy from Scotland. As If. Clones are supposed to look just like you and that Goth chick doesn't look ANYTHING like me! I mean, c'mon, she's an A-cup MAYBE. God. Anyhow, that's just science fiction crap. This isn't about clones, it's about cosmetics, and I WILL get to the bottom of it. No matter what anybody says or does.

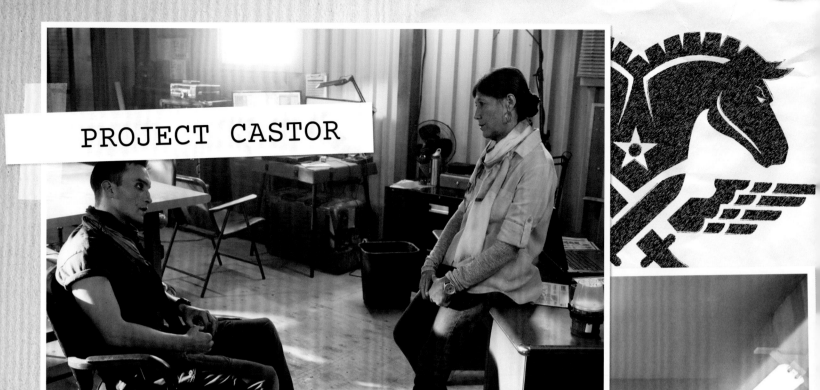

# PROJECT CASTOR

MEMO TO VIRGINIA COADY

Reporting that tests have proven effective in using syllogistic queries to determine cognitive impairment of the Castors.

Per my memo of 7/4, employing syllogisms and gauging the Castors' reaction to them is a useful method by which to determine whether their cognitive functions have become impaired by their syndrome to the point where they can no longer function in the field.

Method has been tested and proven to be a useful measuring tool by which to determine such cognitive impairments. However, the gauging of the autonomic ocular response is currently insufficient for accurate diagnosis. Simple observation of pupil dilation lacks accuracy and carries too many variables. A proper tool needs to be constructed that will more accurately measure pupil response. In addition, such a tool would be invaluable in the field, where any agent can administer the test in case a trained physician like myself is not present.

I look forward to your response.

—Dr. Silva

-Project Castor clones—
unlike Leda, raised in
military environment.

-Dangerous—passing on
sterility to women they
sleep with.

-Unstable—also dying.

Known Project Castor Genetic Identicals
Compiled by Delphine Cormier

## RUDY

It is through Rudy that we learned the most about Castor, as he was Dyad's prisoner when I took over the day-to-day running of the company from Rachel. He and Seth engaged in some rather appalling sexual assaults of women, with the added bonus of infecting them and making them sterile. One of his victims was a Leda clone, Krystal. He was killed by Helena.

## SETH

The one who freed Rudy from our custody, killing several operatives in the process. He was later killed by Rudy as a mercy killing, since he was being debilitated by the neurological disease that affects all the Castors. However, Cosima was able to study his corpse, which proved valuable.

## MARK

Mark went undercover with the Proletheans for reasons we have yet to determine. While there, he fell in love with a fellow Prolethean named Gracie, and they escaped the destruction of the Prolethean compound by Helena. Mark also survived the purge of Castor undertaken by Sarah, Helena, and Paul.

## STYLES

This is one of the Castors who ran security at the base in Mexico in which both Sarah and Helena were imprisoned.

## PARSONS

Helena told Sarah of this Castor clone, who suffered from the same neurological disorder as the others. They literally cut his head open in order to study his brain up close while it was functioning. According to Sarah, he begged Helena to kill him. Helena, unsurprisingly, obliged. Under the circumstances, I cannot say that I blame her. Even Rachel would, I think, hesitate at vivisection, but the masters of Project Castor obviously do not have even her scruples.

## IRA

The only Castor clone we know of that was raised outside the military structure of Coady's "mothering," instead raised by foster parents and later met and moved in with Susan Duncan. Because he was not part of Coady's project, he survived the destruction of Project Castor.

# Metropolitan Police
## WITNESS STATEMENT
### Incident Report #9387623
1/15/2014

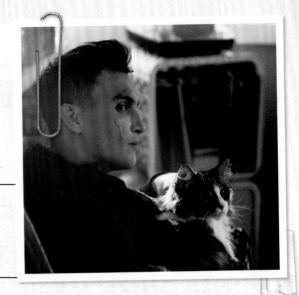

COMPLAINANT: Patricia Natale

OFFICER TAKING COMPLAINT: Det. Arthur Bell

DATE: 15 January 2014

I met a man in a bar named Rudy. He said he was Special Forces and I have a thing for men who are ordered to carry guns. I guess he figured that out. We talked, he bought me a few drinks, and I liked him, so we went back to his place. He poured me another drink, took my coat, very much a gentleman, at least until we got into bed. Even then, he was a very sweet lover, but then I felt four hands on me, which freaked me completely out. His twin brother Seth got into the bed with us. Seth looks exactly like Rudy, but with a mustache and shorter hair. He also had the same tattoo as Rudy on his left arm, a two-headed horse. Still, I didn't like him, and I didn't like being ambushed with a threesome like that. I've done threesomes and they don't do it for me. I like the one-on-one attention. And I came up to the room to be with Rudy. I didn't even know the other guy and so what that he looks like Rudy? After that it got even weirder. I thought they were going to kill me and even as I was frantically putting my clothes back on they were writing things down in a notebook about me and they yanked out some of my hair, putting it in a baggie. Only after that did they let me go.

## COMMENTS

*Det. Bell, followup report 20 January.* Natale is suffering from an illness that has manifested as bloodshot eyes and cervical bleeding, with doctors saying that she is now no longer capable of having children. Her full diagnosis remains unknown, and she is under treatment, though the sterilization is permanent. She also believes—as do I—that it is something that may have been sexually transmitted from her assailant.

## METROPOLITAN POLICE
### IDENTIFICATION DIVISION
SS313-8965TR-A

| SUSPECT NAME: ID / DRIVERS LICENSE | | DEPT CODE |
|---|---|---|
| UNKNOWN SUSPECTS | | 02 -B/ASLT |

| LOCATION OF OCCURRENCE | DATE AND TIME OF OCCURRENCE | WEAPON, FORCE OR MEA |
|---|---|---|
| EMERALD GARDEN HOTEL | AS PER INCIDENT REPORT B9T5, 14.9D1 | UNKNOWN |

| REPORT ON INCIDENT OCCURRENCE | VEHICLE USED BY SUSPECT(S) - (Yr-make-body-col-lic. no / |
|---|---|
| SEXUAL ASSAULT / ASSAULT CAUSING BODILY HARM | N/A |

### SUSPECT WANTED
TRADEMARKS OF SUSPECT(S) (Actions or conversation)

**SUSPECT A -**

** IDENTICAL TWIN PERPS **
(REFER TO B/ASLT 37012)

- SCAR ON R. CHEEK

CURRENT AGE RANGE:
30-42 YEARS OLD

HEIGHT: 5 FOOT 10;
EYES: BROWN;
HAIR: BROWN

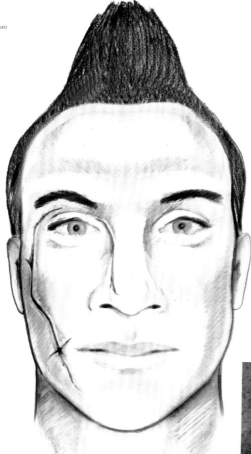

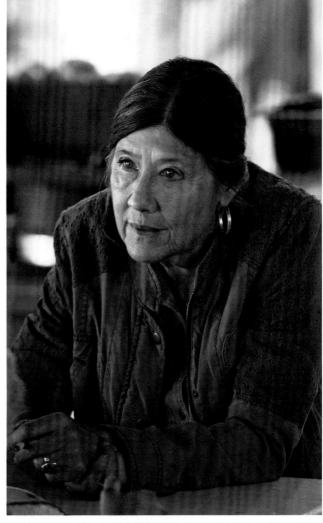

MEMO TO THE DIRECTOR

From: David Benchman
Re: Project Castor

As I feared, Major Dierden's rather black-and-white view of the world has proven disastrous for the project. Upon his return from his long-term undercover mission, he has learned of the sterilizations. Predictably, he did not understand the long-term benefits of the program. I endeavored to solve the problem in as expeditious a manner as possible by assigning Rudy and Dr. Coady to secure the science and shut Dierden down, but they failed. Dierden is dead, but the entire laboratory was destroyed by a grenade. Coady is badly injured, and most of the personnel from the base are dead (some, sadly, by Rudy's hand, as he was not discriminating in his carrying out of my orders). Both Leda clones who were imprisoned on the base are missing, as is one of the Castor clones, Mark. Most of the Castor clones are also now deceased or running out of time.

The classified nature of the project is such that the backups were kept in a bunker underground proximate to the base. Dierden sabotaged those backups before his death and his grenade took care of everything else. We're at a dead end and have to start from square one. Years of work has been destroyed irrevocably.

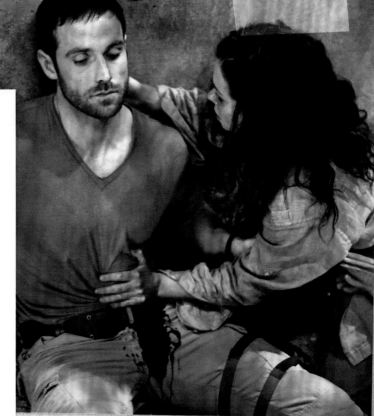

*From the diary of Dr. Delphine Cormier, Dyad Institute*

The longer I got to know Aldous, the more I believed him to be un monstre. I thought his treatment of the Leda clones as scientific experiments first and people second to be appalling. I felt it even more once my job to get close to Cosima became my passion. One at which I succeeded far too well.

I know that many of the choices Aldous made—and that Rachel made, and that our supervisors at Topside have made—were ones that could charitably be called unethical, and justifiably be called illegal. There were times when I believed that it was worth the moral compromise because the science was so important, which is why I provided Aldous with Cosima's blood even after she specifically asked me not to.

But there were many more instances where I believed we had crossed a line. It is why I kept the fact that Sarah had a daughter from Aldous for as long as I could. Now that I am in Aldous's position, I find myself understanding him more. The responsibility for the Leda project is overwhelming, far more comprehensive and difficult than I could ever have imagined as Aldous's protégé and employee. I was unable to see the larger picture.

From my new position, I can see the larger picture. Worse, I now know how easy it is to slide across the moral line that I thought Aldous was so craven, so weak as to ignore. But the work we do is so critical and so important that . . .

Non, that is not correct. It is the sense of self-importance that led to Aldous's downfall, as well as to the fire in which the Duncans' work was destroyed. It is why we cross the line so much, for we have deluded ourselves into believing that what we are doing is of such great importance that the rules of ethics, of law, of human decency do not apply to us. We do this to justify to ourselves that we are working for the greater good, because to think otherwise, we truly would become monsters.

The truth is this: We do not act as we do because the work is so important. Rather, we act as we do because the work is so entrenched. The Leda clones are people with lives that we are monitoring—and many of them are dying. Some of them have died, whether by their own hand like Beth or from within by this disorder that has already claimed Jennifer Fitzsimmons and may claim my beloved Cosima before too long.

Perhaps to lie that our work is so important is the only manner in which we may survive. But it is a lie. The only aspect of the project that can truly be considered important is the search for a cure.

When I was in university, I read Mary Shelley's novel Frankenstein. Like most, I was raised on the cinematic interpretation from 1931 and therefore was surprised to find that the creature who was created by Frankenstein was quite eloquent, verbose, and intelligent. Not at all the mindless monster embodied by Boris Karloff.

But what truly struck me about the novel, and why I mention it now, is the theme of abandonment. Victor Frankenstein created something remarkable, but as soon as he saw how ugly it was, he rejected it, ignored it, and refused to take responsibility for it. And so it became a savage, murderous creature.

Both Project Leda and Project Castor came from a similar place. Like Victor Frankenstein, the Duncans created life from lifelessness, but through Dyad, the creation of science has not been abandoned, but continually monitored and checked. Yet we still have Victor's arrogance. We still have Victor's impatience and unwillingness to accept consequences. And I have become un monstre myself.

There is a mole within Leda. The people behind Project Castor knew of Ethan Duncan's copy of <u>The Island of Dr. Moreau</u> and were able to intimidate Scott in order to obtain it. So few people knew of the book's existence, much less that it was held by Scott and Cosima, that there simply had to be someone providing intelligence to Castor.

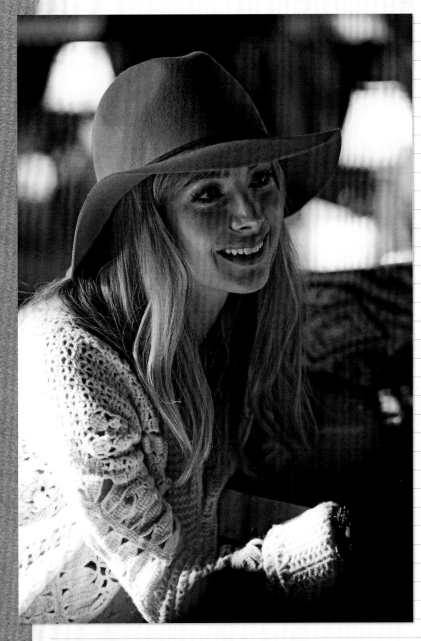

There was only one new person in Cosima's life, and as far as I was concerned, there could be no other person. They met via a dating site, and I had already proven that her profile was false, with a lie regarding her job and leaving out her military career. She even saw the book in Cosima's laboratory.

Dyad is ruthless, but it was not until I went to Shay Davydov's apartment that I realized that I was just as ruthless. I threatened her. I tormented her. I told her to remove her shoes and then told the story of a woman I went to university with who failed at a suicide attempt because she did not use the razor between her toes.

I terrorized her. And I did so because I knew, simply knew, that she had betrayed Cosima. That was the ultimate pain. My position and my promise to love all the Leda clones as I loved Cosima forced me to distance myself from my beloved. And now the next person to whom she had given her heart had stabbed her in it. I would not tolerate that. I would not allow such a person to live.

I was blinded by arrogance, I was blinded by love, and I was blinded by the surety of my position. After all, I was the head of the project. Topside entrusted me with Project Leda, and I needed to protect the clones at all cost. I needed to protect Cosima at all costs.

Instead, I betrayed everything, I tormented an innocent woman. Worse, I tormented an innocent woman who truly appreciated Cosima, who saw the vibrant, amazing woman that I fell in love with. I accused her of a horrible crimes, and committed many horrible crimes of my own. For nothing. Grace—the Prolethean woman who ran away from the cult thanks to Helena's efforts—was the mole. She was in love with a Castor clone who had gone undercover amongst the Proletheans and Project Castor promised to reunite her with him in exchange for information about Leda.

What Grace did, she did for love, even though it hurt many of us. What I did, I did for love, even though it destroyed my soul and nearly got an innocent woman very badly hurt. Le monstre, c'est moi.

From the diary of Dr. Delphine Cormier, Toronto, Ontario

This will likely be my last entry. I do not expect to live out the night.

We have been betrayed. All of us. The woman lying in a coma in our infirmary is not Rachel Duncan, but rather another Leda clone named Krystal Goderitch, a cosmetologist. Dr. Nealon conspired with Rachel to spirit her away to an undisclosed location and leave Krystal in her place.

But Nealon's revelations were far more thorough than that. Neolution is not, as I had previously assumed, the public face of Topside, the pop-science front for Dyad's research. In fact, they are the puppet masters, behind both Leda and Castor.

Nealon attempted to kill me, but he didn't reckon on my recent desire to keep a small firearm on my person at all times. I detest guns, but it became increasingly obvious that my position required me to carry one. It saved my life tonight, though Nealon's last words were an assurance that I would not survive for long.

And so I must say my goodbyes. I have already given a woefully inadequate apology to Shay, as well as my blessing for her and Cosima to continue their relationship. I hope Shay can look past Cosima's horrible taste in previous lovers and be there for ma chère. I somehow doubt it, but I felt the need to at least attempt to atone for the horrible manner in which I treated her.

I write this final diary entry while sitting in my car outside Bubbles. Cosima is in there, along with her sisters Sarah, Alison, and Helena, as well as Detective Bell, Alison's husband, Donnie, Sarah's brother, Felix and her mother Siobhan. Alison has been running for some manner of local office—I honestly can no longer recall which—and the results are to be announced tonight. I know that I am welcome there, despite everything, but the destruction that will be rained down upon me cannot affect them.

I have texted Cosima to say goodbye. I hope I am strong enough to stay out of Bubbles. Seeing her will be hard enough—to see the others would, I believe, break me. Bonne soirée, mes chères. Bonne chance. I fear that Neolution will stop at nothing to control you. I just hope that you will be able to stay strong.

I suspect you will, though. You, Alison, and Sarah are three of the strongest people I have ever encountered, and the number of others who are there in that store with you and on your side—Felix, the detective, Siobhan, Donnie—shows that they are stronger than ever.

I would not bet against them. I wish I could help them. Je t'aime, Cosima. I hope you live longer than I shall.

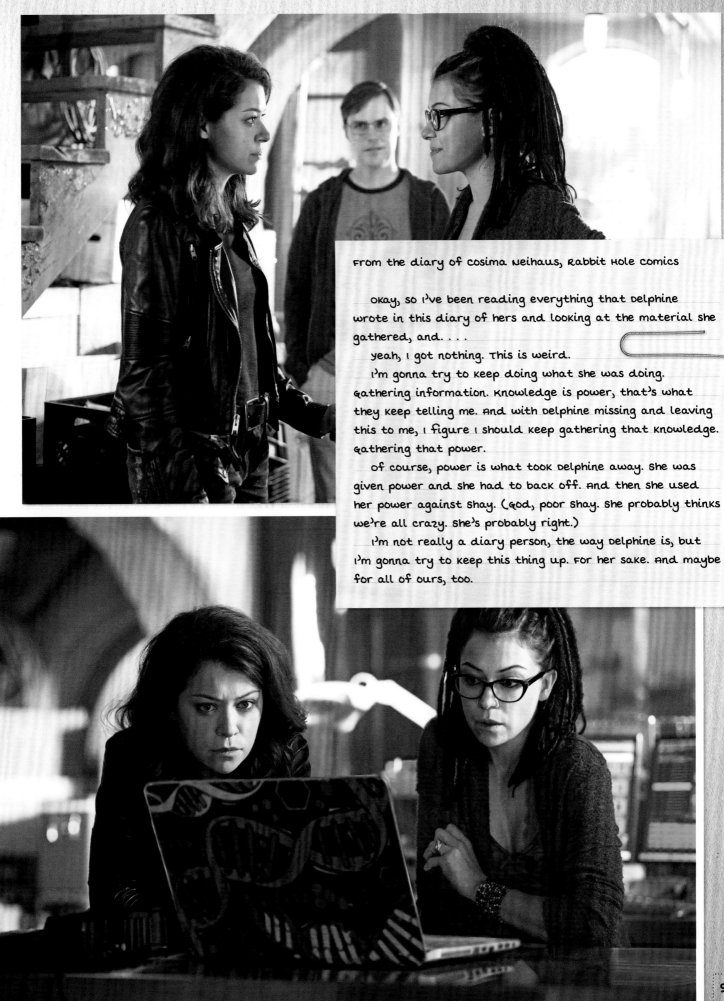

From the diary of Cosima Niehaus, Rabbit Hole Comics

Okay, so I've been reading everything that Delphine wrote in this diary of hers and looking at the material she gathered, and. . . .

Yeah, I got nothing. This is weird.

I'm gonna try to keep doing what she was doing. Gathering information. Knowledge is power, that's what they keep telling me. And with Delphine missing and leaving this to me, I figure I should keep gathering that knowledge. Gathering that power.

Of course, power is what took Delphine away. She was given power and she had to back off. And then she used her power against Shay. (God, poor Shay. She probably thinks we're all crazy. She's probably right.)

I'm not really a diary person, the way Delphine is, but I'm gonna try to keep this thing up. For her sake. And maybe for all of ours, too.

# From the diary of Dr. Susan Duncan

Ethan has done it to me again.

You would think that after so many years of being partners both in the laboratory and in the bedroom that he would be unable to surprise me. And yet, he has managed it. From beyond the grave this time.

Well, to be fair, it was beyond the "grave" last time. I had thought for sure that he had perished in the fire that Aldous set, but he had managed to escape.

For so long, I begged him to tell me who the originals were. I knew only that he had scoured the prisons of the UK looking for a man and a woman who would be the ideal donors for both Projects Castor and Leda.

But he did insist on going it alone. "Our work is too important," he would say in that reedy tone of his. "It is ours, and we must not let anyone take it from us. And the only way to guarantee that is to make ourselves indispensable."

Later, he argued that doctor-patient confidentiality meant that the identity of the original donors needed to be kept between him and his patients. It led to another argument—in the end, that was all we ever did—as I tried to convince him that we had already suspended most other medical ethics, why cling to that particular one?

He never did have an answer.

Now, though, the originals have been found, except the plural is unwarranted. Bless him, Ethan found a chimera, someone who has both male and female DNA. She absorbed her twin in the womb and therefore has two cell lines. Ethan extracted her male cell lines to produce the Castor clones, which were then given over to the U.S. military, while her female cell lines were developed by us.

At least at first. It became clear that Ethan was unhappy with the direction we were going in. It also later became clear that he had a contingency beyond simply saving himself. Two of the Leda embryos had been implanted in a Jamaican woman and Ethan contrived to have them be raised away from the program, away from Neolution.

It was a foolish notion, one that has come back to haunt us all. One twin, Helena, was raised by Prolethean lunatics and turned into a killer. The other, Sarah, has been a thorn in the side of our program for most of the last several months, and it needs to stop.

On top of everything else, Sarah has gotten her grubby little hands on the chimera. Her name is Kendall Malone, and she was relatively recently released from prison. Her murder sentence was reduced because she participated in Ethan's experiment and now she's being held by Sarah and her seemingly endless supply of colorful helpers, both fellow Leda clones and others.

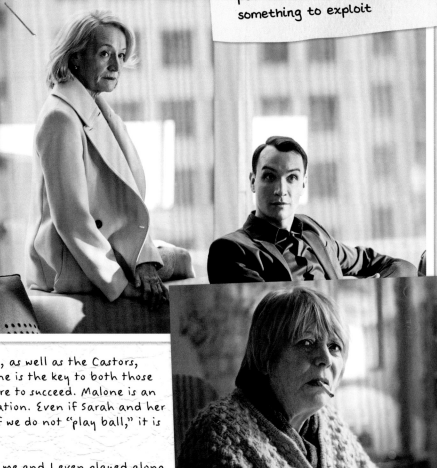

-KENDALL MALONE
- ORIGINAL LEDA

I grow weary of this foolishness. We need to find a cure for the disease that is ravaging the Leda women, as well as the Castors, and we need to be able to make more clones, and Malone is the key to both those things. But we must jump through Sarah's hoops if we are to succeed. Malone is an old woman now, and she has spent decades in incarceration. Even if Sarah and her gang don't make good on their threats to kill Malone if we do not "play ball," it is completely possible that she will simply drop dead.

And then where will we be?

I wish you had trusted me, Ethan. You said you loved me and I even played along and said that I loved you back. You should have accepted that I would have done what was best for the project. Now I have doubts that the project will survive the year.

But no, I am being a fool. We have Charlotte, and Rachel will, I'm sure, raise her properly. Even if we do not get the original, we will prevail. As we were meant to.

Diagnosis
*high blood pressure*

Allergies
*none*

PERSONNEL RECORD
EMPLOYEE: Evie Cho
POSITION: CEO, Brightborn

**PERSONNEL NOTES (PRO):**
- Cho is an ambitious, outside-the-box thinker whose ability to see past preconceptions and the way things have always been done enables her to find new solutions to problems that might not have occurred to others.
- She is a brilliant theoretician, though her science tends to be more focused on big-picture ideas and less on the details of implementation. However, she is aware of this, and knows to surround herself with people who can handle that implementation.

**PERSONNEL NOTES (CON):**
- There are times when things aren't in the box because they do not belong there. Some of Cho's radical ideas aren't things that nobody else thought of because she's smarter than them; they thought of them and rejected them as unworkable. Her drive to succeed means that she will often barrel ahead regardless of consequences.
- Her interpersonal skills also need work, as she has a difficult time with her coworkers and employees. Her psychological profile indicates that this is in part due to her many years with a chronic illness, where she resented the attention she received, even when it was solicitous rather than pitying.
- Still, her difficulties in working with people on what is a very large and far-reaching project might prove problematic going forward. The same holds for her tendency to move forward precipitously.

## CHO TO HEAD NEW PRENATAL OUTREACH PROGRAM

Last week, Dr. Evie Cho, PhD, MD, stepped up to the directorship of Dyad's genetic application interest, Brightborn, with clinics already open in Canada and the United States. Brightborn offers fertility testing and preimplantation genetic diagnosis for aneuploidy, gender selection, and genetic options to those seeking leading-edge advantages for their progeny. Dr. Cho, one of Dyad's top geneticists, had been involved in the project from the beginning, heading R&D. With the company's recent reorganization, she agreed to take a more hands-on position, personally leading the flagship clinic and overseeing the entire program. Cho has been with Dyad for six years, invited to join after publishing her controversial and brilliant dissertation on genetics and intercurrent disease in pregnancy, "Changing the Outcome: Systemic Lupus Erythematosus and the Effects of Exon Removal on Meiosis." Her dual specialties in cellular engineering and obstetrics make her an excellent fit for Brightborn. Congratulations, Ms. Cho!

INITIALS
*B.Si*

**ROUTINE MEDICATION ADMINISTRATION RECORD**

CHART/MEDICAL RECORD
*FC832*

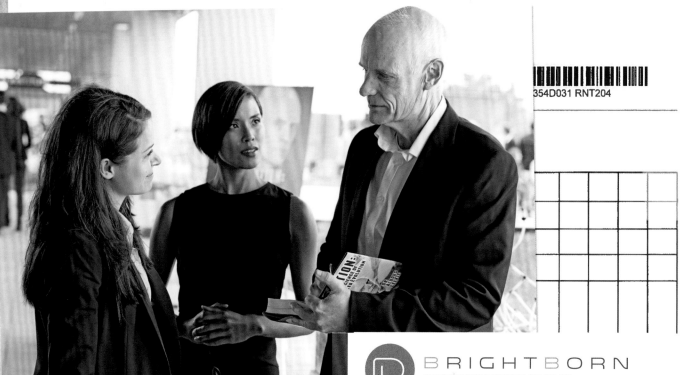

354D031 RNT204

**B R I G H T B O R N**
3045 QUEEN STREET, TORONTO, ON M1E 1D9
T: 416-555-0194 F: 416 555-0384

MEMORANDUM FROM THE DESK OF EVIE CHO

Ferdinand Chevalier:

   While it cost me some pain and a scar that I'm told will likely be permanent if left alone—not that I would ever leave such a blemish alone for long—I believe we have solved our Beth Childs problem. She did not remove Susan Duncan, as I had hoped, but I have made it clear that the lives of her so-called sisters will be forfeited unless she removes herself instead.

   We should have no more difficulty from that particular corner. Let Leekie deal with the other Ledas. They won't be long for this world in any case, but the irritant that is Detective Childs should at last take care of itself.

   And we will simply have to find another way to minimize Susan's influence.

---

| | To... | cho@brightborn.org |
|---|---|---|
| **Send** | From... | security@brightborn.org |
| | Subject: | Police Asset |

I believe I have identified an asset in the Toronto Police Department that we can use.

Detective Martin Duko has a bank account in the Cayman Islands. As far as we can determine, he has placed a good deal of money in it, far more than can be accounted for by his salary as a plainclothes cop.

Further investigation has revealed that he is providing for his niece, Meline. The girl is eight years old and living in a halfway house. Her parents, Duko's sister and brother-in-law, are both in prison. Duko himself put them there after discovering that they were dealing drugs. Duko was deemed ineligible by Child Protective Services to take her in, as he is single and has a dangerous profession.

However, a perusal of his e-mails has revealed that the money in the Cayman account is earmarked for Meline. Furthermore, he has been involved in several cases where there have been discrepancies in evidence gathering. In some cases, the monetary seizures don't match up with the amounts in evidence control; in other cases, there are differing accounts in different officers' reports of how much money there has been at certain scenes.

Also, several of Duko's cases have been closed but did not result in conviction because witnesses recanted or disappeared. The frequency of these incidents is greatly out of proportion to the norm.

Basically, we have us here a corrupt cop, one whom we can easily leverage. He's proven himself willing to bend the law to help out Meline, and if we apply pressure to the girl's continued health and well-being, we should have no trouble turning him into an asset for Brightborn.

Once I receive your approval, I will begin the process of approaching him.

Ramon Gallarraga
Chief of Security, Brightborn
security@brightborn.org

FROM THE OFFICE OF DR. HENRY A. BOSCH

To: Evie Cho

I just had a couple come in, a recently married couple named Julian Gray and Douglas Andrews. Pretty straightforward pair—some communications issues, and both of them have very definite ideas about how to proceed, assuming falsely that the other one will just go along with it—but nothing outrageous. They're both healthy and should be fine going the normal route.

But then they asked for the Brightborn treatments. As I warned you in my memo late last year, word of mouth was bound to spread. Expectant parents are never happier than when they're talking about how their pregnancy is going and that will always lead to saying where they're getting their treatments or what they're doing or how they got pregnant.

I gave Gray and Andrews the documentation on Brightborn, as I think they're strong candidates for IVF and therefore also for the advanced treatments—and goodness knows the more the merrier—but security remains a problem.

Having said that, I think we can bring them in. They are a bit contentious, but they seem more simpatico than I ever was with my ex-wife, so who knows? They may think having a child will make them closer.

Both men provided sperm samples, and both want to be the donor. Tests will likely settle that, though if it doesn't my money is on Gray being the donor. Andrews wants very desperately to be the alpha, but Gray has him wrapped around his little finger.

Anyhow, that's the story. We've got gossips among the clientele, and that's never going to change.

-Donnie, Felix, and I infiltrated Brightborn to learn more about Neolution plans to try to re-create Ethan's work.

-I discovered horribly deformed babies, showing the tragic side of this disturbing organization

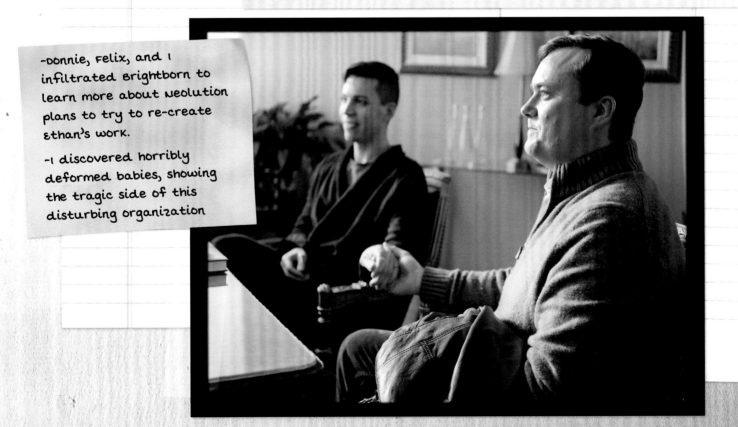

# BRIGHTBORN

3045 QUEEN STREET, TORONTO, ON M1E 1D9
T: 416-555-0194 F: 416 555-0384

Catalogue No.

**5068-37**

BE SURE RED NUMBER

## BRIGHTBORN

### MICRO-EXFOLIATING DERMA GEL

Deep Mineral
Calming Cleanser

Soap-Free PH5.5
FORMULATED
FOR SENSITIVE
SKIN

250 mL - 6.76 FL.OZ.

## BRIGHTBORN

### TARGETED SKIN TONE CORRECTOR

Nutritive Deep
Restorative Solution

FOR AGED
AND TIRED
SKIN

200 mL - 6.76 FL.OZ.

PRE AND POSTNATAL CARE

INCREASED PREGNANCY RATES

PREIMPLANTATION GENETIC SCREENING

EXTRAORDINARY INNOVATION

BRIGHTBORN

5051853793

Reduces the appearance of imperfections. Enriches tired skin while hydrolipidic emulsion minimizes the appearance of enlarged pores.
Tested on imperfection-prone skin
Use: Apply morning and/or evening on the entire face.

SAMPLE - NOT FOR RESALE

## BRIGHTBORN

### HYDROLIPIDIC EMULSION

Lipid Enriched
Restorative Cream

Soap-Free PH5.5
FOR ALL SKIN TYPES

30 mL -1 FL.OZ.

PREIMPLANTATION GENETIC SCREENING

A VISION OF TOMORROW

INITIA

**PRN & IV MEDICATION ADMINISTRATION RECORD**

PD3391 1094

CHART/MEDICAL RECORDS

From the diary of Cosima Niehaus, Rabbit Hole Comics

Delphine's dead.

I didn't believe it until Evie told me.

I still don't want to believe it.

And Kendall is dead too. She was dying anyhow, but Evie doesn't want us to find a cure. Doesn't want us to survive. Doesn't want anything to do with the cloning projects. So she had her pet detective kill Kendall.

But she let me live so I could tell everyone else. After she told me Delphine was dead.

I hadn't touched this diary in so long, but I had to after Evie told me that. I had to read her words, remember who she was, remember that she used to be alive.

Remember the night we actually said we loved each other.

Remember when she said goodbye to me outside Bubbles.

I was afraid I'd never see her again then. But I really didn't want to be right.

Everything's going to shit. Scott and I have been stuck working in the basement of a comic book store. But we're trying. There's this thing, they call it a bot, that Neolution is putting in people's cheeks to alter their genetic codes. They put one in Sarah and turns out Leekie had one. Evie Cho has one, too, they're using it to fix her lupus. It's an amazing piece of biotech, so naturally they're keeping it to themselves. Seriously, half the problems we've been having are because everyone's keeping secrets. Beth wouldn't tell us what the hell was really going on, and then she jumped in front of a train without telling us anything, including about another sister we didn't even know about. Leekie and Delphine were keeping all the secrets, and then Rachel and Nealon and Marion and . . .

I can't even keep track of all the lies and coverups. I just want to live, y'know?

So yeah, Leekie had a bot. And it turns out that Alison and Donnie buried Leekie's body in their garage.

Every time I think that Alison is just a soccer mom and Donnie's just a dork, they go and do something like this to remind me that they're both badasses. Donnie accidentally shot Leekie and they just buried him in their garage. And I've *been* in their garage, you can't tell where they did it.

Seriously, I think if it wasn't for Alison keeping her shit together, we'd all be dead now.

And how far gone are we that the person we all depend on to keep ourselves together is the woman who was in rehab not that long ago?

Anyhow, I got to work on Leekie's decomposing head, which was a big ol' piece of schadenfreude pie. It looks like the bot can rewrite your genetic code. Leekie was trying to get it to head off his family history of Alzheimer's, and like I said, Evie cured her lupus with it.

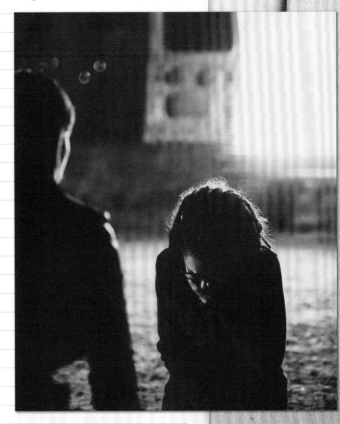

The thing's amazing, that's for sure. Scott and I could study it for years—and with the crappy equipment we've got in the comic store basement, crappy's pretty much what we're stuck with, so it really would take years—and not scratch the surface.

I just wish I knew why they put one in Sarah.

Not that any of it matters. I'm gonna die, and Delphine's dead, and Sarah's off getting drunk, and I have no idea what's going to happen next.

## BEYOND REPRODUCTIVE SUCCESS

BrightBorn Fertility and Reproductive Health Center offers the complete scope of reproductive health services for women and their partners, providing in vitro fertilization (IVF), medical therapies for reproductive disorders and surgical correction of anatomic anomalies. And while the center focuses on successful reproduction, it is distinct in its dedication to the long-term health of patients.

BrightBorn is a global fertility company dedicated to providing improved fertility treatment options for

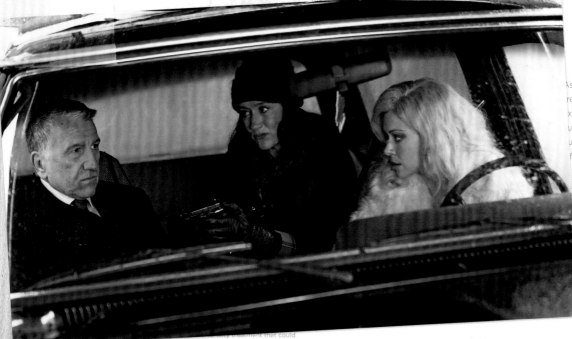

As a leader of innovation, BrightBorn is a revolutionary treatment and reproductive medicine practice focusing exclusively on women's health. BrightBorn's team of cutting-edge researchers and medical professionals provide our patients with personalized, high-quality and complete fertility care in a compassionate and supportive setting.

BRIGHTBORN

...fertility treatment that could enable a woman to increase her egg reserve. This treatment is designed to transfer a patient's egg cells, immature egg cells found inside the protective ovarian lining, to the patient's ovaries where they may mature into fertilizable eggs during the IVF process.

**OUR TEAM** COMMITTED TO THE FERTILITY COMMUNITY

BrightBorn offers the complete scope of reproductive health services for women and their partners, providing in vitro fertilization (IVF), medical therapies for reproductive disorders and surgical correction of anatomic anomalies. And while the center focuses on successful reproduction, it is distinct in its dedication to the long-term health of patients.

**RESHAPING OUR FUTURE** WITH EXTRAORDINARY INNOVATION

BRIGHTBORN

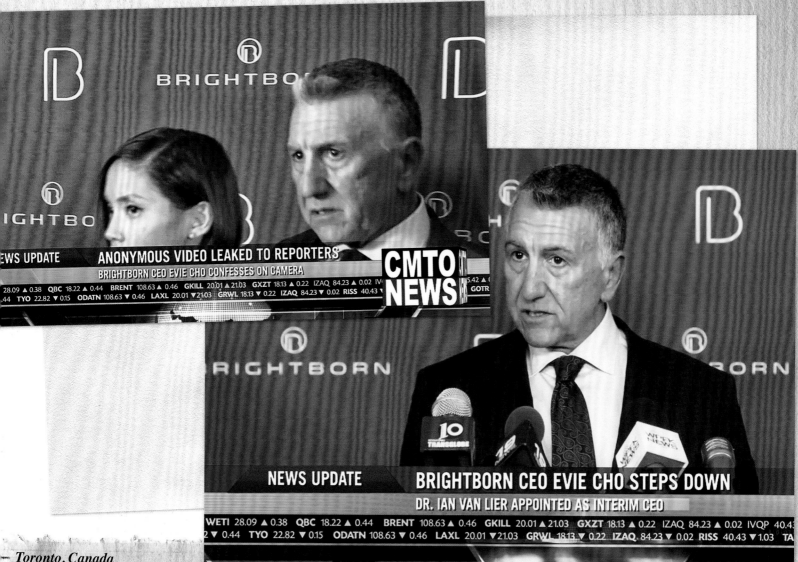

# BRIGHTBORN ROCKED BY BABY SCANDAL

By: Darcie Brooks

Evie Cho, the CEO of the Brightborn fertility clinics, has stepped down amidst a scandal involving human experiments and the murder of infant children.

During her press conference announcing a new Brightborn clinic in Tisdale that would be doing experimental work on genetic modifications with the goal of eradicating disease, two video files were anonymously uploaded to the members of the press: Cho admitting to euthanizing infants who were born deformed as part of Brightborn's genetic experiments, and video footage of one such euthanasia procedure.

Cho was immediately removed as the head of Brightborn and replaced by interim director Dr. Ian Van Lier. A spokesman for the crown prosecutor said that an investigation is underway with regard to criminal charges that may be brought against Cho, which could include murder, conspiracy to commit murder, and human experimentation.

Brightborn's Tisdale clinic's opening has been postponed indefinitely. A source within Brightborn who has asked to remain anonymous has stated that all work in Brightborn's genetics department has been suspended, though their fertility work is proceeding apace.

Cho could not be reached for comment.

# TRUCK ACCIDENT CLAIMS LIVES OF FAMILY, TRUCK DRIVER

**By: Levi Jansen**

A Fiat carrying a woman and her twin daughters crashed into a grocery store delivery truck on Amstelveenseweg near Olympisch Stadion in Amsterdam-Zuid late last night. Witnesses told the police that the Fiat seemed to be out of control and drove straight for the truck while going the wrong way on the thoroughfare.

The driver, Joost van Leider, was brought to MC Slotervaart, where he was declared dead an hour later. The woman and children in the Fiat— whom police have refused to identify pending notification of family—were declared dead at the scene. The girls who die were identical, approximately seventeen years of age.

Police are continuing to investigate the cause of the accident.

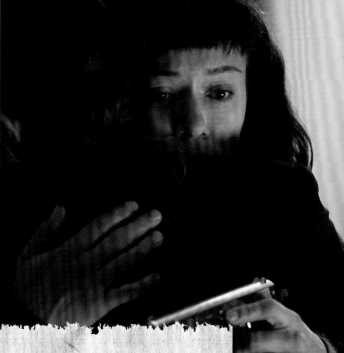

# OIL LINE RUPTURE CLAIMS LIVES

**By: Leena Virtanen**

A rupture in an oil line beneath the city resulted in several explosions across Helsinki, with at least six confirmed dead.

The first reported explosion occurred in the chemistry laboratory of the Kuusi Secondary School in Tapiola. At least two students and one faculty member are confirmed dead.

The second was the residence of the Lintula family, in the same neighborhood. The entire family of three were killed.

A spokesman for Neste Oil stated that the cause of the rupture is unknown, but that their investigators are looking into it.

## BODY OF UNIDENTIFIED TEENAGER FOUND IN RIVER

By: Anna Heikkinen

A taxicab was found in the Keravanjoki River along the Brobacka idrottspark with an unidentified teenaged girl's body in the back seat. The girl, a brunette of approximately seventeen years, was wearing her seatbelt. Investigators discovered that the seatbelt was jammed shut, and had to remove the body by cutting through the strap.

-M.K.—x-factor. Among the first self-aware clones, and only one to survive the Helsinki massacre.

-Brought Beth, Katja, Alison, and Cosima together, but stayed in the shadows.

-Refuses to meet anyone.

105

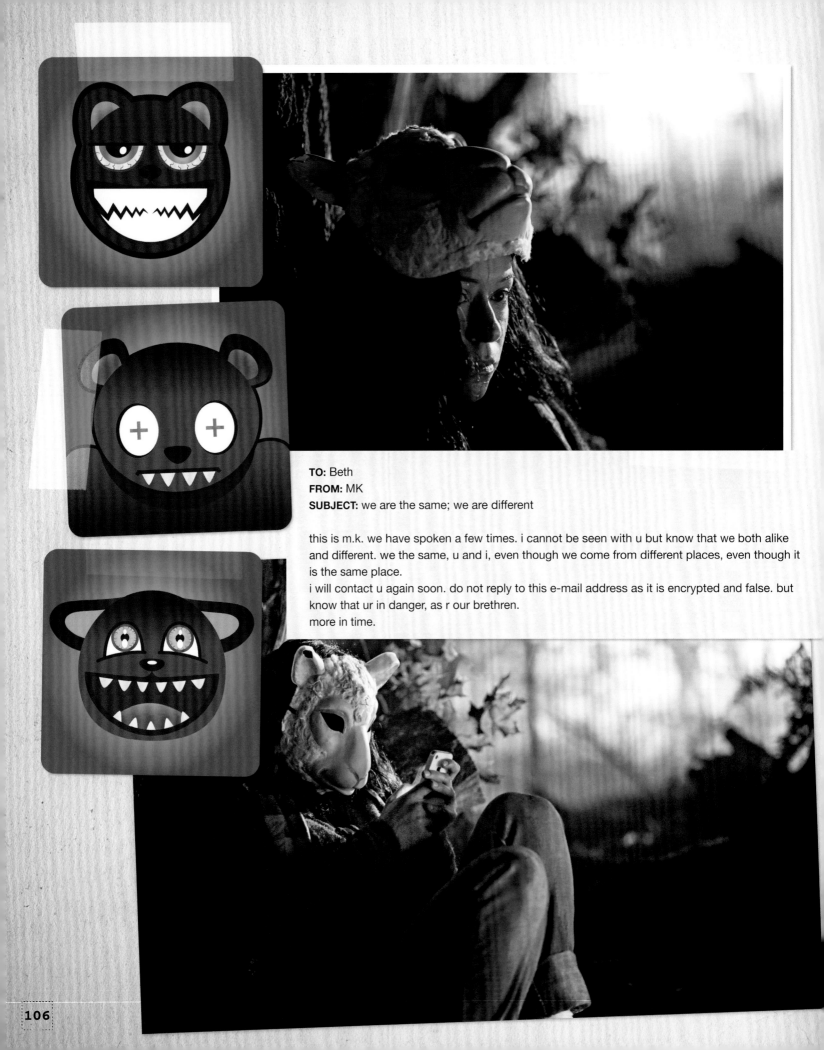

**TO:** Beth
**FROM:** MK
**SUBJECT:** we are the same; we are different

this is m.k. we have spoken a few times. i cannot be seen with u but know that we both alike and different. we the same, u and i, even though we come from different places, even though it is the same place.
i will contact u again soon. do not reply to this e-mail address as it is encrypted and false. but know that ur in danger, as r our brethren.
more in time.

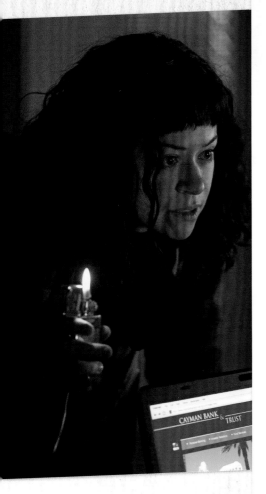

## FROM THE DESK OF
## FERDINAND CHEVALIER, ESQ.

To my dearest Rachel,

I hope this letter finds you well. Indeed, I hope this letter finds you at all, but I'm confident that the ship I've retained for the service of delivering this note to your island will get it to you. It will take a few days.

It was not easy to provide that retainer, as my resources are somewhat strained. I've had to fall back on old military contacts and a depressingly large number of them are dead. Still and all the captain of the White Star is someone I fought in Bosnia with, and he's willing to do a favor for an old chum.

It is, to say the least, maddening to be reduced to this state. It's my own fault, of course. I thought that all the Ledas were taken care of when Helsinki was launched. In the back of my head, I always thought that Miss Suominen might have escaped, but it never made it to the front of my head until I saw her in Dierden's old flat. She's been a busy girl, our Miss Suominen. Quite the hacker she's become, and she managed to access all my offshore accounts. If it wasn't for my SAS pension, I wouldn't be able to feed myself.

Still, I assume you have a plan to put yourself back on top, as you always do, and this letter is by way of reminding you that I'm always here for you. But I'm especially here for you now, as I would like to be by your side when you put yourself back on top. I want to do this together. Particularly if your methodology for doing so will—as I suspect it will—involve stepping on the heads of your "sisters." In particular I wish to have the privilege of shooting Miss Suominen in the gut and standing over her as she dies very slowly and very painfully.

I remain yours, in earnest, in affection, and in submission, Ferdinand

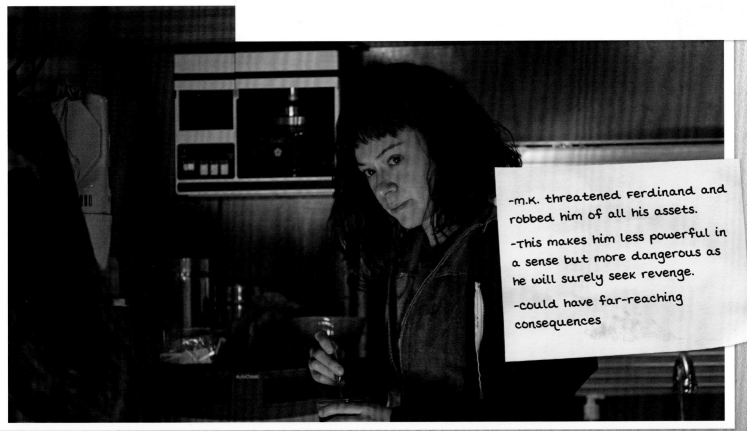

-m.k. threatened Ferdinand and robbed him of all his assets.

-This makes him less powerful in a sense but more dangerous as he will surely seek revenge.

-could have far-reaching consequences

Today 8:32 AM

So u never told me u had a twin sister.

there are many things i have not told you

Yeah. Well, this chick's named Sarah and she wants to talk to u about that biotech u had me look into. She's pretty serious, too. Stole my phone. S'okay, she gave it back.

is this different phone?

Ain't made of money, MK, I'm still payin' off this one. She just wanted the video of Martinez that I sent you. Didn't touch anything else.

i hope ur right that video was horrible to see that man die from a simple implant in cheek, neolution is committing more atrocities ok i will meet with her again

Again? You've talked to her?

she took your place at laundry

Figures.

tell her to come to your place and i will speak for three minutes

As usual. This tech is bad news, MK. Watch your ass.

always

Text Message     Send

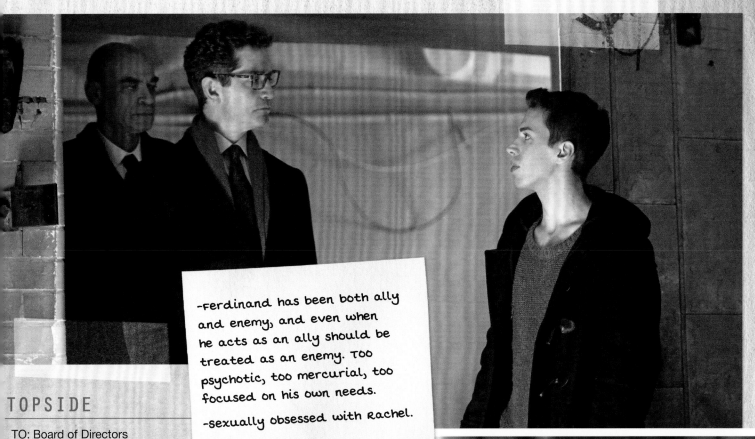

-Ferdinand has been both ally and enemy, and even when he acts as an ally should be treated as an enemy. Too psychotic, too mercurial, too focused on his own needs.

-sexually obsessed with Rachel.

## TOPSIDE

TO: Board of Directors
FROM: Sam Rogers
RE: Ferdinand Chevalier

I would like to recommend Warrant Officer Ferdinand Chevalier for the position recently vacated by Jedediah Smith after his rather unfortunate accident.

Warrant Officer Chevalier has a bachelor's in economics from the University of Sheffield. After earning his degree, he went into private security before enrolling in the Special Air Service of the United Kingdom in 1992. He started as a reservist, then became a full-time soldier a year and a half later. He rose through the ranks over the next seven years, receiving two citations, eventually becoming a warrant officer, first class.

His academic degree would seem to be at odds with the rest of his career, but it turns out that his background explains it: He is the bastard son of the 10th Earl of Sussex, and the economics degree was part of a failed attempt to curry favor with dear old Dad. Once that failed, he went into security, where he discovered a penchant for violence that the SAS helped hone. In addition to the two public citations—a Military Cross and a Distinguished Service Order—he received numerous commendations for classified operations in Kosovo, Ukraine, and Bosnia. Those classified operations involved significant wet work. Every mission in which Warrant Officer Chevalier was involved was a successful one.

He is, if anything, overqualified for the job. We can give him far better financial remuneration than the SAS, and with your permission, I will make him an offer immediately.

—Sam Rogers, Chief of Security, Topside

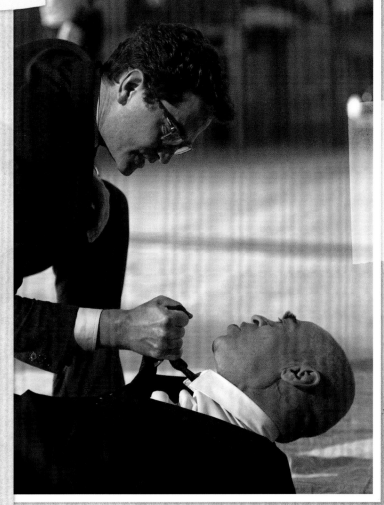

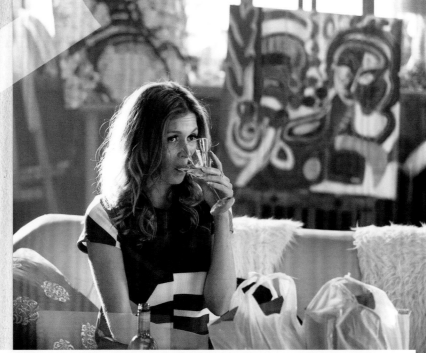

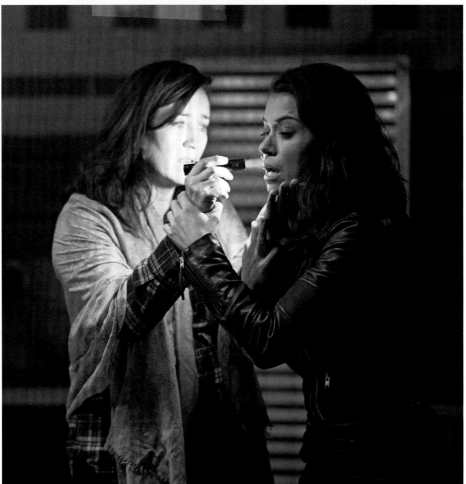

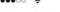

●●●○○ 📶        62 % 🔋

‹ Messages      **Scott**      Contact

Today 8:32 AM

You sure this is a good idea, Sarah?

What part of Brightborn owning GeneConnexion are you missing, Scott? This is my brother, and he's acting like an idiot. This woman has him wrapped around her drunken little finger. What if she really is Felix's sister? She isn't. She can't be.

But what if she is?

There's no way. Not with Brightborn connection, it's another fucking scam. More of these assholes trying to screw with us.

All right, but this is kind of unethical.

What was the last ethical thing you did, exactly, Scott?

Yeah, okay, fair point. I'll ping you when I get the results.

📷   Text Message          Send

To... Ferdinand

From... Daniel Albright

Subject: Re: surgery

Sorry to have taken so long to get back to you, old chap, but I've been on a bit of R&R. And not the fun kind, I'm afraid.

You see, I was in a bit of a dust-up recently. A lorry crashed into my Aston Martin and I'm afraid the lorry got the better end of it. I'm fine, mind you, but there was considerable damage to the ulnar nerve and wrist sheath in my right hand.

I assume you can read between the lines, I'm afraid. While I'm still a doctor, and still tenured here at old Oxford, I'm afraid that my days as a surgeon are well behind me. A pity, really, as the surgery you propose sounds fascinating. I'd heard about these Neolutionist chappies, and I saw some of the early research on these—bots, did you call 'em?—and was intrigued. But I never heard much about it afterward. Kept it all hush-hush, I suppose. Typical, really. It's why I prefer to remain with academia. The politics are hell, of course, but at least everything's out in the open. Still, the possibilities just boggle the mind. To be able to rewrite your own genetic code just by shoving a worm in your cheek. Great to live in the 21st century, eh?

Who is this Sarah Manning woman when she's at home, by the way? I understand why you're helping her out—the resemblance to the lovely Ms. Duncan is quite significant. Speaking of, I'm afraid there's not much joy there, either. I'd hoped that my old friend in Reykjavik might have some leads on where your Rachel wound up, but I'm afraid not.

In any event, pip-pip, and good luck finding someone to remove that blighted object from poor Miss Manning's cheek.

Yours, etc.
Daniel

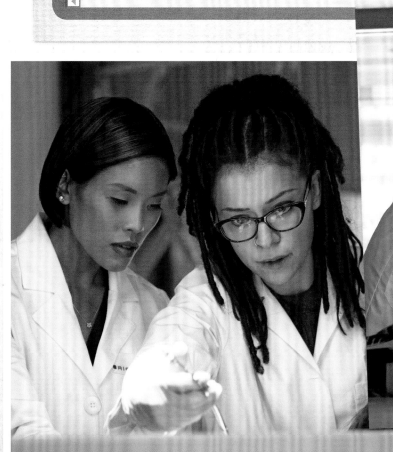

-Neolution bots in cheek can cure many ills—cured cho of her lupus—but life-threatening to remove.

-I managed it with sarah, but was a close call, and we almost lost her.

—Sarah's self-destructive
behavior can rear its
ugly head
—we all need to watch
out for each other

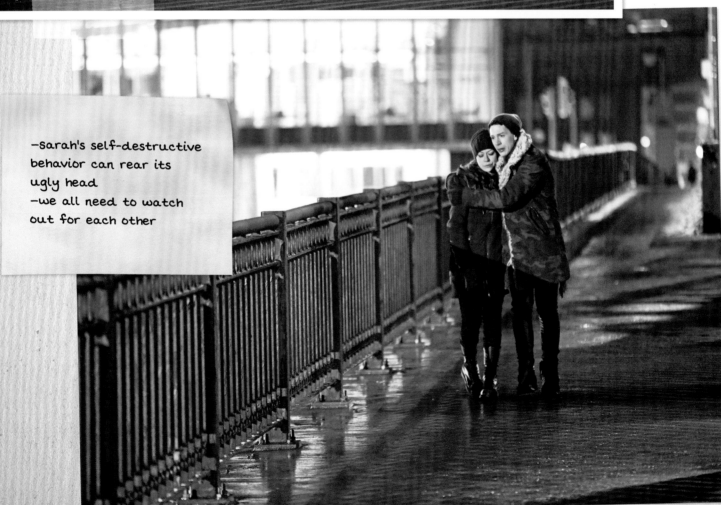

## From the diary of Cosima Niehaus, Rabbit Hole Comics

I am a freakin' genius!

Okay, not always. My stupid idea to put the bot in my cheek was, well, stupid, but Felix saved me from that by telling me that Delphine _isn't_ dead. One of our sisters, Krystal, saw her get shot and also saw her get taken away by a doctor. I don't know where she is, but at least I know she's alive.

Which has given me hope.

But more awesome? Okay, nothing's more awesome than that, but close to that awesome? Is me.

You see I finally figured out how to get a perfect original genetic line even though we don't have Kendall: we take Castor sperm and fertilize a Leda egg. Since Helena's AWOL, it means we have to harvest Sarah, but that's a conversation I'm _not_ looking forward to.

Plus we'll need a Castor clone, but Susan and Rachel have one on their island up north. So maybe we can access him somehow.

Susan is fascinating. First of all, she's alive, which means the fire that killed the Duncans didn't actually kill either of them, which is pretty freaky.

Second of all, I actually already met her. When Donnie and I infiltrated Brightborn, which is when I found out just how snakepitty that place was, we talked. Both before _and_ after I saw a child born with horrendous defects.

Before she was doing a wonderful job of bullshitting me, deflecting my questions about all the babies with dimples and asking about germline editing without actually answering those questions. Then I saw a baby being born with BP syndrome, orofacial clefts, ectodermal anomalies, and severe popliteal webbing—fancy medical terms that boil down to a bunch of genetic deformations.

After that, she was more honest, calling Brightborn's techniques brutal, which is the nice word for it, and trying to talk me into how awesome the Leda experiment is. All I know is, I'm dying, and it's due to something she did to me and I can't control.

Anyhow, that's all water that's so far under the bridge it's in the next county. Kendall's dead, so Susan's plan went out the window.

So instead we go with mine. Did I mention I'm a genius?

In order to do this right, though, I have to go to that island. Which could mean I never come back . . .

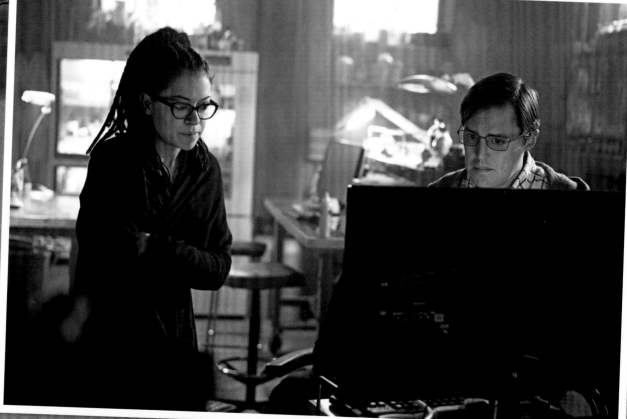

RABBIT HOLE COMICS
AND GAMES EMPORIUM

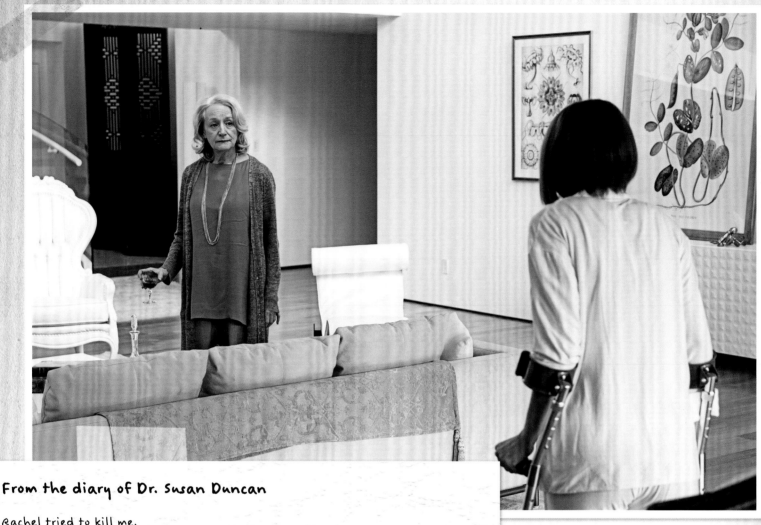

### From the diary of Dr. Susan Duncan

Rachel tried to kill me.

I suppose I shouldn't be surprised. Rachel was always a terrible disappointment to me and I was never good at hiding my disappointments. I was not a particularly good mother—Ethan always had a better knack for parenting than I—but still I never expected quite such behavior. Of course, it turns out that dear old Percival was responsible. He pushed her down that path.

No, that's not entirely fair. I pushed her down that path. Percival merely lit the way when it got a bit dark. What was a surprise was that I found myself incapable of shooting Rachel after that. Killing her would have been a blessing. A far more fitting punishment for her crimes is to saddle her with Percival. Let her be the wide-eyed acolyte who carries out his agenda.

Let her be disappointed as I was to find out the monster he really is.

Percival cured me, of course, because although Rachel will be a more pliable disciple, he requires an actual scientist who understands what he wants accomplished. That might be Cosima, it might even be Cormier or Van Lier, but it will never be Rachel. She's a CEO, not a geneticist. I just hope I can steer Percival away from the worst of his excesses. It's the only chance we all have.

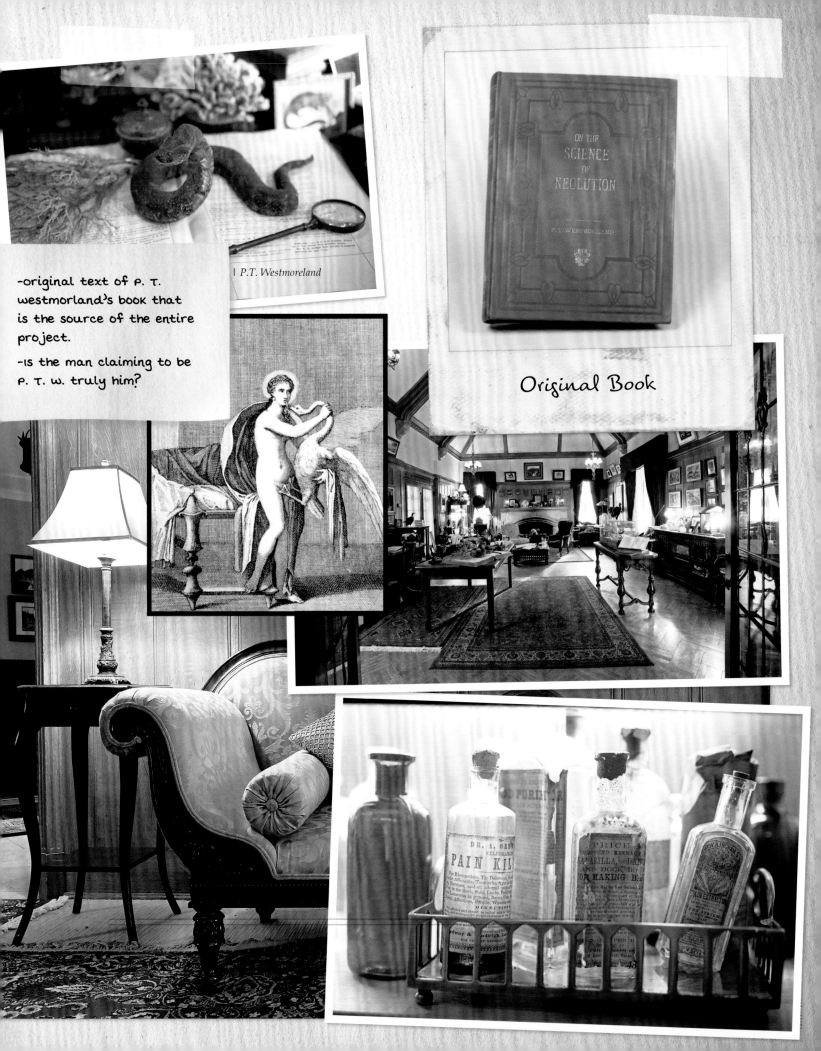

| P.T. Westmoreland

ON THE
SCIENCE
OF
NEOLUTION

P. T. WESTMORELAND

-original text of P. T. westmorland's book that is the source of the entire project.

-is the man claiming to be P. T. W. truly him?

Original Book

From the diary of Dr. Delphine Cormier, Revival

I have my Cosima back!

The day I have longed for has finally arrived. I did not imagine it would happen this soon. In truth, I did not imagine it would happen at all. And yet, she stumbled into Revival, nearly dead. I managed to revive her and now she has recovered. We are together again. She does not entirely trust me, but I will earn that trust back. For too long, I have tried to juggle conflicting agendas of people more powerful than I. However, the time I have spent here in Revival recovering from being shot has provided me with a certain clarity.

I almost died. I thought I would never see Cosima again. But I am alive. And Cosima is here with me. And I swear by all that I hold dear that I will never be away from her again.

| | Annual Variance |
|---|---|
| 0.34 | +0.424 |
| 1.87 | +0.234 |
| 1.08 | +0.4587 |
| 2.24 | +/- |
| 7.67 | +0.256 |
| 0.95 | -.0124 |
| | 2154 |
| | 0.121 |
| | 1247 |
| | -0.25 |
| | 0025 |
| | 1.231 |
| | +/- |
| | 2154 |
| | 4587 |
| | 0.256 |
| | 0.424 |
| | 8452 |
| | 0025 |
| | +/- |

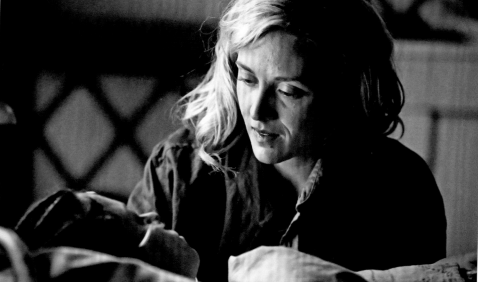

| 0026 | CHQ - #032135513514 |
| 0027 | REV - #452475275257 |
| 0028 | CHQ - #123453514354 |
| 0029 | TRF - #851534534313 |
| 0030 | CHQ - #984564684684 |
| 0030 | CHQ - #984564684684 |
| 0031 | CHQ - #554.45.42.4544 |

**E-03** LN #509-59-23741

EGFP-F EXPRESSION
CSN 0809

R  S  PT

C57B16

GFP CD8 TOPRO-3

SPLEE

Vector Copies per Genome

TIME (hr)

From the diary of cosima Neihaus, Revival

so much has happened, I can barely process it.

Let's see, we start with where I am: Revival. It's a village, believe it or not. I went from being in the middle of a high-tech lab to being in the middle of a nineteenth-century utopian community. seriously, this feels like I died and woke up in Edward Bellamy's wet dream. I got the grand tour from a girl whose name is actually mud. She's a sweet kid, but a little crazy.

Everyone here is a little crazy. But the place is seriously self-sufficient, so yay crazy? of course, the really crazy part is who runs the place.

P.T. westmorland.

one hundred and seventy-year-old P.T. freakin' westmorland.

Even freakier is Rachel. I thought the scariest sight in the world was Rachel when she let the other shoe drop and found out how badly she boned us, but that was before she met up with PTW. Now? she's a true believer, his biggest acolyte, and drank-the-kool-Aid enlightened Rachel is way way scarier than self-interested-and-screw-everyone-else Rachel.

The only thing keeping me sane—and trust me, that's a real relative term at this point—are charlotte and Delphine. charlotte's been taking classes at the school they have and Delphine seems to be the country doctor here in Revival.

I'm still having issues trusting Delphine. on the one hand, I feel kinda shitty about that. I mean, she got *shot*. on the other hand, how can I trust her after everything that's happened? But we're working on it and this place would be unbearable without her. Especially because of the really big thing. okay, yeah, I buried the lede—but at least it's not burying the Leda.

we're being cured.

At least, that's what it looks like. we've still got a ways to go, and my life since I met Beth, Alison, sarah, and the rest of the sestras has taught me that optimism is for suckers, but still, I'm guardedly hopeful that these latest treatments will do the trick for me and charlotte both. And then, eventually, for all of us. If nothing else, before I was struggling for every breath and I felt like hammered shit, and now I don't, so that's better, right?

It's not all sweetness and light. Delphine and I also think we've isolated the gene that is the basis of the "fountain of youth" that PTW claims to have found and that he wants to bring to the world — and may be why Kira's such a fast healing badass. LIN28A is a protein that works in stem cells to grow limbs and which disappears after infancy. If it doesn't, it can cause cancer pretty much instantly. PTW has been experimenting with it for ages, and he went full Frankenstein on some poor bastard who's turned into a proto-sasquatch and was locked up in the basement for his whole life.

I don't know what's going to happen next. But I'm doing everything I can to find out what's really going on here. It's looking like everything we've been through—well, since before we were born, really, started here with PTW and his crazy-ass science. I'm worried that tall, dark, and hairy man in the basement isn't the only experiment gone wrong up here. But I am gonna find out the secret of that science. or die trying. Dammit.

# WELCOME TO REVIVAL!

On behalf of P.T. Westmorland and the rest of the folks here at Revival, welcome! I'm Mud, and I'll be your guide to everything you need to know about our little home, which has been self sufficient and off the grid since the last time the Chicago Cubs won the World Series!

That's right, Revival was formed by PTW (which is what we like to call him) as a refuge from a world that has become far too dependent on outside sources. Power, fuel, food—the average person can't get any of it without a prearranged infrastructure. Here at Revival, we arrange our own infrastructure, thank you very much. We make our own power, we grow our own food—we grow fruit and vegetables, and we raise livestock—we have our own school, and best of all, we're responsible for our own medical care.

And that's why we're the awesomest place in the world! We're working on science here that will change the world. Or at least change people's worlds. And that's what matters, am I right?

So welcome everyone to the finest town on the planet, the home of Neolution!

—Mudd

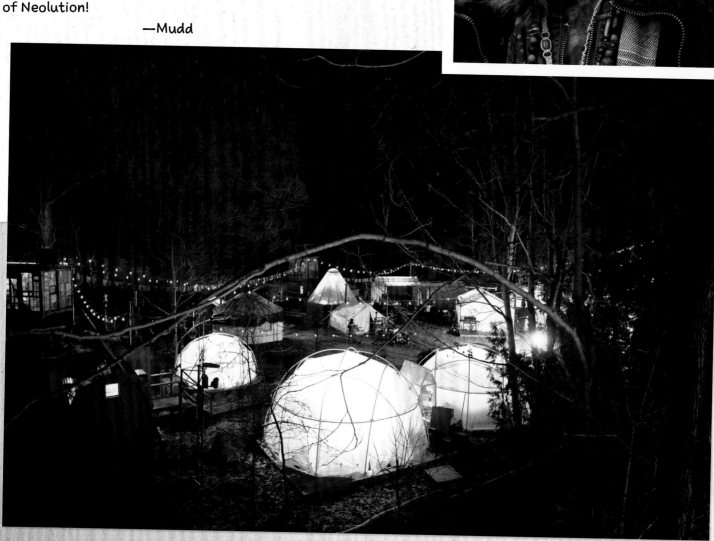

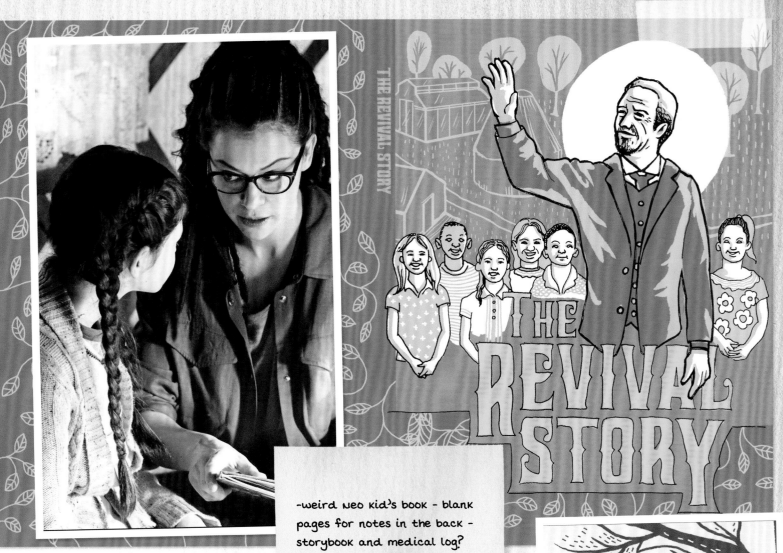

THE REVIVAL STORY

-weird Neo kid's book - blank pages for notes in the back - storybook and medical log?

So that we can
e forever together.

Our bodies, temples
that never crumble.

We are all Revival's children.

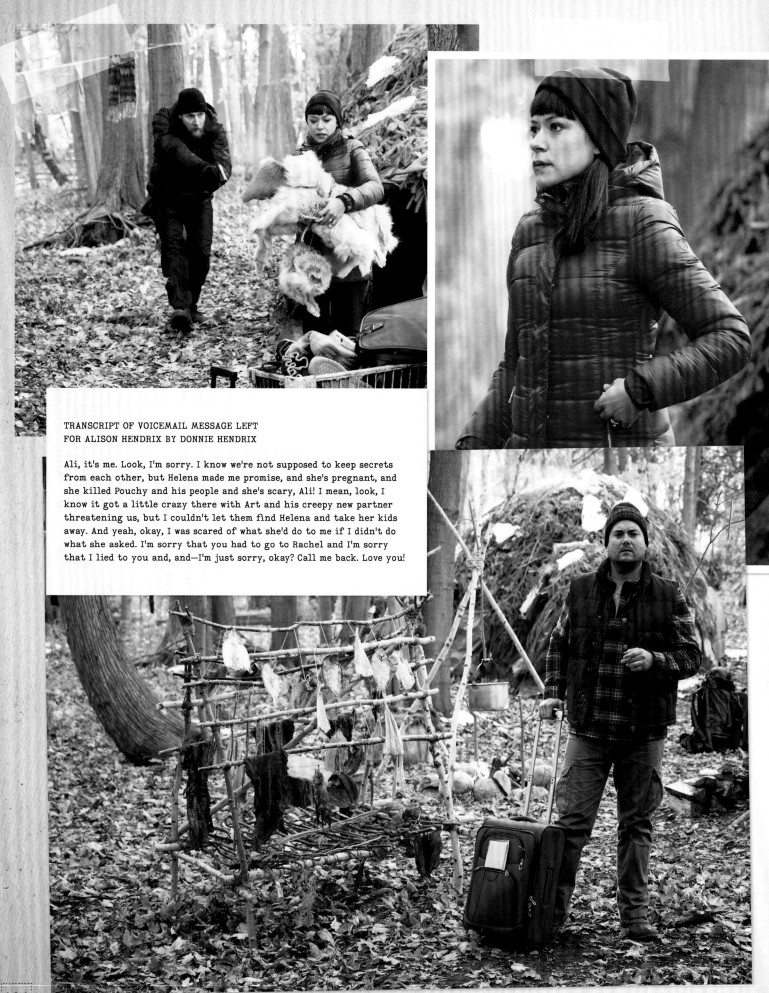

TRANSCRIPT OF VOICEMAIL MESSAGE LEFT
FOR ALISON HENDRIX BY DONNIE HENDRIX

Ali, it's me. Look, I'm sorry. I know we're not supposed to keep secrets
from each other, but Helena made me promise, and she's pregnant, and
she killed Pouchy and his people and she's scary, Ali! I mean, look, I
know it got a little crazy there with Art and his creepy new partner
threatening us, but I couldn't let them find Helena and take her kids
away. And yeah, okay, I was scared of what she'd do to me if I didn't do
what she asked. I'm sorry that you had to go to Rachel and I'm sorry
that I lied to you and, and—I'm just sorry, okay? Call me back. Love you!

# GLENDALE ANGLICAN CHURCH BULLETIN

QUICK NOTES FROM THIS WEEK'S EVENTS

• Thanks to everyone who made the Fall Fun Fair another great success! In particular, thanks to Nona Walker for stepping in to run things this year.

• Reverend Mike received a very nice e-mail from Donnie Hendrix apologizing for the rather appalling scene he and his wife Alison caused at the Fair, with a promise that they are both getting help for their issues. We should keep Donnie and Alison in our prayers and hope that they find their way back to God soon.

Alison is ready to cooperate. I was shocked to find out she and her husband had Dr. Leekie and a missing Castor buried in their garage. I am displeased that this did not show up on our radar. It seems our little housewife is more dangerous than we had thought, but she is no longer a threat to our mission. Tell the police to stand down.

                    - Rachel

100

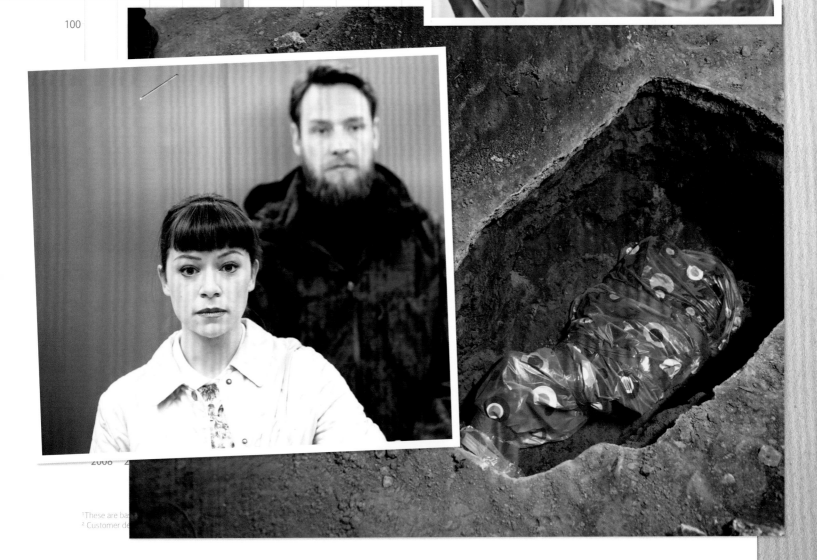

2008

¹These are ba
² Customer de

Delphine notes:

Sarah found Revival village on island, encountered unknown creature and sustained minor injuries. She has been brought in from island by Rachel and a deal has been struck to give Rachel access to Kira, much to Sarah's objection. Siobhan and I encouraged her to take the deal and lay low while we figure out how the scope of Neolution and destroy the organization for good.

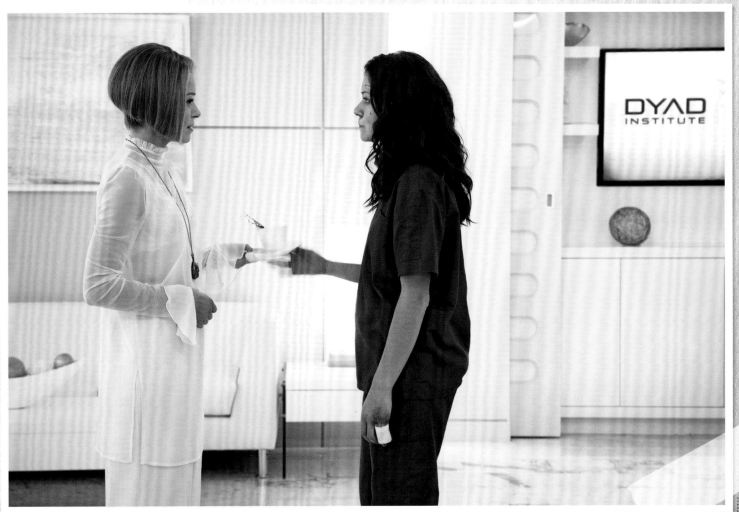

**BREBNER LABS**
INCORPORATED

ABOUT BREBNER    |    SCIENCE & TECHNOLOGY    |    PRODUCTS    |    INVEST    |    CAREERS    |    GALLERY

## ABOUT US

### OUR TEAM

Brebner Labs has an experienced and accomplished team of senior management and board of directors that work together, combining their expertise to guide the progress of the company.

**Adrian Peters, PhD**
CSO and Co-founder

In addition to being Non-Executive Chairman of Brebner Labs, Adrian has held the position of CEO at GLOBUS Bio-Solutions since 2008, with a turnover of more than $200 million, which employs nearly 1,600 people across a number of sites in Europe.

**Ian Van Lier, M.D.**
CSO and Co-founder

In addition to being Chief Science Officer of Brebner Labs Inc., Dr. Van Lier has held the position of CEO at GENPAY Inc. Dr. Van Lier is invaluable in aiding GenPay's goal of significantly expanding our global research and development organization.
Prior to his role with GenPay Ian served on the board of many prominent pharmaceutical firms, including BrightBorn. We look forward to the innovative thinking he will bring to our company.

100

2008    2

**NEOLUTION BOARD OF DIRECTORS:**

1. Hashem al-Khatib
2. ~~Francine Bernard~~ DISINFORMATION PERSON—DECEASED
3. ~~Jules Martin~~ MISSING, REPORTED BY WIFE
4. Baifang Hsu
5. ~~Dmitri Matakiev~~ SUICIDE
6. ~~Seong Pak~~ SUICIDE, FOUND HANGED IN OFFICE
7. Kazue Shimura
8. ~~Ian Van Lier~~ DOC FROM BRIGHTBORN—BODY TURNED UP IN HUMBER RIVER
9. Lucia Zerrelli SUICIDE

[........................] to the Seller in

...er present or future, whether
...out limiting the generality of

...nagement or other contract

...rams or arrangements of any
...vided to each person
...osing Date;

...breach of contract, delict
...ealth and safety violations,
...lawsuits connected with or
...t, occurrence of set of facts
...sing Date;

...ny product sold at any time
...Date;

v) Any Liabilities under [........................] relating to the protection of the environment, including but not limited to the use, storage, handling, transportation or disposal of any hazardous waste or solid waste (as these terms are defined in [........................])

vi) or emission, deposit, issuance or discharge of a contaminant (as that term is defined in [........................]) in a ...eater quantity or concentration than that provided for by ...gulation of the Government to the extent that any such ...ident, occurrence or set of facts or circumstances arose ...or to the Closing Date;

...y Liabilities due to facts or circumstances occurring prior ...the Closing Date, constituting any violation of federal, ...vincial, local or foreign [........................], or any regulation of ...quirement of any governmental body, other than those ...scribe...

—We are trying to figure out what this all means, follow the money. Dyad has shell corporations and companies all over the map.

—If we can find out who is controlling it and where it's being funneled we will be closer to shutting them down.

—Bribes have connected Hashem Al-Khatib to Neolution.

—Multi-national investigation launched into Dyad, all research and financial activities are suspended. Al-Khatib still at large.

2008  2009  2010  2012  2013        2008  2009  2010  2012  2013        2008  2

¹These are based on number of shares after the 2009 share split
²Customer deposits and customer loans and advances are based on year end balances

Today 8:32 AM

I can't take this much longer, Fee.

Look, we're working on it.

How long are you and Adele going to be running this errand for S?

I think it's adorable that you believe that she gave us any details.

Yeah.

Look, be careful, all right?

I'm always careful.

No, you're always cautious, and then when things go to shit, you run away.

I'm not running away.

I hope not. We're counting on you.

To do what, sit on my arse?

At least you're DOING something.

Cosima's working the science with the nerd herd.

S is doing her usual S things.

You and Adele are about to fly to bloody Europe.

What am I doing? Sending my daughter to afterschool vivisection or whatever with bloody Rachel.

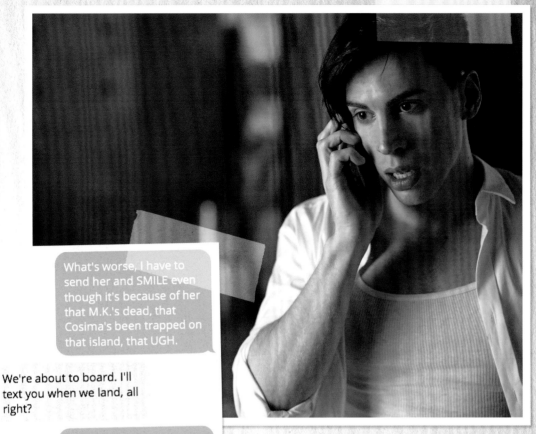

What's worse, I have to send her and SMILE even though it's because of her that M.K.'s dead, that Cosima's been trapped on that island, that UGH.

We're about to board. I'll text you when we land, all right?

Thanks, Fee. Hurry back.

[📷] Text Message  Send

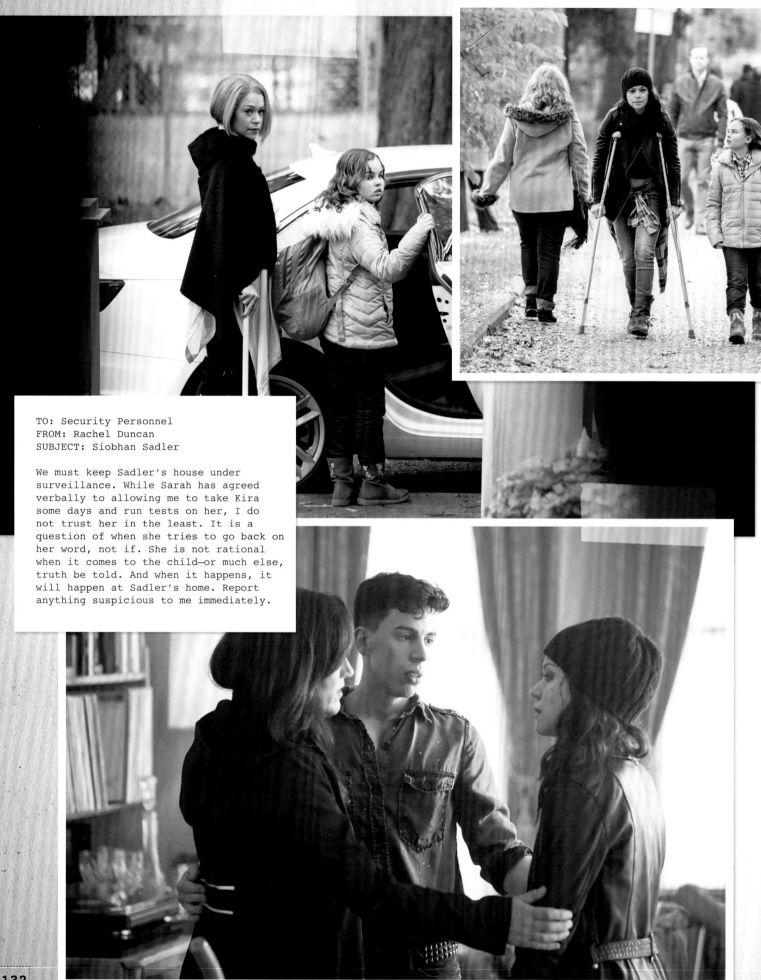

TO: Security Personnel
FROM: Rachel Duncan
SUBJECT: Siobhan Sadler

We must keep Sadler's house under surveillance. While Sarah has agreed verbally to allowing me to take Kira some days and run tests on her, I do not trust her in the least. It is a question of when she tries to go back on her word, not if. She is not rational when it comes to the child—or much else, truth be told. And when it happens, it will happen at Sadler's home. Report anything suspicious to me immediately.

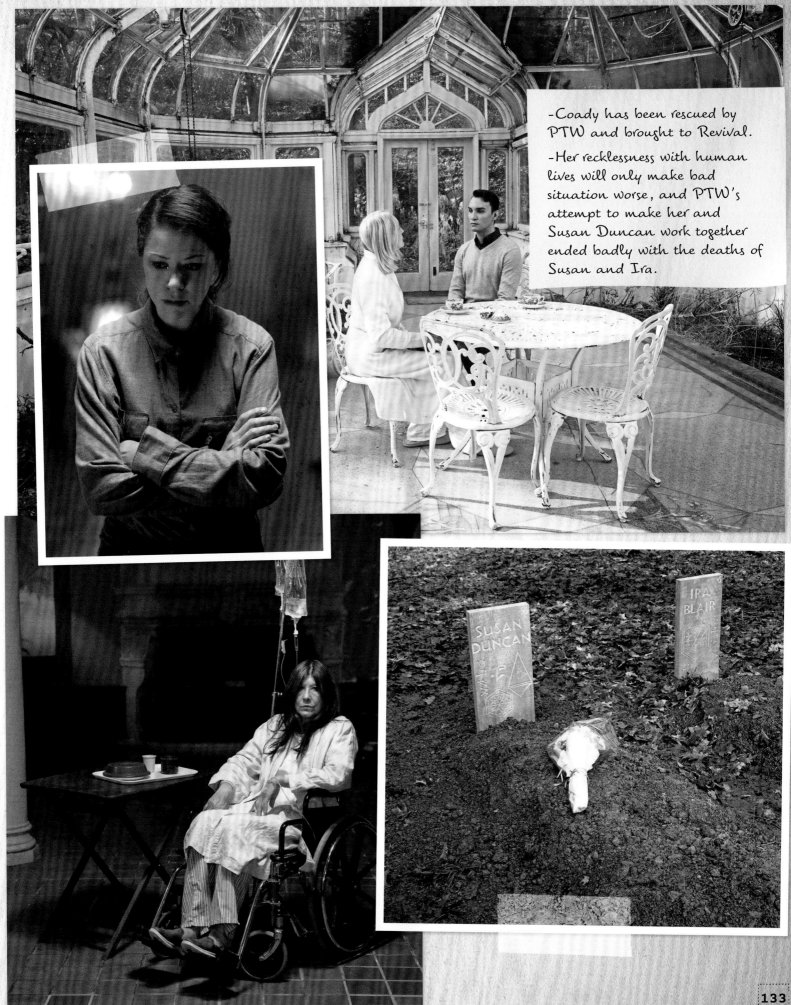

-Coady has been rescued by PTW and brought to Revival.

-Her recklessness with human lives will only make bad situation worse, and PTW's attempt to make her and Susan Duncan work together ended badly with the deaths of Susan and Ira.

# Kay – Bee Natural Beauty

Episode 14 is now live!

Hey everyone! Episode 14 is now live, and it's our most important episode of the vlog yet! Click on the link to watch it right now this second!

We uncover the truth about Big Cosmetics in our newest vlog, which is full of lots of surprises, believe us!

Everything was going normal until it wasn't, and it was just horrible. Big Cosmetics is targeting us, and the first victim is Brie's hair! It started falling out, just because of a cold cream she used!

Whatever you do, do NOT use any products by Global Cosmetics or by BluZone. Especially BluZone, they say they're all noble and vegan and stuff, but they're TOTALLY NOT. They sold out to Dyad, which is the most evil company in the history of the world.

And this is just the tip of the iceberg. To get the whole truth and nothing but the truth, you need to click on this link and watch Episode 14. It's nasty, it's vicious—but it's still fun, because it's us! Krystal and Brie are back, uncovering the ugly truth while looking beautiful. And teaching you how to look beautiful too!

Leave a comment:

COMMENTS

**Mara50267** 2 days ago
OMG, I can't believe Brie's hair is falling out! You must be really getting close to something.

> View all 42 replies
> **Jean Genie** 1 day ago
> Right? That's awful!
> **Yvonne Of Us** 1 day ago
> Are you sure you didn't just mix your Nair up with your shampoo? My sister did that.

**RealMan99999** 2 days ago
WTF? She put straws in her head and her hair falls out? What's that about? Maybe she's just stupid or maybe the straws got caught on her hair or MAYBE THIS VLOG IS JUST STUPID.

> View all 102 replies
> **kgoderitch** 1 day ago
> Thanks everyone for the support! And you RealMan999999999 are NOT a real man!
>
> **RealMan99999** 1 day ago
> Screw you, bitch.

**Jorge Garcia** 4 hours ago
Su comentario condescendiente sobre las personas que no hablan inglés es despreciable. Deberían avergonzarse de ustedes mismos.

**Haruko 1/2** 7 hours ago
I am typing this in my English because you cannot read Japanese. I like your vlog but you are not nice to people not from your country. That is not nice.

**V. Dentata** 1 day ago
I'm guessing that those straws were NOT field-to-face vegan like you thought. Not if it pulls hair out like that. You should get your money back for realz.

**MACHA LIBRE** 2 days ago
OMG, I CANT BELIEVE THAT HAPPENED TO BRIE THAT IS SO HORRIBLE WATCHING HER HAIR COME OUT LIKE THAT! MY HAIR CAME OUT LIKE THAT WHEN I DID CHEMO BUT SHES NOT DOING CHEMO AND OMG THAT SUCKS SO BAD!

# BLU·ZONE™
## COSMETICS

## AGREEMENT OF PURCHASE
## AND SALE OF BUSINESS ASSETS

This Agreement of Purchase and Sale (the "Agreement") is made in two original copies, effective [IMMEDIATELY[]

**BETWEEN:**      **[BLUZONE COSMETICS]** (the "Vendor"), a company organized and existing under the laws of the [ENGLAND] of [THE UNITED KINGDOM], with its head office located at:

[96 HENSLEY GROVE
LONDON, ENGLAND, UNITED KINGDOM
W14 T88]

*SALE APPROVED BY CHIEF EXECUTIVE OFFICE*: **LEN SIPP  CEO**

**AND:**      **[ARTEMIS INCORPORATED** a subsidiary of **DYAD INSTITUTE]** (the "Purchaser"), an individual with his main address located at OR a company organized and existing under the laws of the [CANADA], with its head office located at:

[6750 GARRISON ROAD]
TORONTO, ON
M6T JK8

Honey, I'm home!

I gotta say, I was pretty sure that I'd never get away from Revival. Never get off that island. Never see my sestras again. Well, except Rachel. Seen plenty of her. And I guess charlotte counts as a sestra, too, though I think of her more as a niece. Still, she's part of our one big happy clone family.

And we managed to escape. Sorry, I'm rambling. Still not used to this diary thing. Also I'm exhausted. The boat trip from the middle of nowhere back to Toronto is kinda tiring.

All right, focus, cos. In order. First of all, that monster? His name is yanis, and he was a genetic experiment by PTW gone wrong. And now he's dead. PTW tried to get me to kill him. Handed me a gun and everything, but I refused. They may own the patent on me and the other members of clone club, but that doesn't mean I say, "How high?" when they say "Jump." That doesn't mean I kill someone. Not ever. So he shot him. Bastard.

Oh, and he's not P.T. westmorland. Don't know his real name, but he's not 170. He's just another con artist, like Leekie—shit, with no offense to my sestra, like sarah. Except he's pulled his con on a ton of people who all believe it, starting with the people of Revival. He says he's helping them, but he's just helping himself. He's trying to extend his life. maybe he thinks he will live to be 170, who knows?

But yanis was a liability. Too many people are asking questions about what's going on. And the mask was falling off. charlotte and I managed to escape. I grew up on houseboats, so stealing a boat and heading south was easy enough to do. And by "easy," I mean, "terrifying and insane and nearly got us killed," but at least I knew where to point the boat and how to steer

Now we're back home. charlotte is away from "PTW," Rachel, and susan. maybe she can grow up to be a real girl. And I'm back with my sestras and we can beat these fuckers once and for all. Because we can't let them win. It isn't just that "PTW" has pulled the wool over everyone's eyes, using Neolution as a front for prolonging his own miserable life. It's that he's using Kira. The bastards are going to harvest Kira's eggs. make a whole new set of clones who will have LIN28A. And then use that to make "PTW," whoever he really is, as immortal as he's pretending to be. We cannot let that happen. And we won't.

-M.K. sacrificed herself to save the rest of her sisters. She was dying from the same illness that has claimed so many of the Ledas and is currently ravaging Cosima, but she still was very brave in distracting Ferdinand, which she paid the ultimate price for.

-We must ensure she did not do so in vain.

Today 8:32 AM

> Alison, MK is dead. There's gonna be a service for her tomorrow at my place.

OMG Felix, are you ok? I'm afraid we can't be there in person, but we can Skype in.

> Of course, darling, that's fine.

My God, Felix, what HAPPENED?

> Apparently MK had the clone disease. Sarah tried to convince her to tough it out, give Cos a chance to find a cure. But she wouldn't go for it.

So she died of the disease?

> No she died trying to distract Ferdinand so Kira could get away. He fucking killed her. And it didn't work, either. Kira WANTS to stay with Rachel and find out why she is the way she is. She's a brave little monkey.

I'm sorry, we're just a big mess over here. Let me and Donnie know when the service is and we'll call in.

> Absolutely, love u.

📷 Text Message                    Send

FROM: Alison
TO: sestras@googlegroups.com
RE: My Retreat!

Dear Sestras,

I hope this e-mail gets to all of you. I know Scott said it would work and it is easier than typing out all your e-mail addresses, but still . . . well, never mind. The old Alison would have fussed over it, and probably complained that everyone else didn't just keep track of everyone's e-mail in a spreadsheet or something, but I'm the new Alison! I am following the philosophy of que sera sera. I always used to think that that was an irresponsible philosophy, what will be will be, but it's actually very liberating!

I was in such a dark place before. I felt like I lost everything. I lost my position as school board trustee, I ruined my mother's business, I lost our drug-dealing business—okay, that was no loss, but still—and I saw my husband be arrested in front of our kids. And then the final kick in the tush, I got squeezed out of the Fall Fun Fair.

What's worse, I didn't feel like I was contributing anything to our cause, that I was a burden on all of you. Helena had to keep us hidden in the woods, and then Rachel and her goons tried to use the dead bodies in our garage against all of you. And there's the fact that we had two dead bodies in our garage . . .

The last thing Rachel said to me after I gave her Leekie's head was for me not to take myself so seriously. As usual, Rachel got it entirely wrong. I'm not taking myself seriously enough. It's time that stopped.

So I went to visit the kids in Florida and then I came here to this retreat. And, Lord love a duck, it has been amazing. First, and most important, I haven't touched a drop of alcohol. Not that the temptations haven't been there—this retreat actually has plenty of wine floating around, as the owner is a stockholder in a winery in Mendocino—but I've been focused on me. On experiencing the moment. And on living deep.

Speaking of that, I got a tattoo! I know, it's not my usual thing, but this is all part of the new Alison! This whole place follows the philosophy of Carl Jung and it's all about individuation. I'm finding the best me I can find. And the best me doesn't drink, plays the keyboards, and simply is. Oh, and I cut my hair. Donnie will probably poop a brick when he sees it, but I like it. Besides, why should Rachel be the only sestra with short hair?

Speak to you all soon. I love you all. Alison XOXO

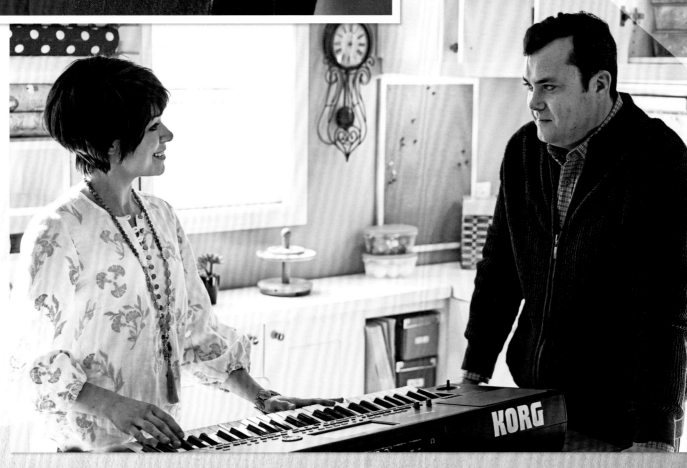

# UNIQUE OPENING BY LOCAL ARTIST

**Felix Dawkins puts on a show in his loft with themed art exhibit**

**By: Howard Frank**

The last time we saw Felix Dawkins was two years ago when his "Visions of Judgment" exhibit opened at the Mehu Gallery. He's been in and out of the scene ever since, but he's come back in a big way with his new exhibit, which is currently showing at Dawkins's loft (aka Gallerie Rimbaud) on King Street.

The opening Saturday night was an impressive piece of performance art to go with his impressive paintings. The exhibit, which Dawkins said is called *Sestra*, is a series of studies of different versions of Dawkins's foster sister, Sarah Manning. One has her with short hair and an eye patch, one has her with dreads, and so on.

The performance came from the subject herself. Manning did a series of quick changes, performing as each interpretation of herself from each of the paintings. Most impressively, she even destroyed one of the works—the one with the eye patch—which this reviewer found both impressive and appalling. Finally, Manning was herself, and Dawkins dedicated the paintings to her, her daughter, their foster mother, and Dawkins's biological sister, an attorney from the States who apparently provided the hors d'oeuvres.

Several members of the local scene attended, but the true VIP at the show was Ezra Lue, who flew in from Geneva just for this opening.

All the paintings were purchased by evening's end with four exceptions: the eye patch painting, which is unsellable, the one of Manning in her true form, and also the two deviations from the theme, to wit, the portrait of Manning's daughter and foster mother. Dawkins explained later that those two were not for sale. Dawkins said he has since received tremendous interest in his work and plans to pursue his art further possibly in New York City and beyond.

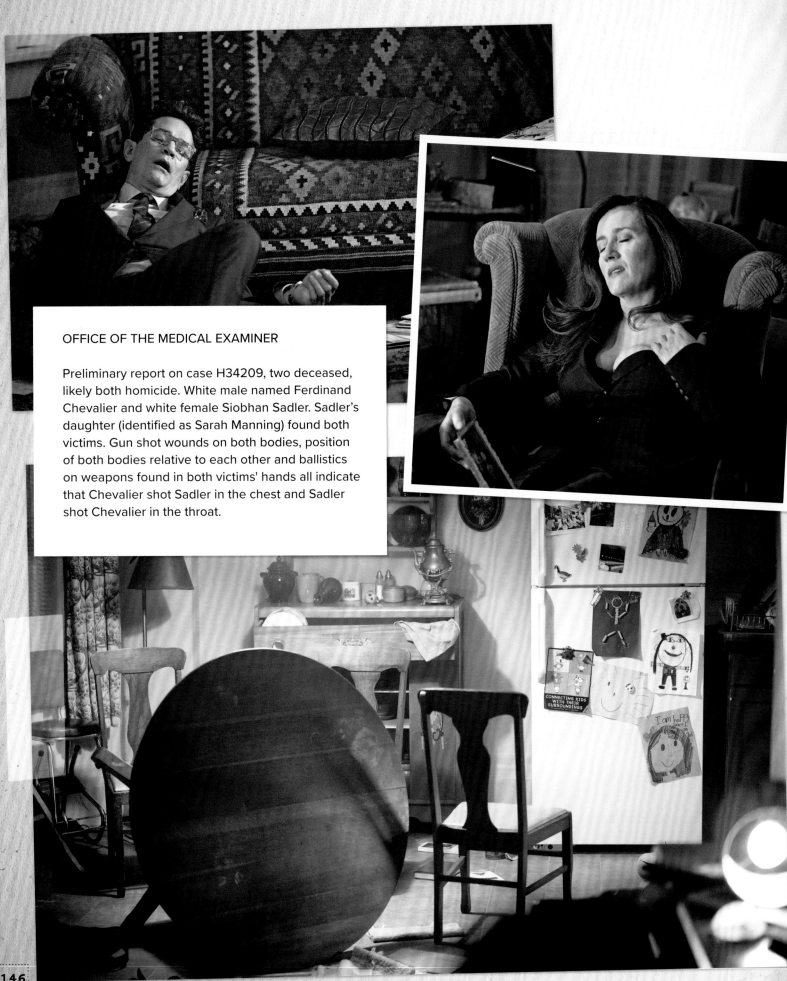

## OFFICE OF THE MEDICAL EXAMINER

Preliminary report on case H34209, two deceased, likely both homicide. White male named Ferdinand Chevalier and white female Siobhan Sadler. Sadler's daughter (identified as Sarah Manning) found both victims. Gun shot wounds on both bodies, position of both bodies relative to each other and ballistics on weapons found in both victims' hands all indicate that Chevalier shot Sadler in the chest and Sadler shot Chevalier in the throat.

# IN LOVING MEMORY - Siobhan Sadler
Loving mother, friend, and fighter to the end.
Irish toast: "May God grant you always . . . A sunbeam to warm you, a
moonbeam to charm you, a sheltering angel, so nothing can harm you."

Just remember my loves—
Death is nothing at all.
I have only slipped into the next
room. You can call me by my
old familiar name.
Put no sorrow in your tone.
I promise we will laugh at this
difficult parting when we meet again.

All my love,
S.

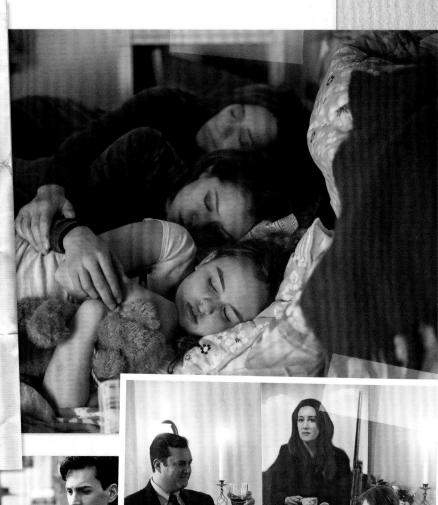

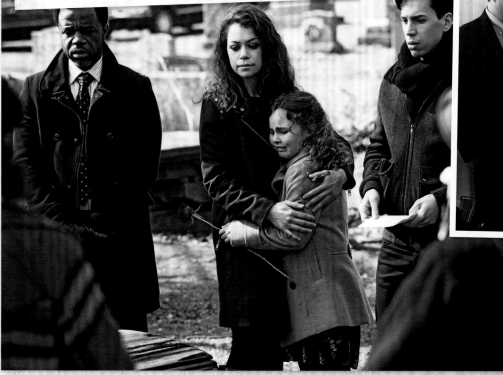

## Obituary

### WINSTON W. TRALLEY

WINSTON W. TRALLEY, The untimely passing of Mr. Winston W. Tralley, at the age of 23, evoked much sympathy in the Grantchester Meadows and her surrounding villages. The deceased, a bachelor, was the eldest son of Mr. and Mrs. J. Tralley of Bury St. Edmunds. An avid rugby player, Mr. Tralley died playing the sport he most enjoyed. At Woodside, Wortham, he had begun steps towards a career as a chemist. He was a student of University of Cambridge, as a chemist and was a member of University of Cambridge, Faculty of Pharmacology Graduating Class of 1963. The tragic incident took place whilst participating in a rugby game in Wortham, October 26. Two brothers and three sisters are left to mourn his loss.

The interment took place at Redgrave Church, the officiating clergy being the Rev. H. G. Slater, Mr. Miles Foster, who was at the organ, rendered "O rest in the Lord," and accompanied the singing of "Abide with me."

The principle mourners were Mr. F. Trolley, Mrs. W. Buck; Mr. J Ruffles and Mrs. G. Tralley, brothers

### MR. JOHN PATRICK MATHIESON (CAMBRIDGE, ENGLAND)

AUGUST 13, 1967 — Funeral Services were held on Thursday morning at 9:30 o'clock from the Great St. Mary's Church for the late Mr. John Patrick Mathieson whose death was officially announced after he failed to return after sailing through a storm off the coast of King's Lynn.

A small private service was held for friends of

MR. J. P. MATHIESON

Mathieson. As he was the only child to the late William and Annabelle Mathieson of Texas, Mathieson was honoured without family in attendance. He was known best in some smaller academic circles around the University, but elected to keep much of his personal life private.

As authorities have thus far been unable to locate the remains of Mr. Mathieson he will be honoured with a small marker to remember his passing.

## NAMES OF STUDENTS REGISTERED FOR 1964

| (1) | (2) | (3) | | |
|---|---|---|---|---|
| Student No. | | Address in the United Kingdom. | | rcted of ation |

> PTW is a fraud!!!! Scott and Hell-Wizard have worked diligently to learn his true identity—someone who died in such a way that could have been falsified in the late 1960s. Regardless, he is not a 170-year-old, but simply an old man who fronted the work of smarter women than him in order to prolong his own miserable life.

| | | |
|---|---|---|
| 10582 | Brow... | ... Road, Merrow, ..., Surrey. |
| 10583 | Bail... | ...nchley, ...W.3. |
| 10584 | Bell... | ... Road, ...E.5. |
| 10352 | Baker, Alfred | ...treet, Gillingham, W.3. |
| 10585 | Baker, Charles | 161 McGill Terrace, Woodside, Middlesex. |
| 10586 | Baker, David | 7 Hickman Street, Gainsborough, Lincolnshire. |
| 10588 | Baker, Henry Thomas | 4 Leonard Road, South Chingford, E.4. |
| 10613 | Baker, Robert | The Lynch, West Stour, Gillingham, Dorset. |
| 10589 | Baker, Thomas J. | 13 Braintree Road, Cosham, Portsmouth, Hants. |
| | | 60 Martin Road, Kettering, Northants. |
| | | 720 Maidstone Road, Wigmore Billingham, Kent. |
| | | 8 Ferrier Crescent, Woodside Aberdeen. |
| | | 144 Muirhouse Ave Motherwell, Lanarks. |
| | | 121 Mashiters Walk, Romford Essex. |
| | | 11 McGill Terrace, Gourdon, Montrose. |
| | | 44 Dubbs Land, Bingley, Yorks. |
| | | North Grand Rd, Leeds 6. Yorks. |
| | | 5C Charles Street, St. James Bristol 2. |
| | | 16 Mossfield Road, Farnsworth Nr. Bolton, Lancs. |
| | | 16 Tintern Road, Carshalton Surrey. |
| | | 501 Hopes Land, Ramsgate, Kent. |
| | | 5 Hathleen Road, London S.W. 11 |
| | | 9 Stanpit, Christchurch, Hants. |
| 10624 | Butler, Jerome | 56 McGill Terrace, Gourdon, Montrose. |
| 10865 | Butler, Matthew | 37 Camden Square, Camden Town, London N.W.1 |
| 10866 | Butler, Robert | 65 Lennyduff Road, Fraserburgh, Aberdeen. |
| 09489 | Butler, William | 84 Calgarth Road, Windermere Westmoreland. |
| | | 718 Insley Road, North Finchley, London. |

| | | | | | |
|---|---|---|---|---|---|
| 1 | POL | 1 | | | 1968 |
| | | 1 | | | |
| 1 | MATHS | 1 | | | 1967 |
| | | 1 | | | |
| 1 | HIST | 1 | | | 1969 |
| | | 1 | | | |
| 1 | LAW | 1 | | | 1966 |
| | | 1 | | | |
| 1 | SCI | 1 | | | 1968 |

Dec. 19, 1968

### HENRY E. GONARD (CAMBRIDGE)

News of the death of Mr Hendry Gonard, only son of Mr and Mrs R E Gonard of The Market Place, Kenninghall, which occurred at the River Wensum following a tragic accident whereby Mr Gonard fell from a punt and drowned at the age of 24 years has cast a gloom over the parish.

A member of the Church choir and Kenninghall Royal Air Cadets and a student at the University of Cambridge Mr Gonard was well-known and much respected by all.

At St Mary's Church on Tuesday a Requiem was said in the presence of a good congregation The interment took place at the cemetery where representative of the Oddfellows dropped sprigs of thyme on the coffin.

The immediate mourners were Mr and Mrs W J Gonard parents Mr and Mrs A G Harrison Rm and Mr A Musk aunts and uncles Mr Tebble Mr Walter Bale and Mr Radley friends

CHARLES FLATMAN

# OBITUARIES

## Timothy P. Midwell

The death of Mr. Timothy Midwell, only son of Mr. and Mrs. R. E. Midwell, of The Market Place, Kenninghall, took place on Saturday the 10th of February near Petersfield. Mr. Midwell was found collapsed outside The Flask Tavern and Inn, nearby University of Cambridge where he was pursuing his studies. The death of the graduate student at Cambridge University at the age of 26 years, has saddened the academic community. A member of the Church choir and Kenninghall Royal Air was said in the presence of a good congregation. The celebrant was the Vicar (the Rev. D. A. Watson). The body was received into the Church on Tuesday afternoon, and rested there overnight.

The funeral took place on Wednesday amid every expression of sympathy, the Vicar officiating. Mr. F. W. Stone was organist for the 23rd Psalm and the deceased's favourite hymn "How Bright these glorious spirits shine," and Bachs Cantata "Jesus Joy of Man's Desiring" and Handels "Largo."

The immediate mourners were: Mr. and Mrs. R. E. Skeen, parents; Miss R. Williamson, fiancée; Miss N. Burton, Mr. A. Wheeler, Mr. and Mrs. W. Barrett, Mr. and Mrs. Bangay, Mr. and Mrs. T. Burton, Mr. and Mrs. A. Burton, Mr. W. Burton, Mrs. R. Swindells, Mr. and Mrs. Hewett, uncles and aunts; Mr. and Mrs. R. Williamson.

Mr. and Mrs. Ashworth and Mr. and Mrs. Byford were unable to attend.

Others at the church were Mr. and Mrs. W. E. Brock (North Lopham), Mrs. W. Sidell, Mrs. J. Beales (Quidenham), Mrs. D. Balls (Eccles), Mrs. W. Smith, Mrs. B. Pulfer, Miss Catling (also representing Mr. E. H. J. Macro (Old Buckenham), Mrs. S. J. Barber (Eccles), Miss Michell, Miss G. E. M. Singers-Bigger, Miss M. I. L. Carter, Mrs. Gowing (Delham), Mrs. R. Hoskins, Mrs. W. Bailey, Mrs G. Solly (also representing the staff of J. Sainsbury Ltd), Mr W. J. Clarke, Miss Finch, Mrs. M. Robinson, Mr. and Mrs. Ives, Mrs T. Gernham, Mr. H. Cockrill, Mrs. R. B. Dunn, Mr. and Bussy Bussey (also representing V. Beales, Mr. R. A. Mallott, Mrs. H. Bailey (also representing the staff at Mesara F. Sizer), the Kenninghall Air Cadets under the direction of Mr. E. A. Flowerday, who also represented the headmaster, teachers, and scholars at Kenninghall School.

The many beautiful floral tributes included wreaths from the Church choir, organist and servers; the Vicar and congregation of St. Mary's Church, Kenninghall, and other friends; J. Sainsbury; staff; Mr. and Mrs. C. Ives (the deceased's employers); and Mr. and Mrs. D. A. Shepperson (previous employers).

The funeral arrangements were carried out by Messrs. E. H. J. Macro (Old Buckenham).

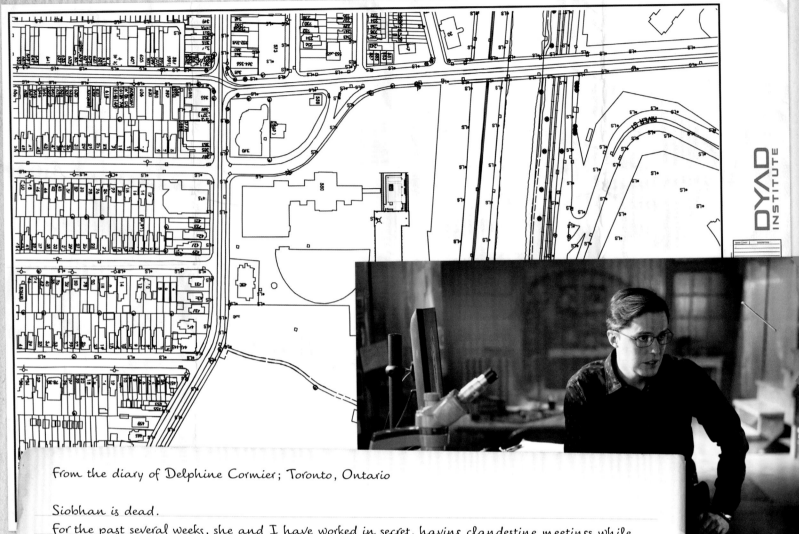

From the diary of Delphine Cormier; Toronto, Ontario

Siobhan is dead.

For the past several weeks, she and I have worked in secret, having clandestine meetings while I was travelling on Neolution's behalf. More recently, we colluded with Rachel Duncan and Ferdinand Chevalier to finally bring down Neolution. Felix and Adele were able to gather some intelligence, I supplied some more, but it was Rachel who brought it all together.

Among us, we have managed to assemble enough to finally bring Neolution's mendacity to light. Ferdinand wanted to blackmail them, but instead, we have released the information to the public. Every aspect of this project has been designed to keep itself secret, from Coady's covert Project Castor to keeping the Leda sisters naïve to the various IVF clinics run by Dyad being used as a cover to implant clones.

The way to stop them is the same way you get rid of ants that hide under a rock: simply lift the rock and expose them to sunlight, and they will scurry.

I had thought that working with Ferdinand would be the most difficult aspect, but in truth it was working with Rachel. Especially since we were forced to let her spend time with Kira. But in truth, I believe that is why we were able to turn her to our side in the end. The other Ledas are her competition, mirrors of the life she could never have. In Kira, I believe she finally was able to see hope.

Would that I could find such hope myself. Siobhan is yet another corpse to add to the appallingly large pile of them. I should have found another way, but once Ferdinand realized we would not be blackmailing the Neolution board—in other words, once he realized we would not be making him rich—he turned on us. Siobhan sacrificed herself to stop him, and now we have lost a great ally and a great enemy.

I am so tired of sacrifice. I am un médicin. My job is to heal, to preserve life. I have already lost too many loved ones. This needs to stop.

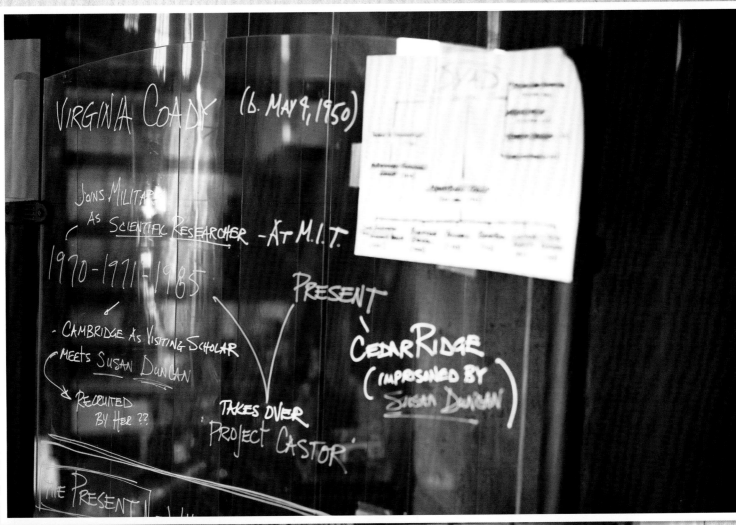

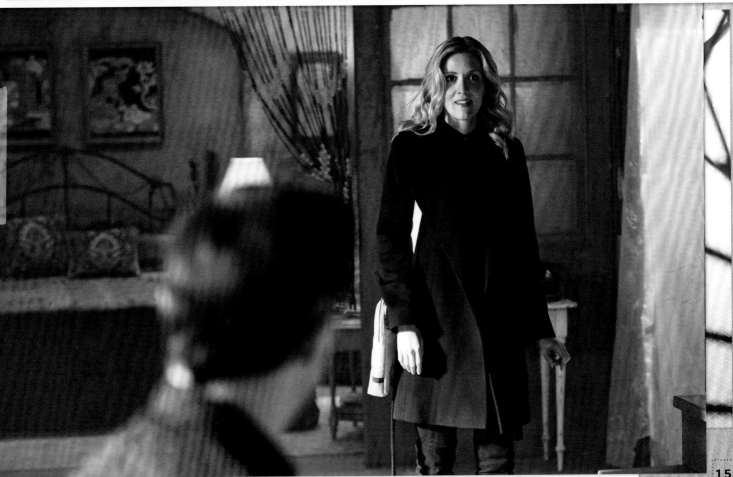

Dear Ethan and Ferdinand:

You're both gone. Dead. We will never get a chance to reconcile and I'm at a loss. Neither of you will ever get to read this, never get to hear what I have to say to you both, but I'm going to write it anyway because I'm rather drunk and it feels like the closest thing to telling you to your faces.

As I sit here in this hotel room, making full use of the minibar, I find myself thinking about you both. The only men who ever cared about me. The only people who ever loved me. Or is just that you were the only ones I loved back?

Susan never loved me, of course. She never loved anyone. She was my mother, but she only saw me as part of her grand experiment to save the human race from itself. But you two did, you both saw me and it got you both killed.

There was a time that I thought that Aldous loved me, but he was merely following orders, as he always did. He was the charming face of Neolution, the man who could sell it to the public, give the "Freaky Leekies" someone to worship and to emulate. I thought that the man claiming to be P.T. Westmorland loved me, but he was also using me, the same as Susan. In fact, he was worse, he used all of us. And yet when they were alive, Aldous and PT were the two I tried most to please. What a waste.

Aldous was my mentor, my father figure after Ethan and Susan allegedly died. I tried so hard to show him that I was an asset, that I was more than just another Leda, that I was capable of making a contribution without being naïve. I proved myself to him as an asset, but he never saw me as anything other than a part of the experiment. I wasn't a person, I was a clone.

As for the fraud "P.T. Westmorland," he has proven himself a finer con artist than even Sarah. I desperately wanted to please him, I devoted myself completely to his cause. He made me feel special, "The chosen one." But all of it was a sham. He pretended to trust me, pretended to love me, all the while using my eye to spy on me, to bring me under his heel. Nothing has ever felt better than to rip him out of my head.

Speaking of heels, there's you, Ferdinand. What was it you said? You'd gladly have lived under my heel forever? Ideally one of the spiked ones, no doubt. You did care enough to help me. You came running back to me even after you felt I'd betrayed you. You felt so betrayed by my devotion to Neolution that you killed M.K. Yet you took me back again and again.

And Ethan, my father, you always showed me love and affection. Yet in the end, you let me down too, didn't you? Ethan, you didn't love me enough to tell me that you faked your death, to take me with you when you went into hiding after the fire. No, you left me with Aldous and his puppet masters in Neolution. And then when I finally got you back, you took your own life. Leaving me alone, again.

As for you, Ferdinand, I gave you every opportunity to take advantage of our freedom from Neolution and run away. I'd forgiven your excesses, you'd forgiven my temporary defection to Neolution, but you didn't love me enough to overcome your endless greed. Your greed was your end. What a fool to reject me and instead walk into the lion's den of the Neolution board with the blank disk I gave you. I hope Siobhan killed you swiftly.

How sad is my life? I sought out love from those who couldn't give it. I received love from two men, but they didn't really ever want to know me.

The last image I have of you, Ethan, is disappointment. The last image I have of you, Ferdinand, is anger. You thought you loved me, but you both died thinking of me in anything but a loving light.

Meanwhile, I sit here in a hotel room having saved Kira from Neolution and delivered her back to her mother, helping to free us all. The Leda program was unforgivable, but hopefully this gesture, this list, redeems something. Sarah and her band of Sestras are free, but will I ever be? I see their love for one another and I hope to someday find someone that shows me even half of that love. I am unforgivable, but I can try, at least for now, to live for myself and not for others.

Yours in love and anger,
Rachel Duncan

## AGREEMENT FOR WAIVER AND RELEASE

This Waiver and Release Agreement ("Agreement") is made and effective as agreed to:

BETWEEN: DYAD INSTITUTE / "COMPANY"
6750 GARRISON ROAD
TORONTO, ON M6T JK8

AND: RACHEL DUNCAN / "PROPERTY"
[ ID NO.  779H41 ]

**Recitals**

Employee is former property of the Company and the Parties wish to resolve any claim by Employee against the Company and all other existing differences completely and amicably, without litigation. Employee acknowledges that the payment to him under this Agreement is being made for the sole purpose of avoiding the uncertainties, vexations and expense of litigation.

The Parties represent that they have been advised about the Agreement by their respective counsel, are competent to enter into it, fully understand its terms and consequences, and enter into it knowingly and voluntarily.

NOW, THEREFORE, in consideration of the above recitals and the mutual promises and conditions contained in this Agreement, the Parties agree as follows:

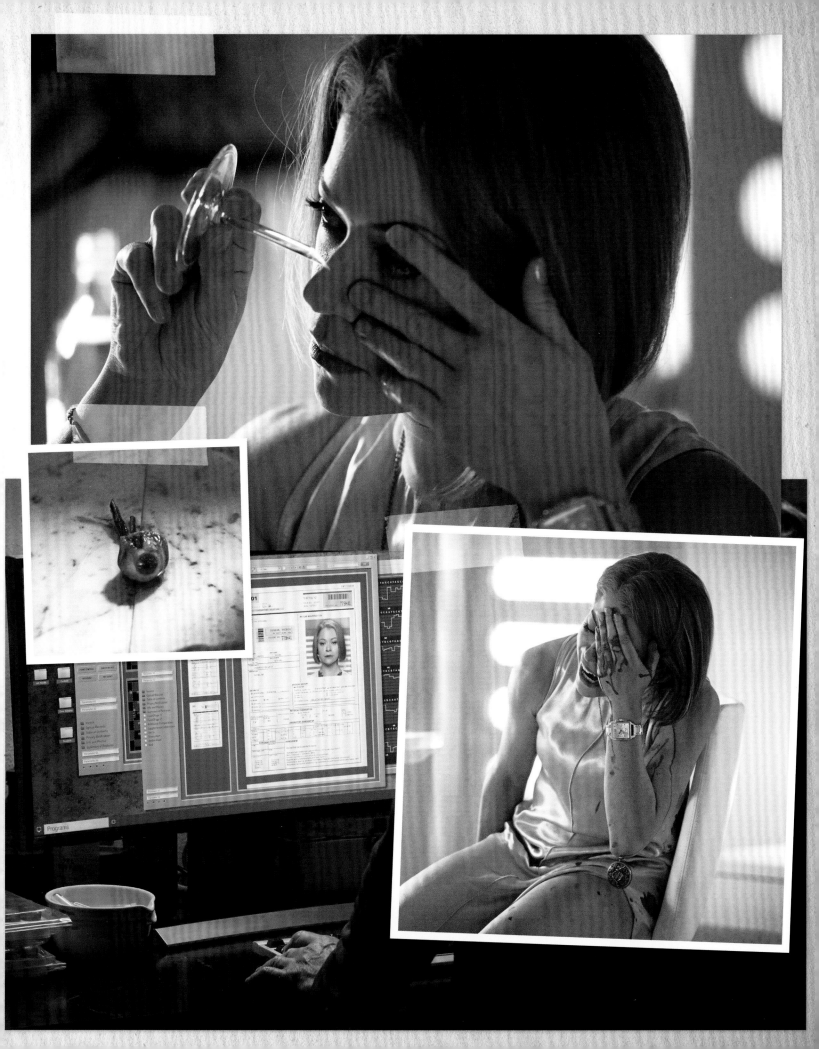

-Helena has been hiding out at a convent in a remote location to protect her twin babies from Dyad.
-She is writing a memoir about her extraordinary life and her relationship with her fellow Leda clones (her "sestras").

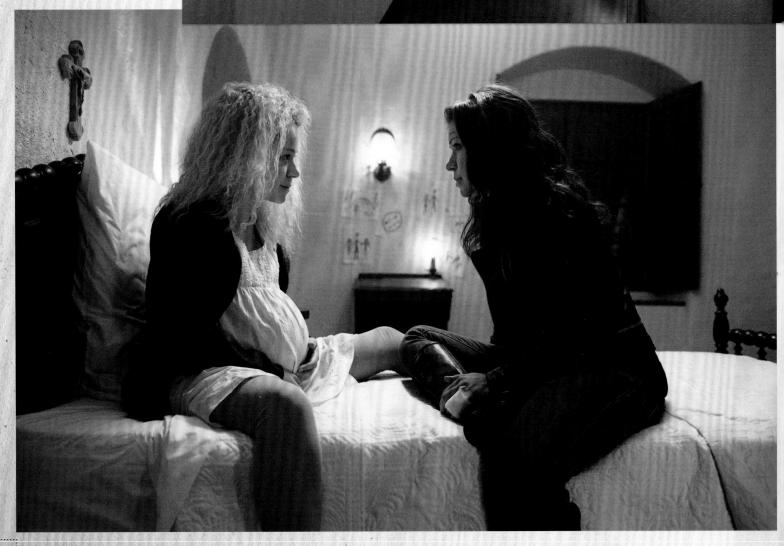

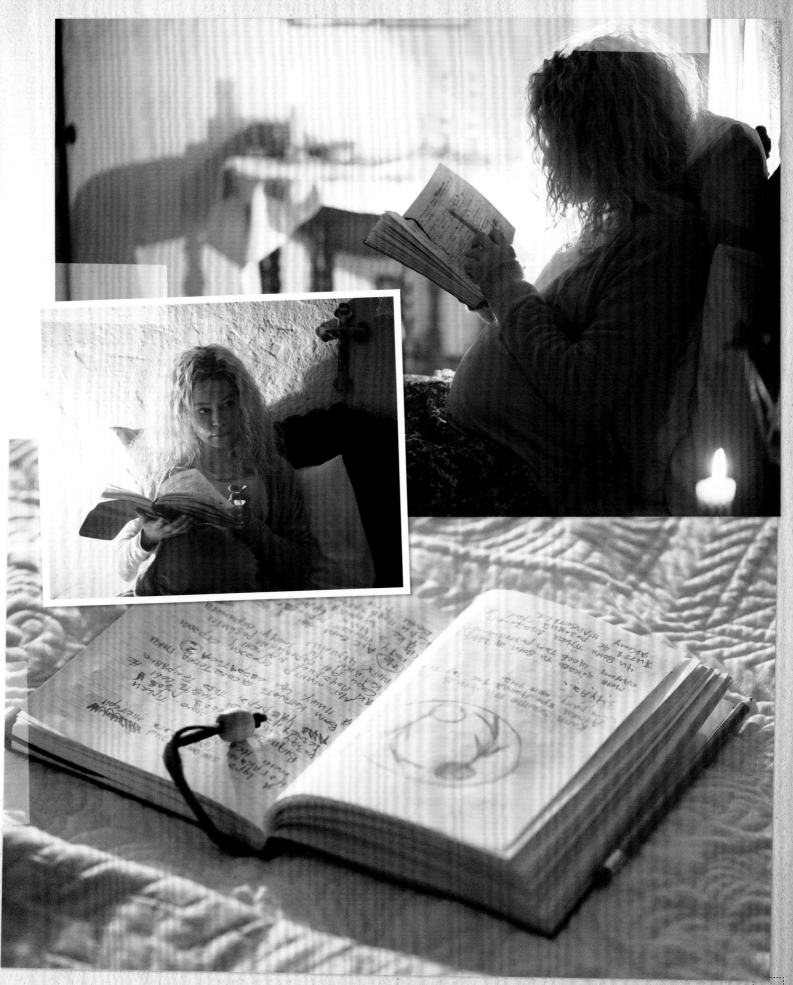

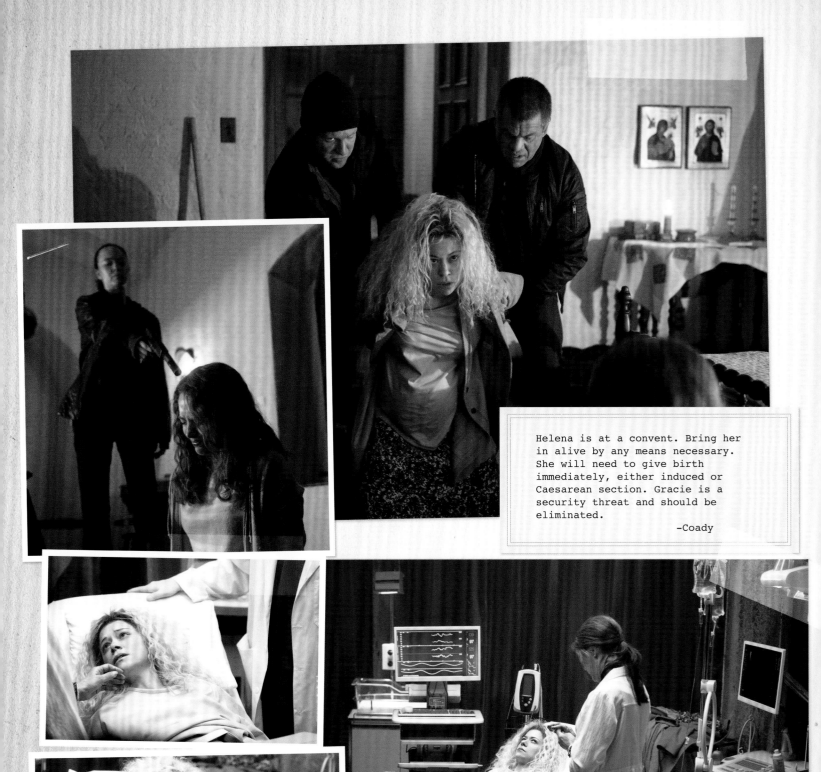

Helena is at a convent. Bring her in alive by any means necessary. She will need to give birth immediately, either induced or Caesarean section. Gracie is a security threat and should be eliminated.

-Coady

I have no idea why I'm leaving this message. I know that Project Castor has been disavowed and I know that you can't even admit that you know who I am. Still, a long time ago, you said to call this number in case I needed to reach you right away. And the voicemail box still seems to be working, though I wonder who is even listening to it. Probably some intern in your office.

But I need to get this out to someone, and it's not like I have friends or family I can call. It's been all about the work. It's always been about the work. And now the work is going to shit.

After you disavowed me, David, I had thought everything was lost. Then I got rescued by P.T. Westmorland. At least that's what we call him. His real name is John. He was our beard. Susan and I were using him as cover, since it's not like women were allowed to be scientists back when we started. Hell, we're barely allowed to be now in the oh-so-enlightened twenty-first century.

Susan and I had a falling out ages ago, so when John got me out of the institution she trapped me in, I wasn't thrilled to see her there. But she seemed willing to bury the hatchet, so I was willing to put up with her naïve idiocy.

Besides, it's always better to keep your options open. Castor and Leda. Nature and nurture. Science and weaponry.

God, I thought that we were starting over. Getting a fresh start, and using the Ledas to get it right this time. But no. I've got bodies dropping all around me. John killed Susan for trying to kill him, Gracie was killed because she lied about finding Helena, and both Mark and Ira are dead, too. The last of my boys. I had to kill Mark myself.

It's funny, when the compound burned and most of the remaining Castors died and you disavowed me, I didn't feel anything. But losing both Mark and Ira—the last two—for some reason that one really hurt. Maybe I didn't feel anything after Dierden blew it all up because I knew Mark and Ira, at least, were still out there.

For many years, I've wanted Susan the hell away from all of this. I always thought that if we could just get rid of her and her doddering fool of a husband, the project could work. We could stop the out-of-control freight train of extinction that we are all riding.

But it wasn't her, it wasn't Ethan, it was John. The man whose money and whose gender allowed two brilliant women to do their work without the patronizing looks and the obnoxious comments and the dismissive memos. It was John that was in our way.

And now, he's ruining all of it. He's started to believe his own myth, and it's already taken down Susan and the last of my boys. I'm sure I'm next. Once Helena's twins are born, I suspect that I will become just as expandable as everyone else.

David, or whichever intern is listening to this voicemail, I'm sorry we weren't able to make the project work. I'm sorry that John's ego got in the way. If it hadn't been for that, we might have been able to make a better world.

Or maybe not. After all, if it wasn't for John, we wouldn't have been able to even start in the first place.

Goodbye.

(END RECORDING)

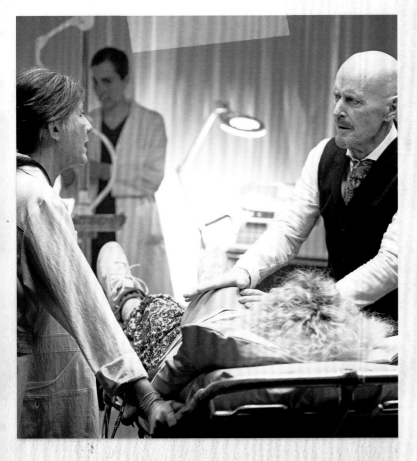

| | CLONE ID. :: | LEDA NAME :: | LAST KNOWN ADDRESS | :: | COUNTRY :: | D.O.B. |
|----|--------|---------------------|------------------------------------------|----|-----------|------------------|
| 1 | 876A18 | Oksana Petrov | Fauchalds gate 28B, Oslo, NO | | NORWAY | March 6, 1984 |
| 2 | 902A27 | Kalista Papadakis | Olvias 112, Athens, GR | | GREECE | March 14, 1984 |
| 3 | 943A16 | Ana Ferreira | 1080 Calle Juan Pérez, Mexico City, MX | | MEXICO | March 13, 1984 |
| 4 | 991A23 | Lisa Glynn | 406 Whitepine Dr, Calgary, AB | | CANADA | March 12, 1984 |
| 5 | 105B64 | Yvonne Gustafson | Mejdells Gate 220, Lillehammer, NO | | NORWAY | May 7, 1984 |
| 6 | 186B03 | Asa Yamato | 116-3 Setagaya Dori, 4 Chome, Tokyo, JP | | JAPAN | June 8, 1984 |
| 7 | 292B16 | Lily Ng | 1704-48 G/F Jubilee St, Central, HK | | HONG KONG | June 10, 1984 |
| 8 | 308B94 | Hülya Eröz | 10880 Feralzci Sk, Istanbul, TR | | TURKEY | Sept. 9, 1984 |
| 9 | 311B72 | Christie Damphouse | 55 Del Mar Blvd El Paso, TX | | U.S.A. | June 11, 1984 |
| 10 | 320B18 | Veronica Giannocari | 1059 Via Venezia, Crotone, IT | | ITALY | Sept. 17, 1984 |
| 11 | 324B21 | Cosima Niehaus | 2818 Como Avenue S.E., Minneapolis, MN | | U.S.A. | March 9, 1984 |
| 12 | 354B82 | Tamiko Nakamura | 11 Ozu, Higashiyama Ward, Chuo-ku Pref. | | JAPAN | June 8, 1984 |
| 13 | 406B54 | Avigail Cherney | Ben Yehuda St 1008, Tel Aviv, IL | | ISRAEL | June 11, 1984 |
| 14 | 442B76 | Kemila Barret | Av Gdor Marcelino 3401C, Buenos Aires | | ARGENTINA | May 7, 1984 |
| 15 | 601B41 | Joanna Moore | 12 Harris Court, Fargo, ND | | U.S.A. | March 11, 1984 |
| 16 | 718B06 | Helen Assimakopoulos | Lavragka 68, Athens, GR | | GREECE | March 8, 1984 |
| 17 | 907B54 | Adrian Sheepers | 888 Bankhead Terrace, Edinburgh, SC | | SCOTLAND | June 11, 1984 |
| 18 | 202C41 | Camila Torres | 55 Rua Santo Maria, Cartagena, CO | | COLOMBIA | April 8, 1984 |
| 19 | 308C11 | Zarin Silva | 288 Rua Jorge Machado, Sao Paulo, BR | | BRAZIL | April 17, 1984 |
| 20 | 320C65 | Tony Sawicki | 48 Stenson Road, Cleveland, OH | | U.S.A. | March 4, 1984 |
| 21 | 419C05 | Leticia Santos | 111 Novo vale, Sao Paulo, BR | | BRAZIL | April 6, 1984 |
| 22 | 448C11 | Gabriela Sousa | 280 Rua Novo Flores, Rio de Janeiro, BR | | BRAZIL | April 13, 1984 |
| 23 | 461C05 | Olivia Jones | 49 Charlotte St, Sydney, AUS | | AUSTRALIA | August 12, 1984 |

DYAD INSTITUTE | 6750 GARRISON ROAD TORONTO, M6T JK8 | 416.555.0139 | WWW.DYADINSTITUTE.REG

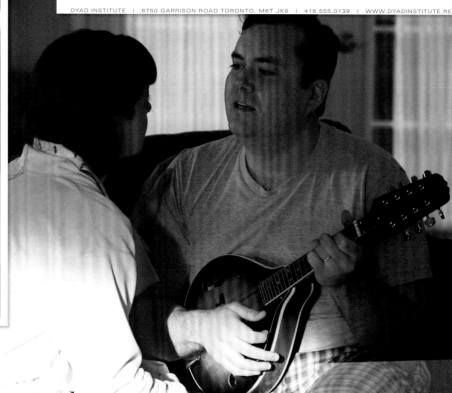

From the diary of Delphine Cormier, Toronto, Ontario

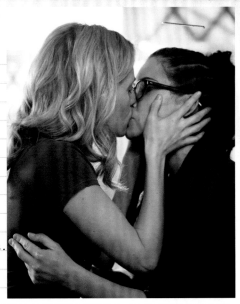

After all this, we somehow contrived to have a happy ending.

It is not completely happy, of course. Siobhan is dead, as are M.K., Susan Duncan, Kendall Malone, Paul Dierden, Katja Obinger, Dr. Coady, Ira, Mark, Gracie, and so many others. There are times when, despite everything, I even miss Aldous. Miss our conversations in French, miss our lengthy chats about evolution, philosophy, and food.

But there is something else that is dead, and that is Neolution. The man who claimed to be the 170-year-old P.T. Westmorland was, in fact, a normal old man named John who used the Duncans, Aldous, Coady, everyone to prolong his own miserable life.

And there has been life. Despite the best efforts of Helena to kill herself, she survived and gave birth to twin boys. Deux cousins de Kira!

Most of all, vous êtes un famille. We no longer have Siobhan, who sacrificed herself to save all of her daughters, but we have the family she died to save. Helena lives with her boys in the Hendrix garage, Alison and Donnie Hendrix struggle to work and make a better home for themselves and their children, Sarah is living with Kira in Siobhan's old house, Felix is in New York living the life of a great artist, plus we have our support in Art, Scott, and Hell-Wizard.

And Cosima and I have each other.

We have the cure. We have been seeking out Leda clones all over the world and inoculating them against the disease. We were too late to save the Castors, but we may still save the Ledas. According to the information provided by Rachel—an attempt, it seems, at redemption on the part of the prodigal sister—there are 284 Ledas out there. We have the information we need to find them and make sure that they live long, healthy lives.

But even as Cosima and I work to save her sisters, we also work to save ourselves. Ours has been a difficult road, from my time as her monitor to her time thinking I was dead after I was shot to Siobhan and I attempting to expose the Neolution Board of Directors to our discovery of the importance of the LIN28A protein to finally getting Cosima off the island and back with her sisters. We have been through life and death together. It is my hope that we will now only have to worry about living life together.

Perhaps we might even be able to bring a life of our own into the world. Even with the cure, the Leda clones remain barren, but I am not. . .

Cosima said something the other day, and asked me to write it in the diary. I told her she could, but she wished me to write the final entry. It is this:

Evolution cannot be imposed from above—or from below. It comes from the side and hits you in every possible direction before it is through with you. It is the perfect melding of order with chaos, as random environmental factors clash to bring about an orderly development. The arrogance of John, of Susan and Ethan, of Dr. Coady, of Aldous was that they all believed they bring universal order to a process that cannot function without constant chaos. Many people died chasing that dream, including the five of them.

Those of us who still live will fight for life to continue in all its mad, chaotic glory.

This is the final entry in this diary. I have placed it with the other material, including Cosima's own entries, in the hopes that it might bring wisdom and understanding of what has happened to me, to Neolution, to Project Leda, to my dear Cosima and her sisters.

Au revoir,
Dr. Delphine Cormier

HarperCollins books may be purchased for educational, business, or sales promotional use. For information please email the Special Markets Department at SPsales@harpercollins.com.

First published in the United States in 2017 by
Harper Design
*An Imprint of* HarperCollins*Publishers*
195 Broadway
New York, NY 10007
Tel: (212) 207-7000
Fax: (855) 746-6023
harperdesign@harpercollins.com
www.hc.com

Distributed throughout the world excluding the United Kingdom by
HarperCollins *Publishers*
195 Broadway
New York, NY 10007

ISBN 978-0-06-266396-2

Library of Congress Control Number 2016958629

*Produced by*

INSIGHT
EDITIONS

PO Box 3088
San Rafael, CA 94912
www.insighteditions.com

Publisher: Raoul Goff
Associate Publisher: Vanessa Lopez
Art Director: Chrissy Kwasnik
Designer: Brie Brewer
Managing Editor: Alan Kaplan
Project Editor: Kelly Reed
Editorial Assistant: Hilary VandenBroek
Production Editor: Rachel Anderson
Production Manager: Carol Rough and Lina sp Temena
Production Assistant: Sadie Crofts

Special thanks to story editor Mackenzie Donaldson.

ROOTS of PEACE     REPLANTED PAPER

Insight Editions, in association with Roots of Peace, will plant two trees for each tree used in the manufacturing of this book. Roots of Peace is an internationally renowned humanitarian organization dedicated to eradicating land mines worldwide and converting war-torn lands into productive farms and wildlife habitats. Roots of Peace will plant two million fruit and nut trees in Afghanistan and provide farmers there with the skills and support necessary for sustainable land use.

Manufactured in China by Insight Editions

10 9 8 7 6 5 4 3 2 1